MANGA MANIA

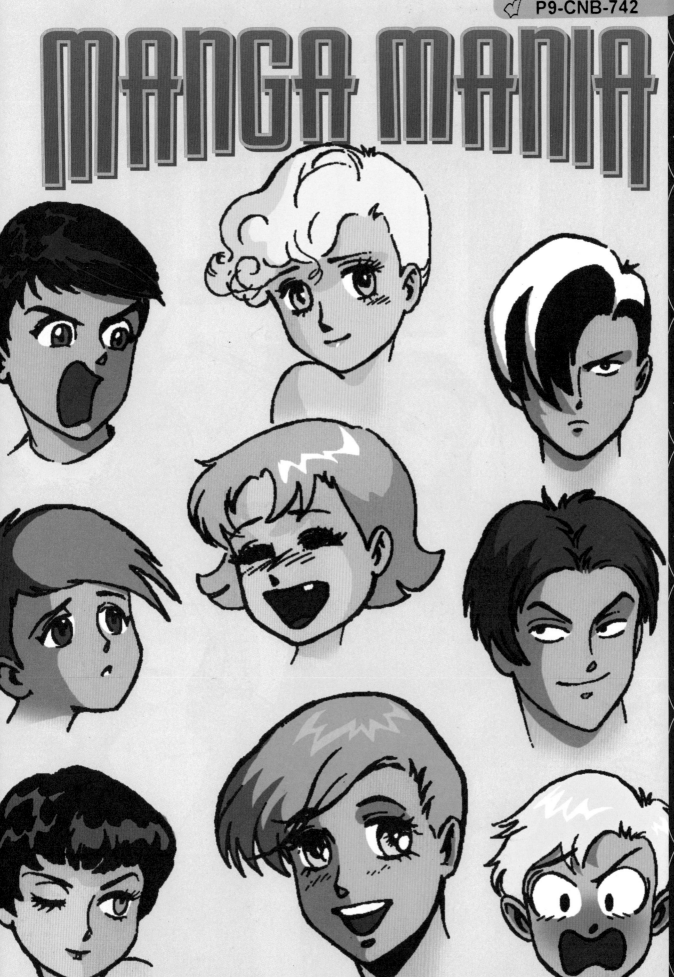

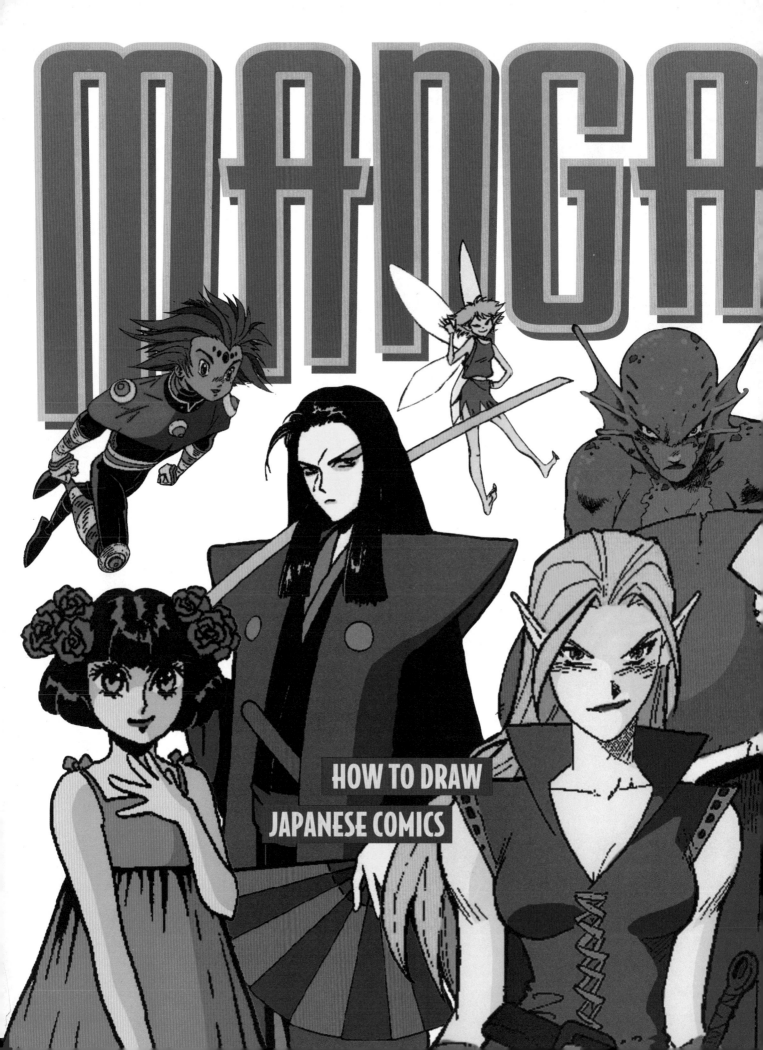

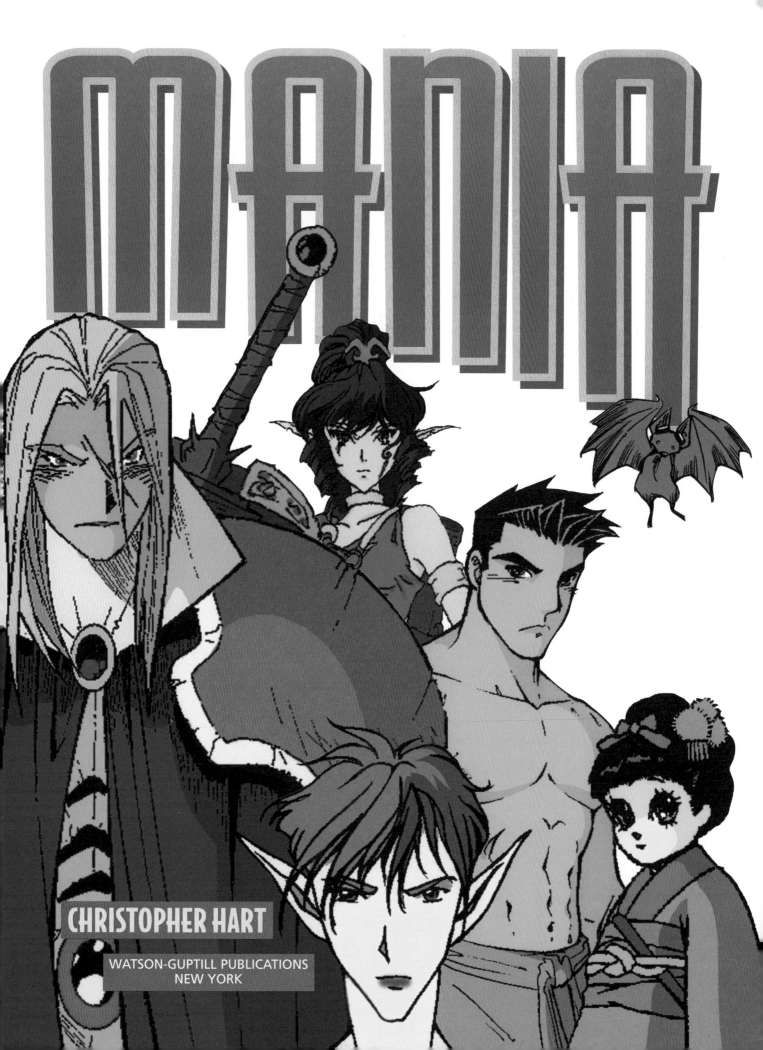

MANIA

CHRISTOPHER HART

WATSON-GUPTILL PUBLICATIONS
NEW YORK

Dedicated to you,
 the aspiring cartoonist
 and the serious art student

SPECIAL THANKS TO:
BILL FLANAGAN,
editor-in-chief of
Animerica Extra magazine,
from Viz Communications,
one of the largest publishers
of manga comics in
the United States,
for his exclusive interview
and for providing the
accompanying images;
and
MIYAKO MATSUDA,
editor/translator of
Protoculture Addicts
(an anime/manga
magazine), for help
with the translations

CONTRIBUTING ARTISTS:
Colleen Doran, 1, 9–22, 29–33, 46–65
Lea Hernandez, 23–27, 71, 117
Francis Manapul, 82–95
Mike Leeke (penciler), 97–113
Svetlana Chmakova, 66–70, 72–81, 122, 123
Andy Kuhn, 28, 34–45
Tim Smith, 116, 118–119, 124–125
Bill Anderson (inker), 97–113
Christopher Hart, 97, 115, 120–121, 126–137
Cover art by Francis Manapul

Senior Editor: Candace Raney
Project Editor: Alisa Palazzo
Designer: Bob Fillie, Graphiti Design, Inc.
Production Manager: Ellen Green
Color by J. J. Abbott, Brimstone

First published in 2001 in New York by Watson-Guptill Publications,
a division of VNU Business Media, Inc.,
770 Broadway, New York, NY 10003
www.wgpub.com

The Library of Congress Cataloging-in-Publication Data
Hart, Christopher.
 Manga mania : how to draw Japanese comics / Christopher Hart.
 p. cm.
 Includes index.
 ISBN 0-8230-3035-0
 1. Comic books, strips, etc.—Japan—Technique. 2. Drawing—Technique. I. Title.
 NC1764.5.J3 H37 2001
 741.5'952—dc21

 00-068580

Manufactured in U.S.A

11 12 13 14 / 08 07 06 05 04

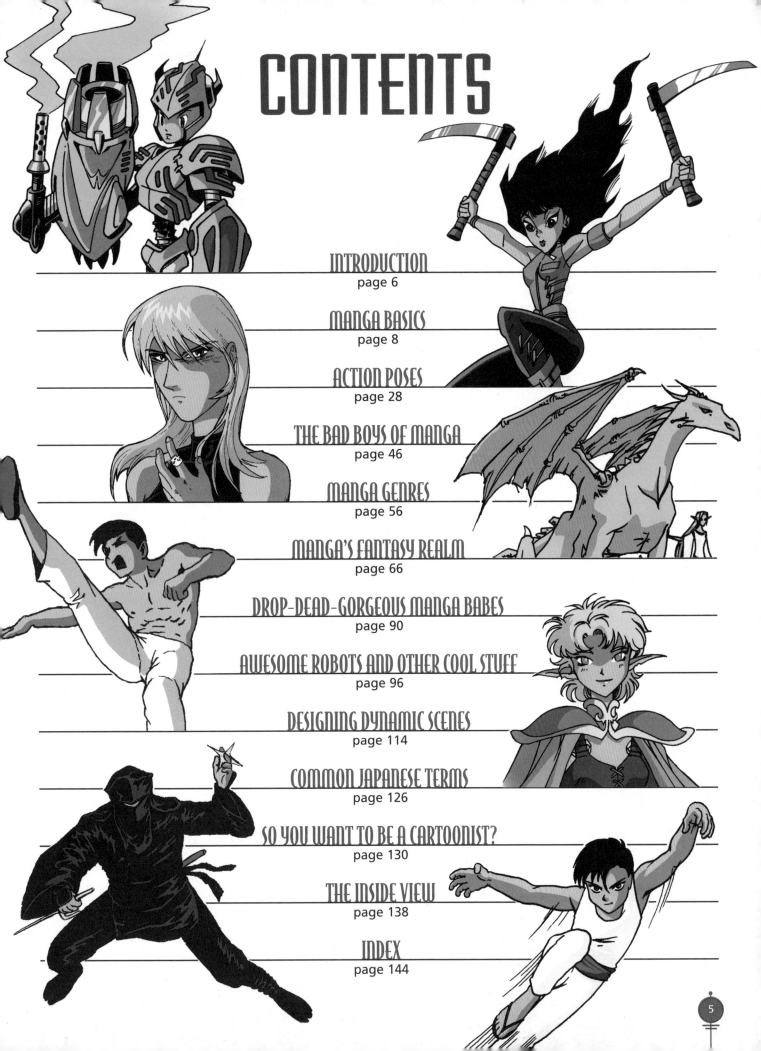

CONTENTS

INTRODUCTION

Manga (pronounced "mahn-ga," with a hard "g") means *comics* in Japanese and refers to Japanese comic books. Most Americans discover manga from *anime* (pronounced "an-ah-may"), which is Japanese animation. Usually, however, it's the original manga comic books that inspire the animated television shows. Japanese comics have a large following in America and are in the process of stealing increasing market share from western comic book publishers. Manga also boasts an extremely loyal fan base; in fact, there are many comic book conventions in America that gather exclusively to promote the manga art form.

It's impossible to overstate this, but manga is more than huge in Japan and other parts of Asia. It is a *phenomenon*. Its popularity stretches across all ages and both genders. By contrast, western-style comic books are targeted at teenage boys. Just as you would expect to see commuters in New York City reading the *Wall Street Journal* to and from work, you would see commuters riding the rails in Japan devouring the latest issue of their favorite manga comic. Manga is meant to be read quickly; therefore, the speech balloons are kept to a minimum and the action and expressions tell the story.

In Japan, manga comic books can be 200, 300, even 1,000 pages long, compared to their 22-page western counterparts. Manga artists are held in high social esteem in Japan, and popular manga artists head production facilities employing numerous artists to assist them in churning out the immense number of pages needed to fill the ever-hungry appetites of voracious fans.

Years ago, Hollywood discovered manga and brought it to the United States in the form of animated television shows, such as *Astro Boy, Kimba the White Lion, Gigantor, Speed Racer,* and *Tobor the Eighth Man.* Today, Hollywood is still mining Japan for animated shows, but with increasing frequency, it is turning comic books into television shows, television shows into movies, and movies into toy and licensing empires. Who hasn't heard of *Digimon, Dragon Ball Z, Sailor Moon,* and *Pokémon.* But now, original manga comic books, translated from the Japanese, are being published with increasing frequency in the West. The manga invasion is in full swing.

What accounts for the appeal of manga? For one thing, the style is unique and instantly recognizable: those huge, dazzling eyes; the delicate upturned noses; the flowing hair and wildly animated mouths. In addition, manga focuses primarily on creating appealing characterizations of ordinary people, while western comics push the envelope to produce chiseled anatomy, intensity, and violence. A manga character will, therefore, be easier to relate to than, for example, an action hero who eats plutonium for breakfast and blasts through concrete walls. As a result, for people who haven't had a great deal of exposure to life drawing and anatomy, manga is generally easier to draw. Faces are more subtle. Bodies don't have to pop with bodybuilder muscles. Emotions can be conveyed in the eyes or through body language.

There have been many books written about manga from a historical perspective. Although you'll certainly deepen your understanding of the art of manga from this book, that's not the primary purpose. The primary purpose is to give you the step-by-step visual instruction you need to draw and invent your own cool comic book characters in all the popular manga genres. These include *shōnen* (boys') comics; *shōjo* (girls') comics; school comics; teen comics; fantasy, sci-fi, and robot comics; samurai comics, and many others, which are all included in this book. Plus, this book moves beyond how to draw appealing characters to also demonstrate, through clear visual examples, how to pose those characters, costume them, and design eye-catching comic book panels around them.

I very much look forward to your future success and to your, quite possibly, becoming a professional *manga-ka* (manga artist) with your drawings published around the world!

MANGA BASICS

MANGA loosely translated means "comics" or "comic books" in Japanese. As a genre, manga is immensely popular in Japan, so it is no surprise that the craze is catching on here in America. The manga style of drawing, however, differs greatly from western-style comic book illustration. In this chapter, we'll go over all the basic elements that make manga, manga.

The head of the manga-style comic book hero differs in construction from that of its western-style counterpart in that it's usually much rounder and not nearly as angular. This is partly due to the younger age of many manga heroes. Facial proportions for young characters differ from those of adults. The eyes are lower down on the head and the chin is rounder. In teenage and adult characters, the chin is elongated and the entire face narrows. The chin is never square, but tapers to a point gently; however, even in teenage characters, the eyes still tend to be fairly low on the head, giving most manga characters a youthful appearance.

Another important thing to notice is that the eyes are generally spaced far apart on the head. This allows the manga artist to draw large eyes without crowding out the other features. Wide-set eyes also serve to emphasize the roundness of the head, which underscores the young appearance. The nose is always subtle and small, no matter the age of the character; in this way, it doesn't compete with the eyes. The mouth is also small and restrained, but as you'll see on the upcoming pages on manga expressions, the mouth can grow wildly in size to reflect a host of strong emotions.

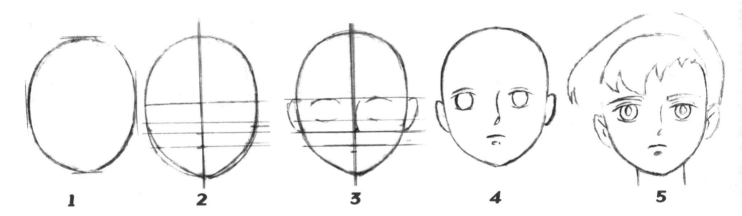

1 2 3 4 5

FRONT VIEW

1 Start with a circular shape. Although it's not really an oval, it's slightly taller than it is wide.

2 Divide the face in two with a light, sketchy vertical guideline. This is crucial, because it will help you to space the eyes evenly—in a frontal view, if one eye is further away from the center of the face than the other, you're sunk. Next, add a set of parallel horizontal guidelines across the middle of the head to indicate where the eyes will go. Sketch another light horizontal guideline to indicate where the bottom of the nose will be, and one more to indicate where the lips will go. The bottom of the nose falls about halfway between the top of the eyes and the chin. Also, don't leave much room between the bottom of the nose and the lips; you want a short upper lip, which is a trademark of a youthful character. Long upper lips are reserved for older and sinister characters.

3 Start to sketch in the eyes, working large. Don't be shy on this one. The eyes are the focal point of the manga face. Use a simple, lightly drawn curve to indicate the bridge of the nose. Place the ears low on the head, falling between the top eye line and the nose line, and indicate the bottom lip with a small line.

4 Now you can erase the guidelines if you wish. Begin to define the eyelids, and draw a small shape at the bottom of the nose to indicate its underside.

5 Make a decision about how the hair should fall, either to the left or to the right, and then build it up. This adds height to the head, giving the effect of pushing the eyes further down the face.

6 The final result is a young manga boy.

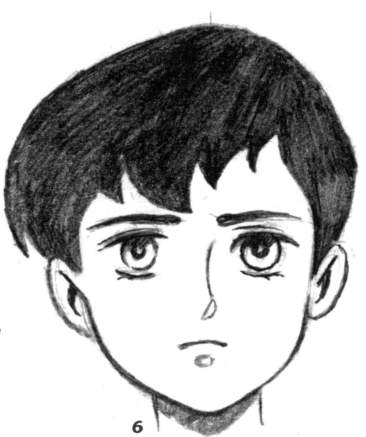

6

TURNING THE HEAD

In comic books as in other forms of cartooning, such as animation and comic strips, it's essential that artists have the ability to turn a character to different angles while still retaining its recognizability. This is why lightly drawn guidelines are so important; by placing them at the same point or level on a character, no matter which direction that character is facing it will maintain the same proportions. And, this helps in maintaining recognizability.

The rear views are less common head turns that you won't see in most how-to-draw books. And although they aren't the most favored head positions, you'll certainly need to use them as a manga artist.

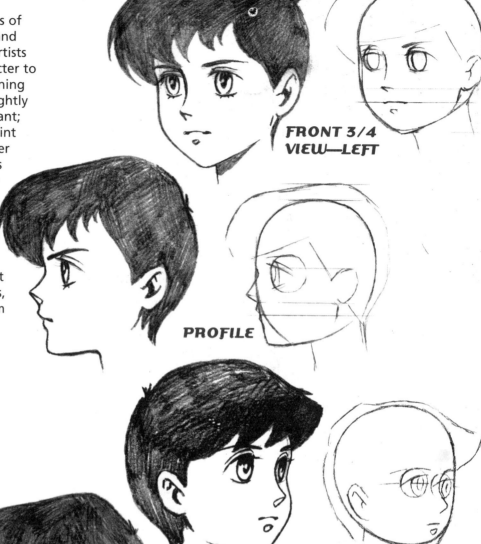

FRONT 3/4 VIEW—LEFT

PROFILE

FRONT 3/4 VIEW—RIGHT

REAR 7/8 VIEW

This is the view most often used when two characters are having a conversation. The speaking character usually faces the reader in a 3/4 view, while the back of the head of the listening character faces the reader in a rear 7/8 view. Only a hint of the nose and an eye is visible on a character in this position. Sometimes, but not always, you can work in a bit of the lips; and with young characters who have plump cheeks, the lips usually disappear behind the mass of the face.

REAR VIEW

This view is generally used for characters walking away from the reader or sitting in front of another character. Note how wide the head is in the rear view and how low the ears are on the head. In addition, the boy's cheeks would be visible, if not obscured by the hair.

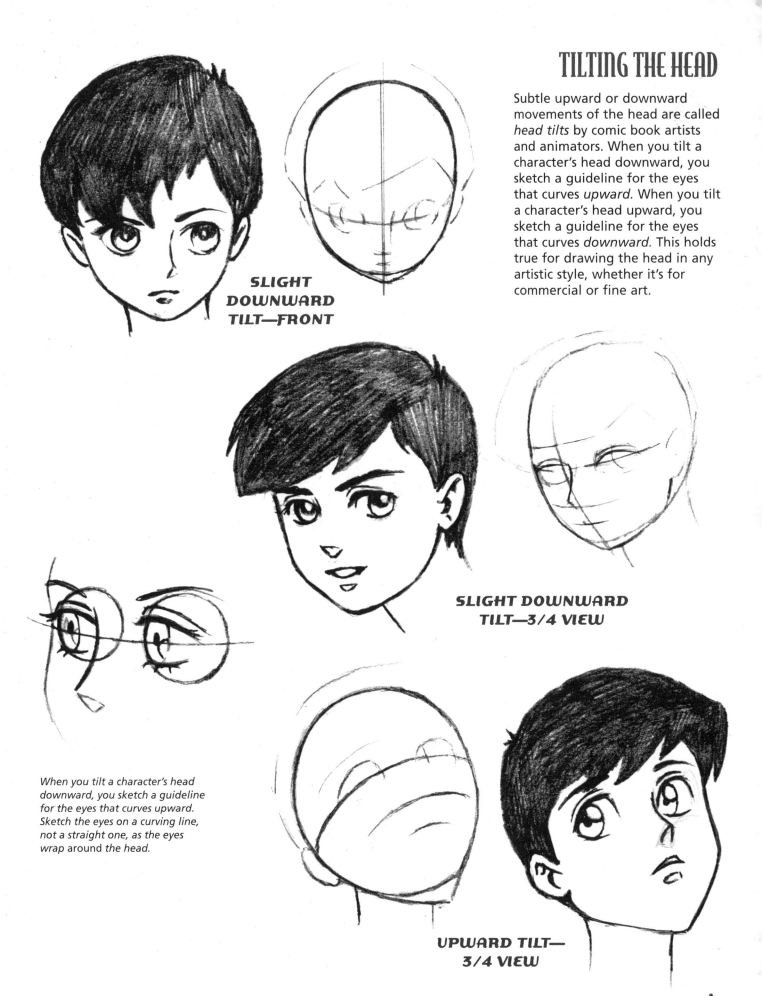

TILTING THE HEAD

Subtle upward or downward movements of the head are called *head tilts* by comic book artists and animators. When you tilt a character's head downward, you sketch a guideline for the eyes that curves *upward*. When you tilt a character's head upward, you sketch a guideline for the eyes that curves *downward*. This holds true for drawing the head in any artistic style, whether it's for commercial or fine art.

SLIGHT DOWNWARD TILT—FRONT

SLIGHT DOWNWARD TILT—3/4 VIEW

When you tilt a character's head downward, you sketch a guideline for the eyes that curves upward. Sketch the eyes on a curving line, not a straight one, as the eyes wrap around the head.

UPWARD TILT— 3/4 VIEW

THE MANGA EYE

The beautiful, hypnotic eyes are perhaps the most challenging element to draw on the manga character. The eyes must be drawn correctly, because they attract so much attention to themselves.

While you may want to simply draw beautiful, reflective eyes, remember that the eyes shouldn't appear to be mere ornaments but rather functioning organs that are able to see. They must be able to convey intensity and a range of emotions.

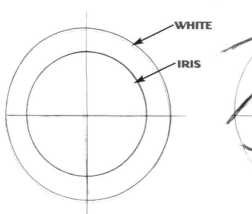

WHITE

IRIS

The orbit of the eye (the eye socket) is simply a large hole in the head.

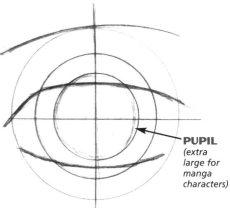

PUPIL
(extra large for manga characters)

The eyeball itself is round, while the eyelids cover the top and bottom sections of the circular eyeball, giving the eye its almond-shaped appearance.

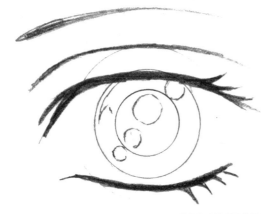

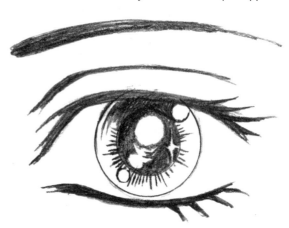

EYE SHINES
Whereas the eyes of western-style comic book characters have one or perhaps two eye shines at the most, manga eyes display many shines—several in both the iris and the pupil. There may even be a few star bursts, too.

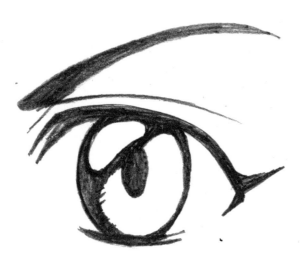

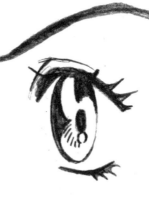

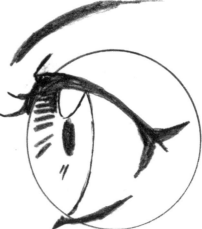

ALTERNATE SHINE
Here's another front view of a typical manga eye. Instead of many small shines in the eye, there's one huge shine. This elongated shine actually curves around the eyeball, helping to establish that the eyeball is round.

SIDE VIEW
Note that the eyeball maintains its round form as it peeks through the opened eyelids in the side view.

EYE CLOSE-UPS AND VARIATIONS

All these examples show attention to detail and star quality by illuminating the eyes with heavy shines. It's also very important to vary the thickness of the lines used to create the eyelids, irises, eyelashes, and eyebrows, as demonstrated here. The top of each iris is, to one degree or another, covered in shadow, or at the very least, the upper eyelid appears thicker due to the shadow it casts on the eyeball.

STANDARD
Note that of the three shines, the largest one is in the iris, not the pupil. If the pupil is mostly obliterated by a large shine, the expression will read as "stunned."

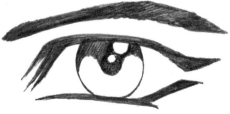

HERO
The long and lean quality of this eye is created by the slashing angle at which the top eyelid travels from the inner corner of the eye to the outer one. In addition, the eye is slender because the bottom eyelid pushes up on the eyeball.

STAR BURST
This type of eye has a proliferation of shines and is used primarily in shōjo ("girls'") manga, which caters to a young female readership. It's important to note it would not be possible to create this many shines if the eye were not so heavily shaded—the shading creates a place for the shines to exist. The more shines you want, the more heavily shaded the eye must be!

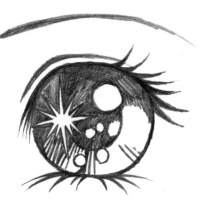

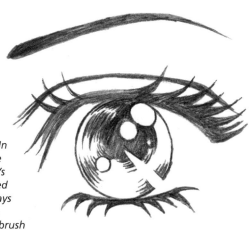

ORNATE
Note the details of the lines that create a pattern in the iris. In addition to the three circular shines, there's a fourth, sliver-shaped shine. Eyelashes always curve away from the eyes. The top lashes brush upward; the bottom ones brush downward.

EYE CLOSED

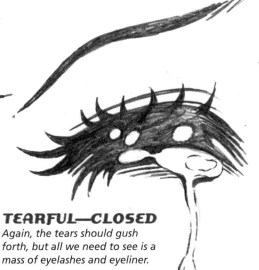

TEARFUL—CLOSED
Again, the tears should gush forth, but all we need to see is a mass of eyelashes and eyeliner.

TEARFUL—OPEN
When the eye is crying, it should look as if the tears are bubbling over the lower lid with streams of tears cascading down the cheek.

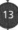

THE MANGA EYE AND CHARACTER TYPES

You should base your choice of eye design on the type of character you're drawing. The style of manga eye must fit the character. If you love those big shōjo-style eyes but are drawing a villain, you must resist the impulse to use gigantic eyes for the evil character. For sinister characters, use slender eyes with sharp eyebrows.

Since manga has such a wide variety of styles, there are many eye types from which to choose. Generally, the more realistic the character, the more almond-shaped the eyes. The younger the character, the rounder and taller the eyes. For fantasy and young-girl characters, much emphasis is placed on the lashes, which are drawn individually, rather than bunched together as they appear on more mature characters and in western-style comics.

Although comic book artists who work in the western style use heavy shadow to create mood and tension, that isn't always the technique used in manga. Look at the young-boy character in the lower left corner of the facing page: His eyes are heavily shaded, but the result is a more doll-like appearance, not a more dramatic one. His eyes shine like beacons of truth, conveying a palpable sense of earnestness.

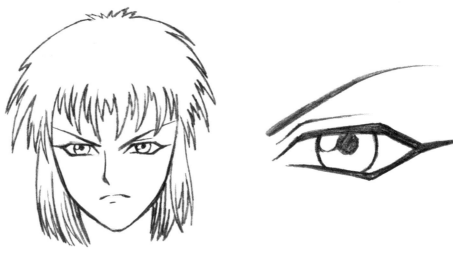

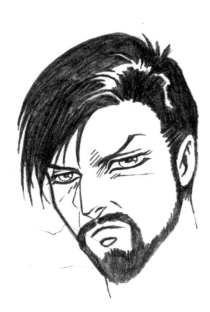

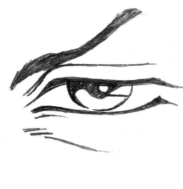

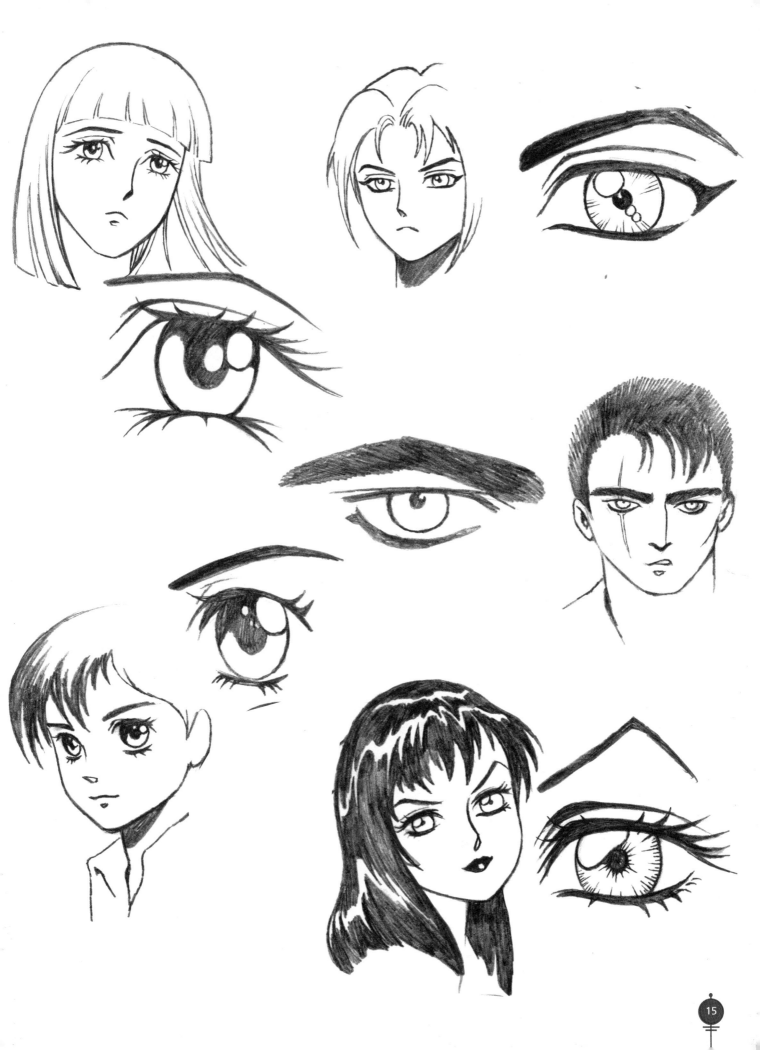

MANGA HAIRSTYLES

Because of the large forehead areas (due to the huge eyes), the heads of manga characters have a lot of surface area to cover with hair. You'll generally notice an abundance of hair energetically tossed on your typical character. Be generous in your application; let the hair flop over the forehead, over the eyes, and around the sides of the head. Work loosely, with long, free strokes.

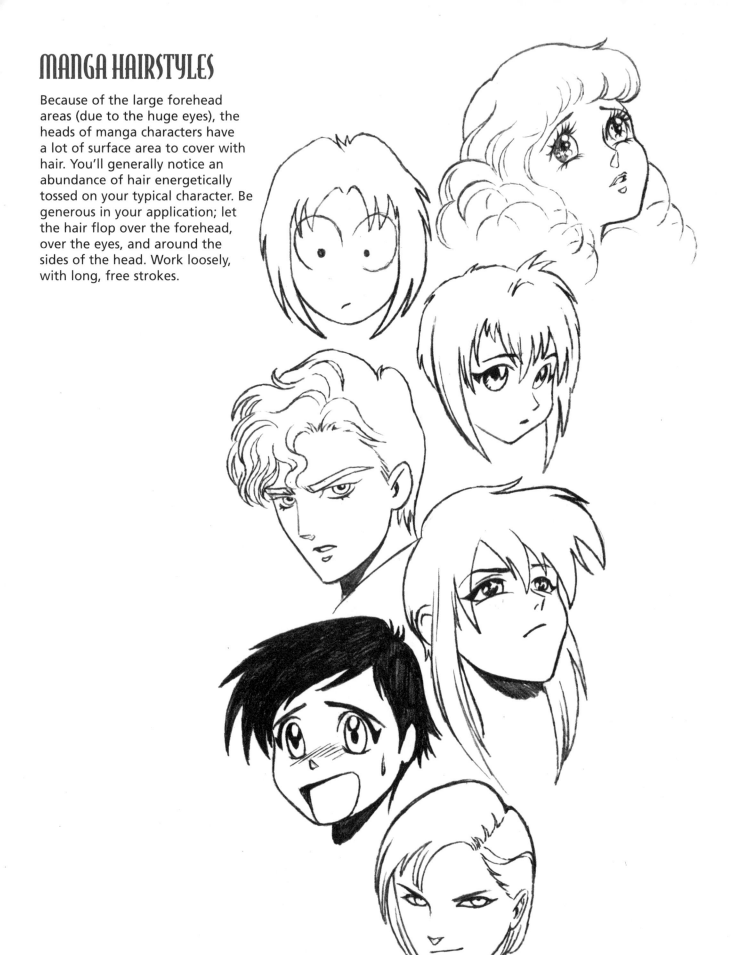

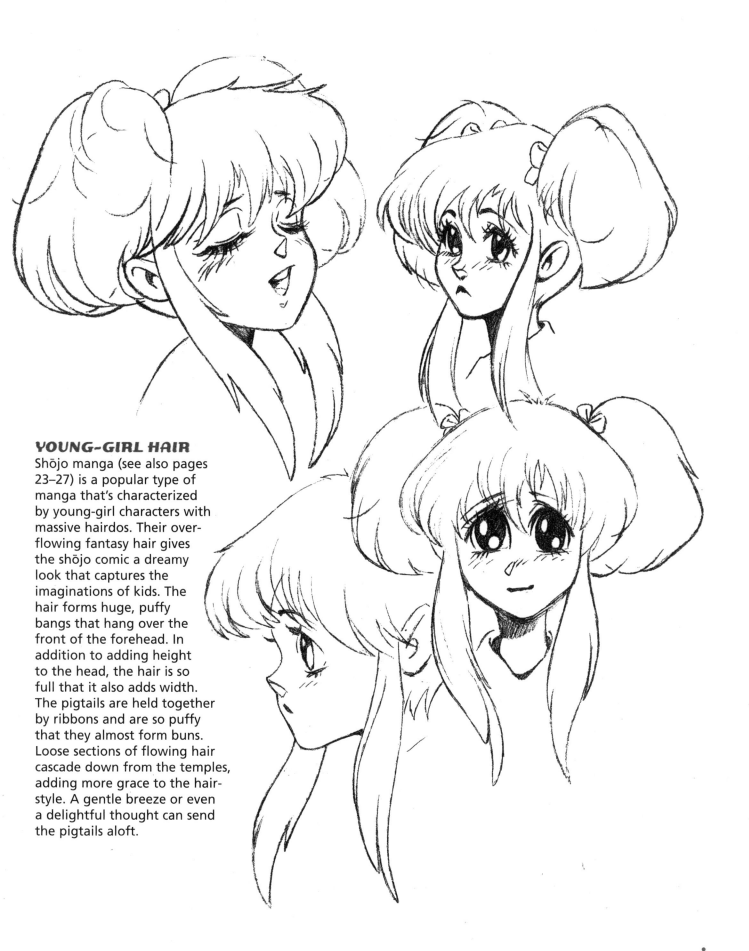

YOUNG-GIRL HAIR

Shōjo manga (see also pages 23–27) is a popular type of manga that's characterized by young-girl characters with massive hairdos. Their over-flowing fantasy hair gives the shōjo comic a dreamy look that captures the imaginations of kids. The hair forms huge, puffy bangs that hang over the front of the forehead. In addition to adding height to the head, the hair is so full that it also adds width. The pigtails are held together by ribbons and are so puffy that they almost form buns. Loose sections of flowing hair cascade down from the temples, adding more grace to the hair-style. A gentle breeze or even a delightful thought can send the pigtails aloft.

THE YOUNG MANGA BODY

Since many manga characters are young kids, you have to be able to draw a young body convincingly. (We'll get to adult characters later on.) Beginning and young artists tend to draw kids as skinny, tiny adults. But kids' proportions are different from those of adults. Kids have relatively shorter limbs, which are slightly plump and not at all bony. The neck is delicate and not well muscled. The torso is rather compact. The chest attaches to the hips by way of a shortened waist. The posture is forward leaning—the tummy protrudes slightly, as does the chest (teens with bad posture sometimes exhibit sunken chests). And, the shoulders are square; teenagers have sloped shoulders, but young kids don't.

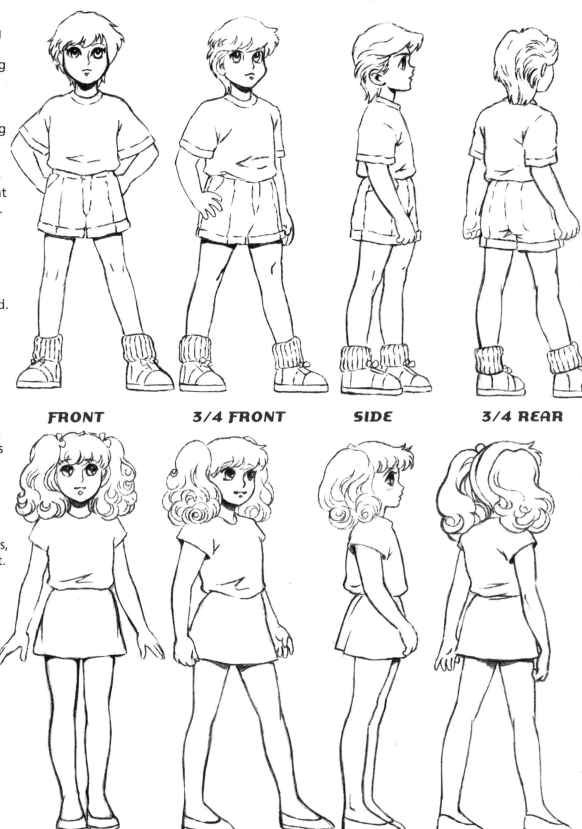

FRONT **3/4 FRONT** **SIDE** **3/4 REAR**

Note the ellipses drawn in the fingers. Artists draw these at the joints as guidelines to remind themselves that the fingers are not flat but three-dimensional, and have depth. It's a good habit to get into.

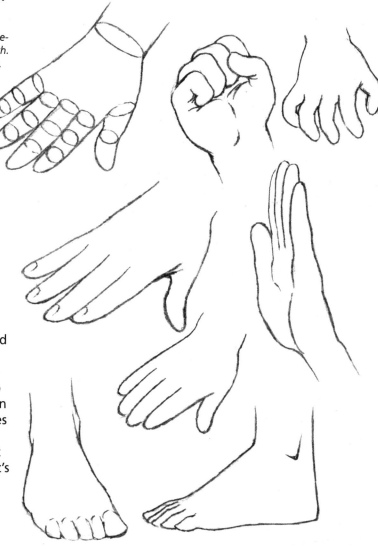

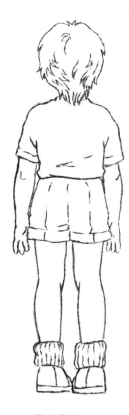

REAR

HANDS, FEET, AND SHOES

The hands and feet of kids are less bony than those of adults. The knuckles barely show, and the fingers and toes are slightly pudgy. The backward curve of the thumb is also less pronounced on kids. When drawing shoes or sneakers, remember that the foot is not a flat slab. It has height to it. It's basically a triangle that's thickest near the ankle.

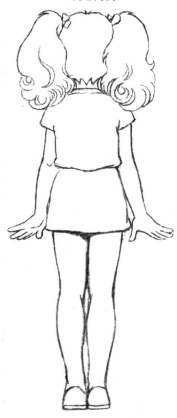

REAR **3/4 VIEW** **BOY'S SNEAKER** **SIDE**

GIRL'S SHOE

REAR **SIDE**

PRETEENS

Manga is famous for the variety of age groups that it represents in its stories. Instead of focusing on children, teens, and adults, manga subdivides these categories further. One such popular subdivision is that of preteens.

SHY GIRL

Sweet and simple, her body still retains some of the rounder qualities associated with younger children, and of course, the pose is dripping with cuteness. The flowers in her hair are among the more popular items used in manga to embellish a character. Note the popular bob hairdo, which makes the character look cute; long, flowing hair would make her dreamy. Note that black hair requires highlights to give it life.

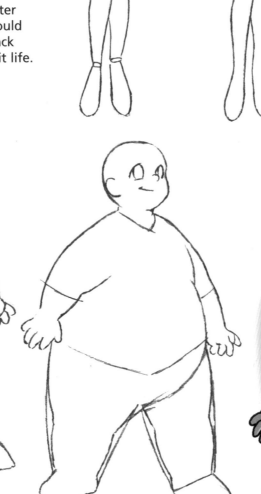

BURGER BOY

The general rule is that skinny characters are tall and heavy characters are short. The clothes of a heavyset character are usually casual or untidy. The eyes, like all the features, should be large and round. Even the fingers are pudgy. He's an unassuming character, without guile.

Young manga teens have romantic dreams, fantasies, and crushes, and they suffer from unrequited love, but all of these human conditions are dealt with at an innocent distance. In this way, preteen and young-teen readers get to live out their dreamy notions of romance through the medium of comics.

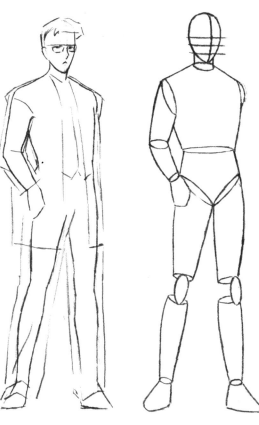

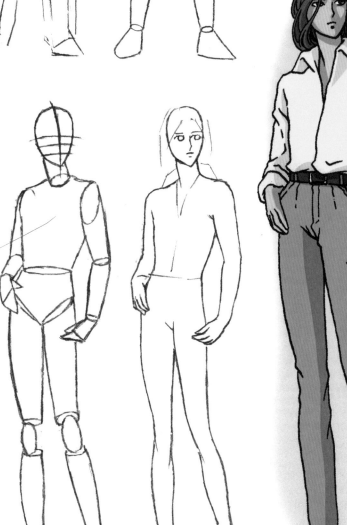

AMBITIOUS YOUNG MAN

Skinny characters should wear oversized clothes that swim on them. This guy is trying to look important by building himself up, and he does this by buying clothes that are too large for his meek build and, perhaps, too formal for his position or status. His face has a lean, hungry look. The eyes on this type of character are always narrow, and the eyeglasses are a good prop that puts one more obstacle between him and the reader.

WISTFUL MALE

Thoughtful, reflective characters are popular for young teens. They convey a sense of wistful teen pathos.

YOUTHFUL ADULTS

You can retain a youthful quality in your characters by omitting all but the most necessary facial creases. For female characters, the body is shapelier and longer, with wider shoulders, a narrow waistline, and wide hips.

FANTASY GIRL

Everything on the fantasy girl—her hair, her eyes, her jewelry, her bejeweled dress—is an ornament that supports her character. She's more doll-like than real. She's always poised. She's almost a vision as she graces the story with her presence.

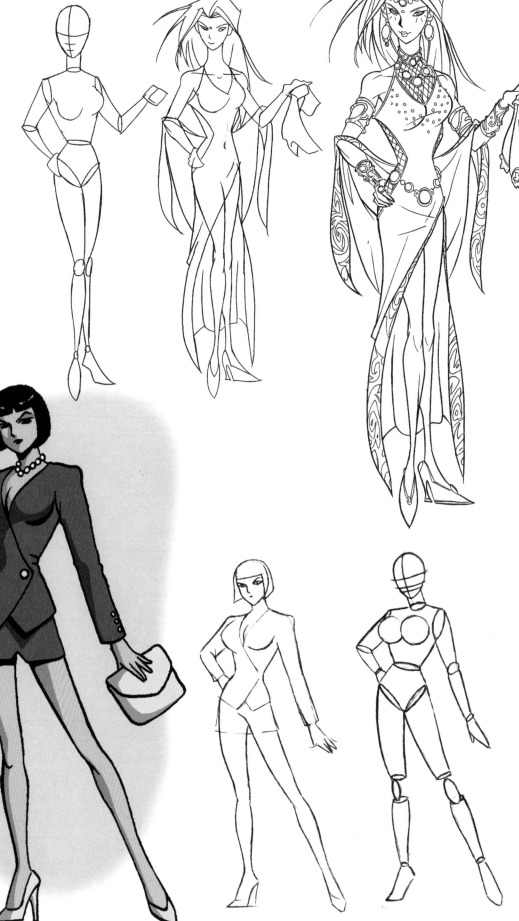

BUSINESS SHARK

Her hair is cropped short, as is her skirt. Everything about her is tight and in control, even the pearl necklace. There are no loose ends to flap gracefully in the wind. Nothing on her should look comfortable. One look at her reveals bad thoughts behind those eyes.

THE SHŌJO STYLE

Shōjo (girls') manga is filled with humor, innocence, grace, mischief, and silliness. Although it has been thought of primarily as a comic book style that appeals mainly to girls, it is becoming increasingly popular among boys, as well, because the shōjo stories and characters are so compelling. Everyone can relate to shōjo characters. They're not samurai. They're not androids. They're regular kids having a good time and finding their way through the twists and turns of life.

EXPRESSIONS

Here are some good examples of the perky expressions of shōjo characters. Notice that the eyes—the most important feature of any manga character—and most notably the pupils, can enlarge, shrink, and change shape based on the expression.

All shōjo expressions, even downtrodden ones, should show vigor and energy. Expressions in young manga characters are rarely subtle. The characterizations are the star of shōjo. Therefore, the characters must maintain a level of intensity throughout a story.

Shōjo characters frequently bound from one emotion to another as new elements of the story are introduced; your character may be glum in one panel, and then may remember a good thought and become elated in the next panel, without transition.

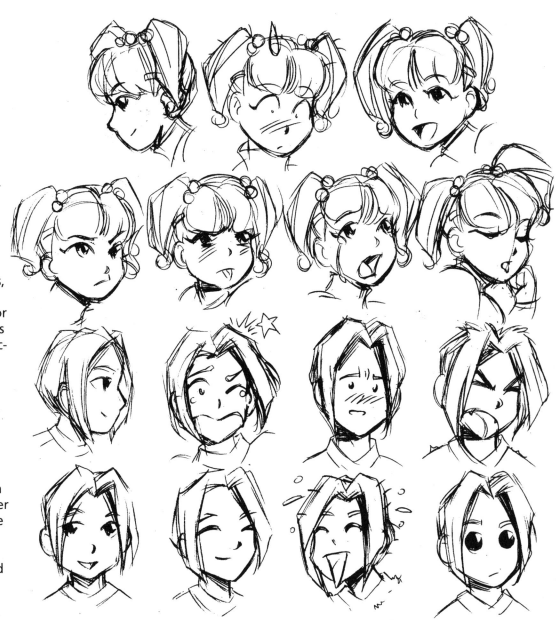

BODIES IN MOTION

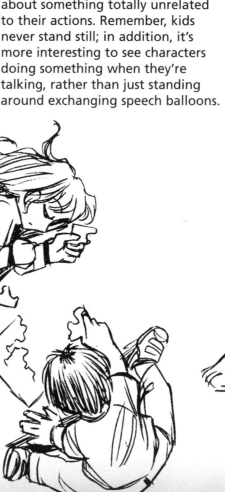

The body language of shōjo kids is proper, straight, formal, earnest, and true. No craven poses or sunken chests. The head makes up approximately 1/4 of the character's height, whereas on adult characters the head is approximately 1/7 of the entire height. Pose shōjo figures in playful positions. Show them *doing* things, even if they're in a conversation about something totally unrelated to their actions. Remember, kids never stand still; in addition, it's more interesting to see characters doing something when they're talking, rather than just standing around exchanging speech balloons.

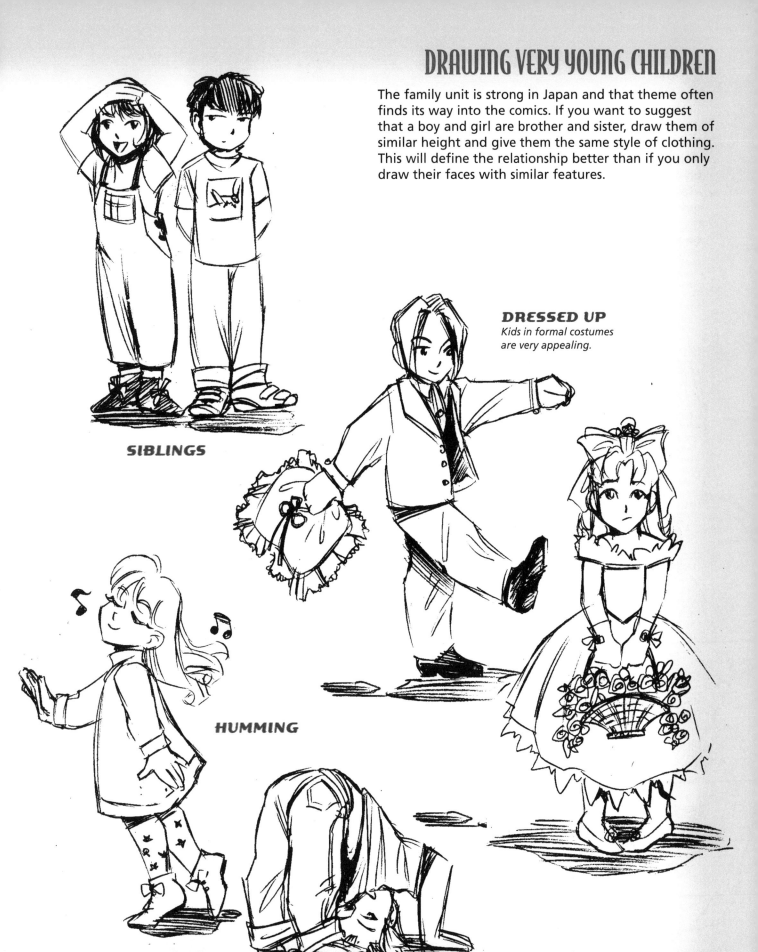

DRAWING VERY YOUNG CHILDREN

The family unit is strong in Japan and that theme often finds its way into the comics. If you want to suggest that a boy and girl are brother and sister, draw them of similar height and give them the same style of clothing. This will define the relationship better than if you only draw their faces with similar features.

SIBLINGS

DRESSED UP
Kids in formal costumes are very appealing.

HUMMING

PLAYING

PRETEEN SHŌJO FACES

As kids grow, their faces lose some of their roundness, and the angles
of the bones of the face begin to show. These angles are formed, most
noticeably, by the cheekbones and jawbone. The chin becomes pointier.
The bridge of the nose, which is so subtle on young children that many
artists don't even indicate it, gains some prominence, and the eyes take
up a somewhat smaller percentage of the area of the face than they
used to. Hairstyles also become more defined as preteens try to carve
out identities for themselves. Note the overall slenderizing of the
lower half of the preteen face, as compared with that area
on younger characters.

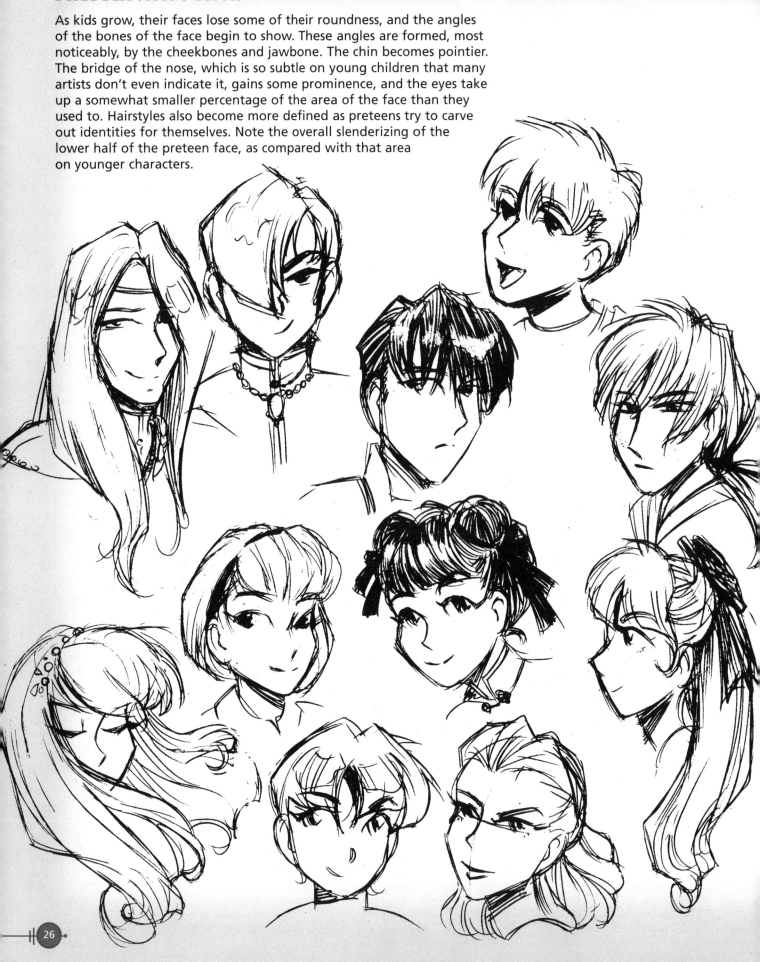

One of the funniest and most endearing manga character types is the shōjo animal companion. These furry little creatures are more than just pets—they are essential members of the group. They are cute buddies. They frequently mug for laughs and are given physical bits of humor to play out. They should be drawn to look very young, with the proportions of babies. This means that the head should fully take up 1/3 of the total height. Keep the hands and the feet small.

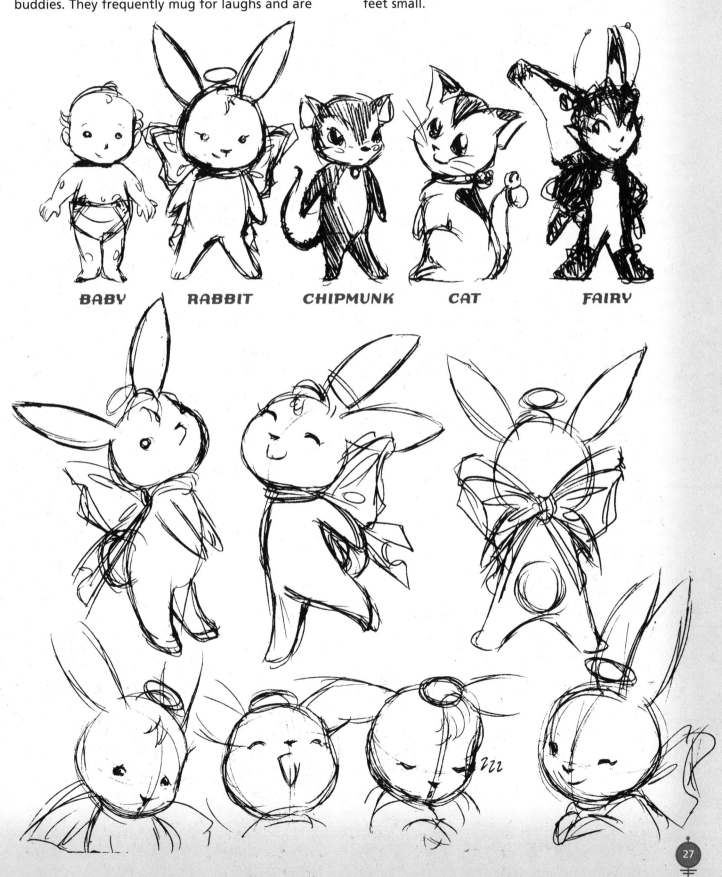

BABY **RABBIT** **CHIPMUNK** **CAT** **FAIRY**

ACTION POSES

So far, I've talked about basic manga heads and bodies, but it's equally important to be able to depict characters in motion. A panel in which the star character explodes into action will dominate the comic book page. It has to—the excitement is irresistible to the eye. Even a well-drawn comic book can't run brooding pose after brooding pose without becoming monotonous. By infusing the page with action, you keep readers on the edge of their seats. Action is the lifeblood of comics.

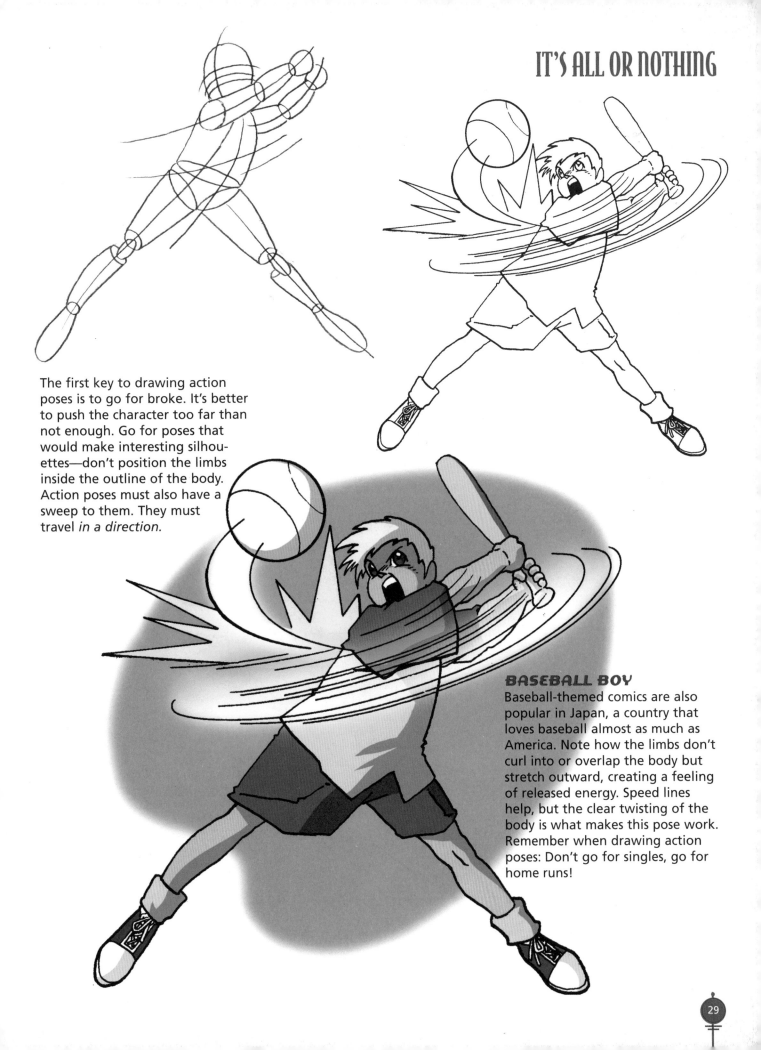

The first key to drawing action poses is to go for broke. It's better to push the character too far than not enough. Go for poses that would make interesting silhouettes—don't position the limbs inside the outline of the body. Action poses must also have a sweep to them. They must travel *in a direction.*

BASEBALL BOY

Baseball-themed comics are also popular in Japan, a country that loves baseball almost as much as America. Note how the limbs don't curl into or overlap the body but stretch outward, creating a feeling of released energy. Speed lines help, but the clear twisting of the body is what makes this pose work. Remember when drawing action poses: Don't go for singles, go for home runs!

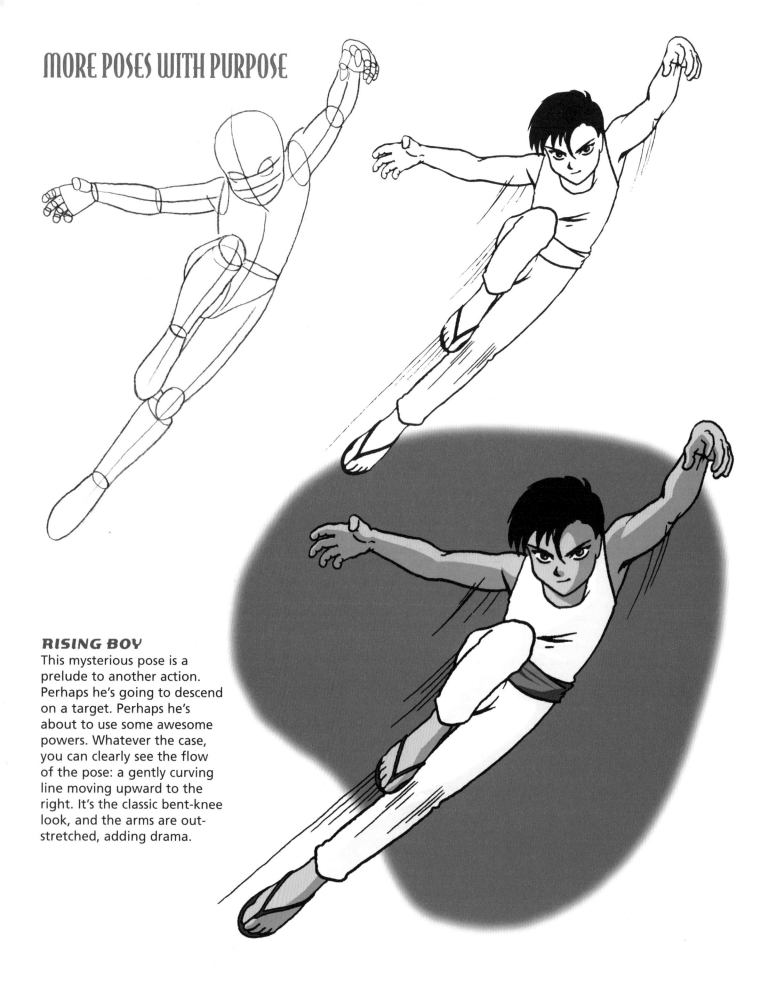

RISING BOY

This mysterious pose is a prelude to another action. Perhaps he's going to descend on a target. Perhaps he's about to use some awesome powers. Whatever the case, you can clearly see the flow of the pose: a gently curving line moving upward to the right. It's the classic bent-knee look, and the arms are outstretched, adding drama.

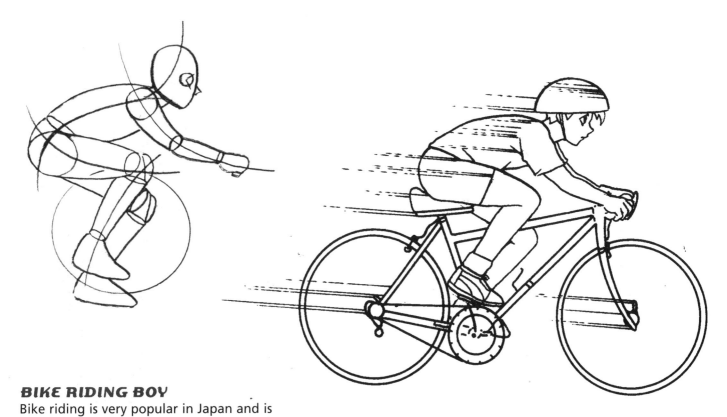

BIKE RIDING BOY

Bike riding is very popular in Japan and is often depicted in Japanese comics. Note how far forward the rider is leaning. The torso is parallel to the ground! The head tilts up to see the road. To indicate even greater speed and effort, drop the head a touch, and show the rider peering up from under the eyebrows at the street ahead.

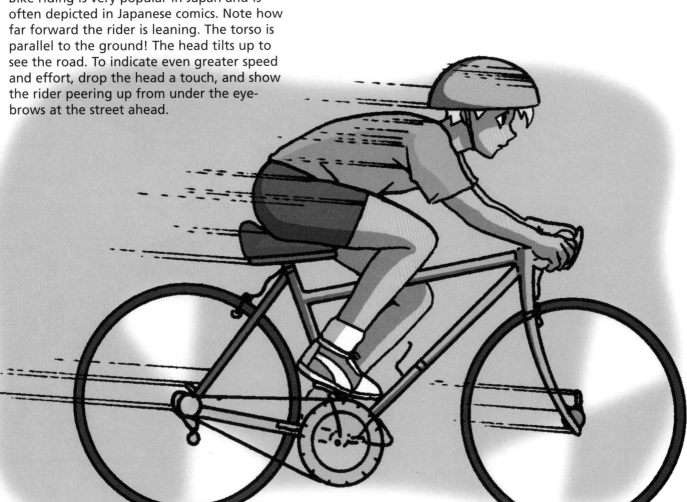

WALKING BOY

It's easy to draw a character walking from a side view, but it's more of a challenge from the front. The secret to this pose is the upper body twist, which moves *counter* to that of the legs. Let the arm swing (which is always counter to the leg movement) pull the body, rotating it. Note that this pose breaks the general rule about creating good silhouettes. Unless the figure walks with legs wide apart, in a very cartoony manner, there's simply no way to create a clearer silhouette out of this pose. Therefore, the effectiveness of this pose relies on the twisting dynamics.

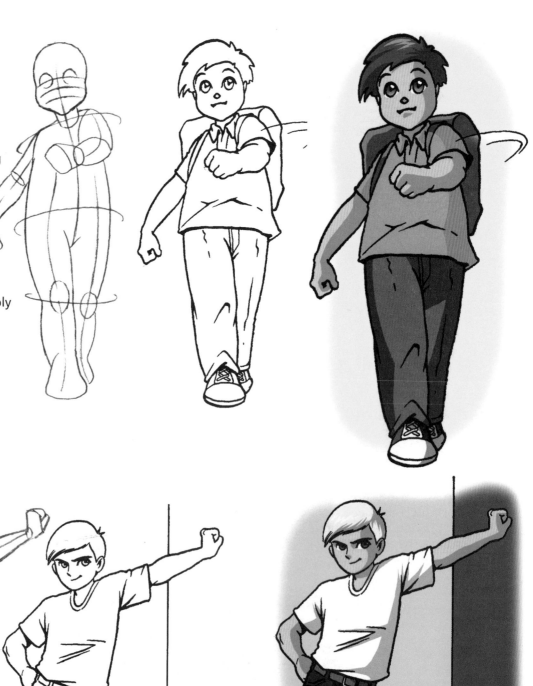

LEANING BOY

Note the significant slant of the shoulders, which tilt in the opposite direction of the hips. Just because this boy is standing still doesn't mean that this isn't a figure in action. His body is working in many ways to accommodate the distribution of weight.

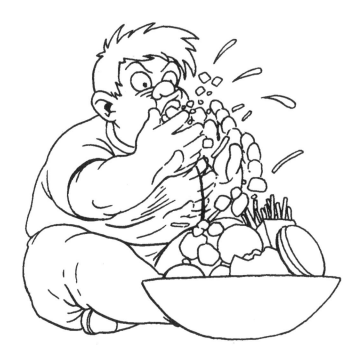

FACE-STUFFING BOY

Note that not all action poses show overt actions. For example, you can show a person sitting stiffly, or sitting in a way that relates to the chair or to the clothing, mood, and physical build of the character. In other words, put some action into nonaction poses. This boy could just as easily be sitting in a chair eating a sandwich properly, but where's the fun in that? So he's posed in a comical way, bunched up into a ball on the floor. He's eating at a fast clip, turning his meal into an aerobic exercise.

SHŌNEN MANGA

Shōnen manga means *boys'* comics—ones read primarily by boys. This type of manga is rougher around the edges and more action- and hero-oriented than shōjo, the girls' manga. Shōnen has become popular in America in the form of animated television shows in which kids either are crime fighters themselves or fight beings who have super powers, or in which the kids are assisted by friendly creatures who have their own strengths.

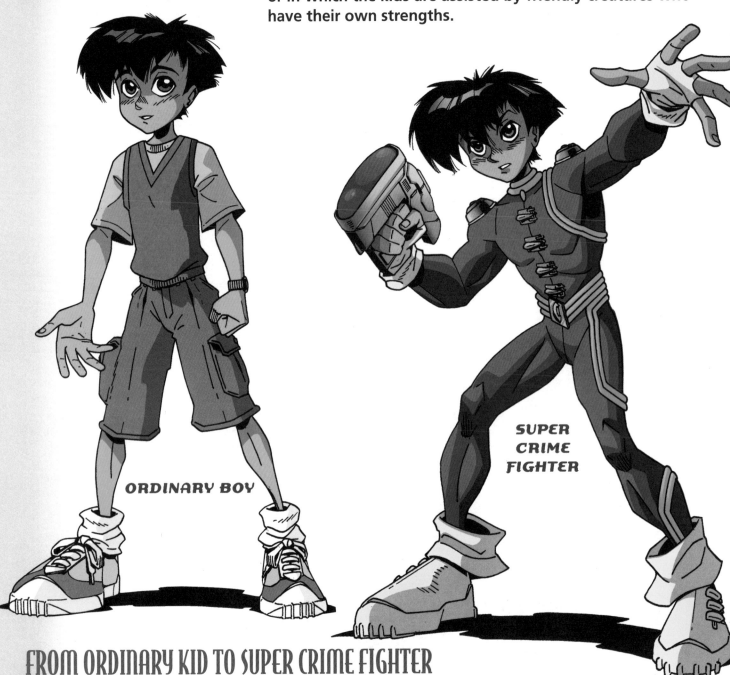

ORDINARY BOY

SUPER CRIME FIGHTER

FROM ORDINARY KID TO SUPER CRIME FIGHTER

The super crime fighter shōnen kid is more muscular than an ordinary adolescent, but not massively so. It's more of a matter of giving the muscles defined shape rather than greater size. Perhaps the most important elements of super crime fighter kids are their costumes, without which they would look strangely built for their age. With the costumes, they become characters in a role, with a purpose—to fight bad guys, save the world, and make it home in time for dinner.

SUPER CRIME FIGHTER GIRL

Not all shōnen characters are boys or children. They can be a range of ages, but *the drawing style itself reads young.* This is evidenced by the big eyes, round faces, and lack of realism in the approach—it's still very cartoony.

Turning an ordinary gal into a shōnen super crime fighter requires a slightly different approach than the one used for a boy. Rather than defining various muscle groups, try to enhance the general shape of her figure. The hips become curvy, the thighs slightly fuller, and the arms less bony.

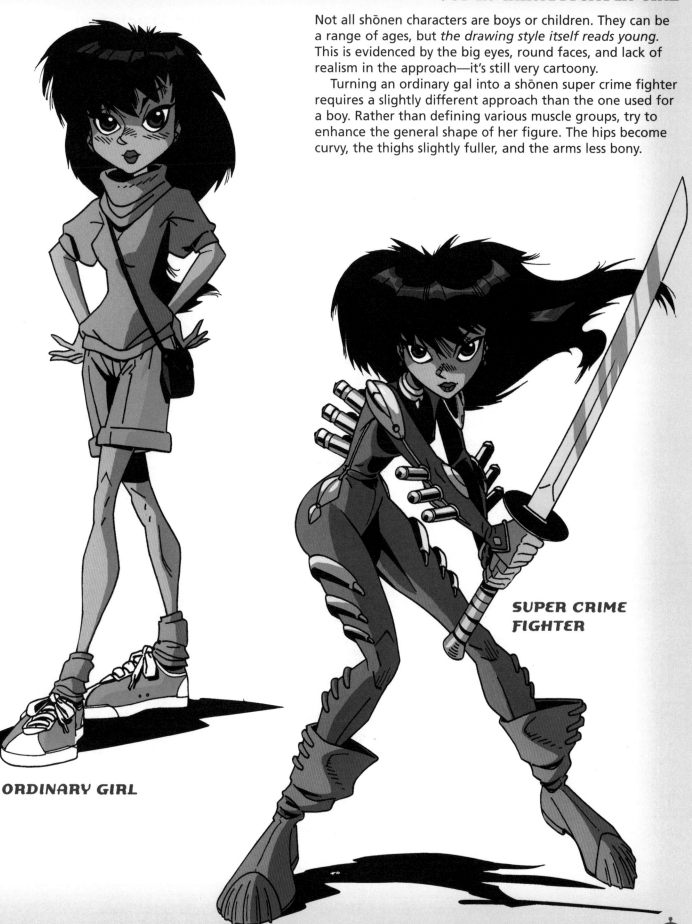

SUPER CRIME FIGHTER

ORDINARY GIRL

THE SUPER POWERS OF SUPER KIDS

Shōnen comics feature lots of super kids who have super powers. However, unlike western-style comics, in which there's usually a correlation between the strength of a character's powers and his or her appearance, shōnen characters may remain physically similar to regular kids, only with mild physical enhancements and cool costumes. This has a positive effect on readers, who sense that they don't have to look like Mr. Universe in order to possess extraordinary skills. Again, manga's strength is in turning an ordinary person into something extraordinary through characterization and storytelling.

SUPER STRENGTH

Super-strength powers aren't indicated by Herculean muscles—what's the fun in that? Anyone with Herculean muscles should be able to carry around a couple of tons overhead. Super strength is that much more awesome if it's a characteristic of a little kid, like this one tossing around a two-ton boulder.

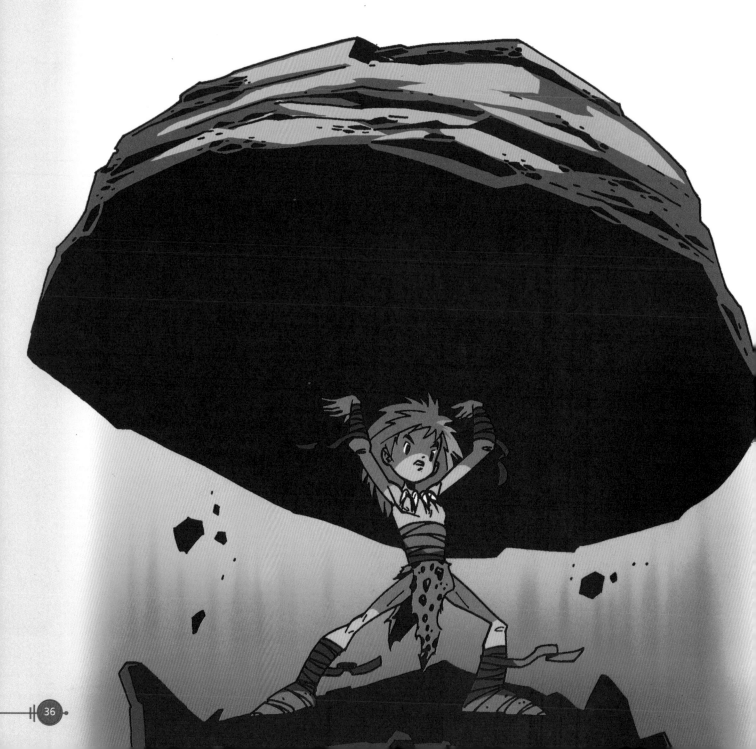

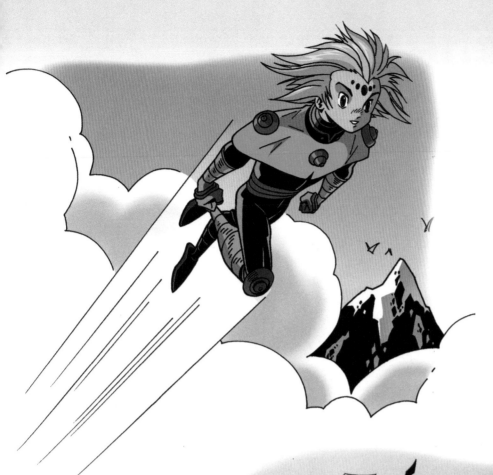

FLIGHT

The ability of human characters to soar unaided by machine has been around since the early days of comic books, and it remains an essential component in the comic book artist's arsenal of super powers. In comics, the power of flight has evolved into almost a genetic predisposition, sometimes aided by a costume. A flying pose is most effective when several limbs are outstretched, either in front of or trailing behind the character. Both legs can be shown outstretched, but artists usually favor the classic, one-bent-leg flying pose.

SUPER SPEED

You've heard of a four-minute mile. How about a four-second mile? Super speed is a very cool super power. Characters who run at lightning speed blur the path behind them (indicated by speed lines), creating a look that approximates flight, as was the case with my favorite boyhood anime *Tobor the Eighth Man.* The more realistic the super physical abilities, such as the ability to run fast, the more readers will be able to relate to the character and fantasize that they could be running the lightning fast sprint after the bad guys.

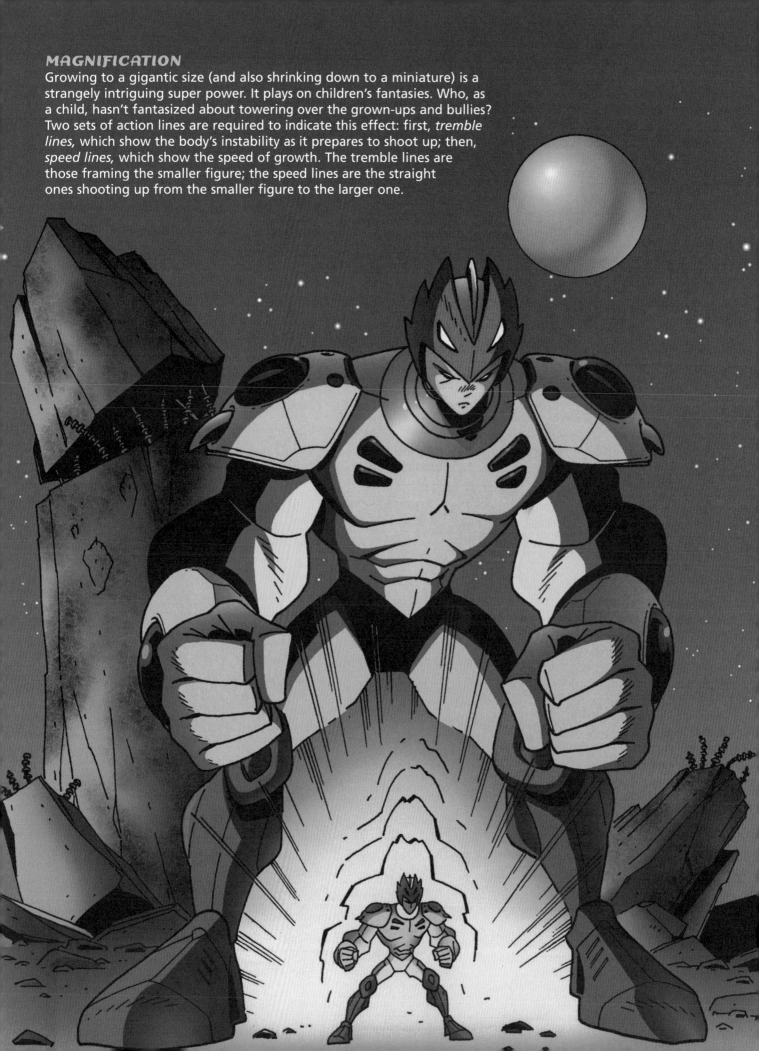

MAGNIFICATION

Growing to a gigantic size (and also shrinking down to a miniature) is a strangely intriguing super power. It plays on children's fantasies. Who, as a child, hasn't fantasized about towering over the grown-ups and bullies? Two sets of action lines are required to indicate this effect: first, *tremble lines,* which show the body's instability as it prepares to shoot up; then, *speed lines,* which show the speed of growth. The tremble lines are those framing the smaller figure; the speed lines are the straight ones shooting up from the smaller figure to the larger one.

SUPER WEAPONRY

Not all super powers are imbued at birth. Any ordinary kid can be transformed into an action hero with the help of a highly sophisticated, battle-ready uniform that doubles as a weapon. The weaponry should be oversized and appear extremely heavy. The huge uniform, from which the character derives his (or her) power, adds to the appearance of strength.

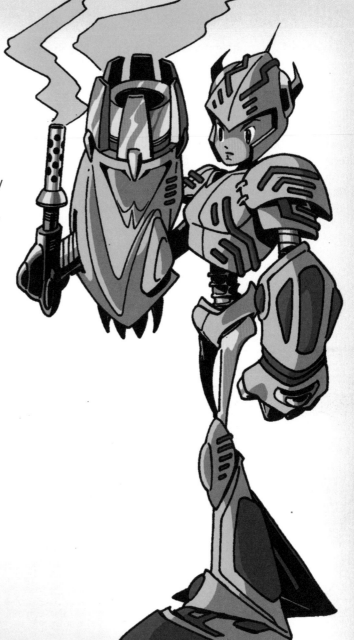

DEMATERIALIZATION

This is different from becoming invisible. Dematerialization is the ability to walk unimpeded through solid objects. It lends itself to brain-teasing graphics in which part of the body disappears into an object as the character passes through it. Dematerialization has its perils, though: If the object is very heavy and solid, there's always the danger that the character could become stuck inside it, entombed forever!

DYNAMIC POSES

The final piece of the puzzle in creating outstanding shōnen super kids lies in planning consistently dynamic poses. This is essential and requires a different approach from that used for drawing ordinary kids. Super kids can't be doing super things all the time, but you've got to make them look super even when they're not doing anything particularly impressive. The main things you'll want to avoid are flat poses. Increase the use of poses in which characters appear to move toward readers, whether due to their pose or to exaggerated perspective in the drawing. (See box on facing page). However, when positioning characters toward the reader, it's usually more effective to position them toward the reader *at an angle,* rather than head-on.

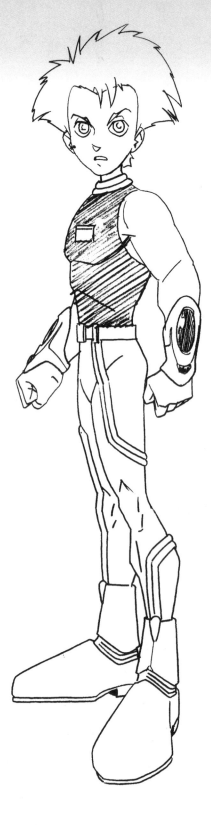

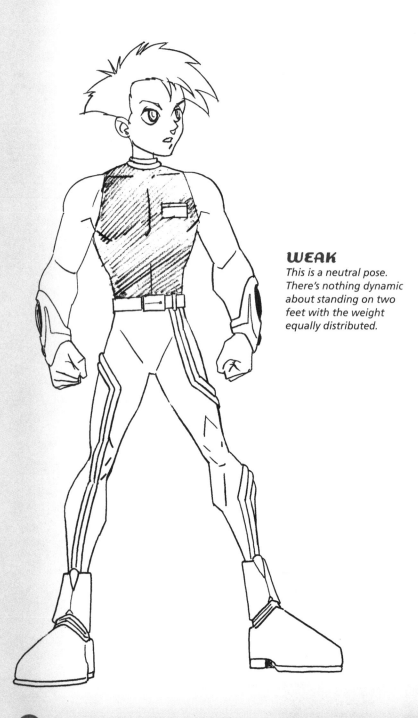

WEAK
This is a neutral pose. There's nothing dynamic about standing on two feet with the weight equally distributed.

BETTER
This pose is an improvement because it isn't as flat and symmetrical as the previous one. However, the unexaggerated side pose has the unhappy effect of slimming down the character's physique until he's but a slender reed. And, with his feet close together, he doesn't seem to be standing his ground with any authority.

DYNAMIC

Now the character appears as he should—full of spirit and energy. Why is this so, when he isn't actually doing anything? Because he's positioned so that the near half of his body appears larger while the far half becomes smaller as it recedes from the reader. Notice the use of the horizontal vanishing lines, which the artist employs to create a perspective grid on which to draw the character. All parts of the character's body—most notably the shoulders, chest, knees, and feet—recede along these vanishing lines.

PERSPECTIVE AND VANISHING LINES

Drawing your characters and scenes in perspective gives your images a feeling of depth and energy. The rule of perspective tells us that objects closer to us appear larger, while those farther away appear smaller. So, objects drawn in perspective get smaller as they recede into the distance away from the reader. In order to indicate correct perspective and reduce the right parts of a drawing the right amount, artists make use of *vanishing lines*. When positioned correctly, these lines would eventually meet at a single *vanishing point* if they were to be extended (in the example here, that would be off the page to the left). By following correctly placed vanishing lines, you'll ensure that your characters are shown in correct perspective.

DYNAMIC FLYING

WEAK

BEST

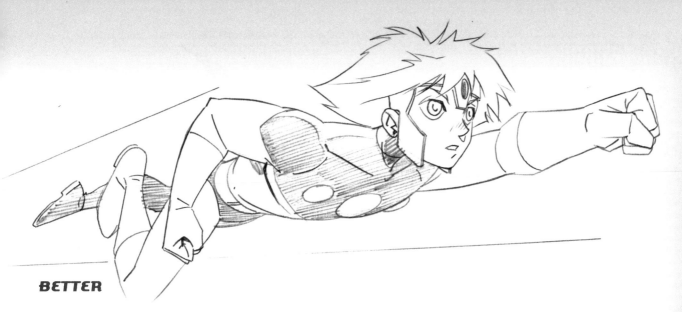

BETTER

By avoiding a flat side shot, you make the reader feel the character's presence to a much greater degree. Notice again how the vanishing lines, used as guidelines, are sharply angled and recede severely into the distance in the most dynamic pose.

DYNAMIC LEAPING

Front and side views of a character generally shortchange the reader. You want it to seem as if the character were bursting out of the picture, almost knocking the reader over. You achieve this by making it appear that the figure is *above* the reader, jumping *down,* ambush style.

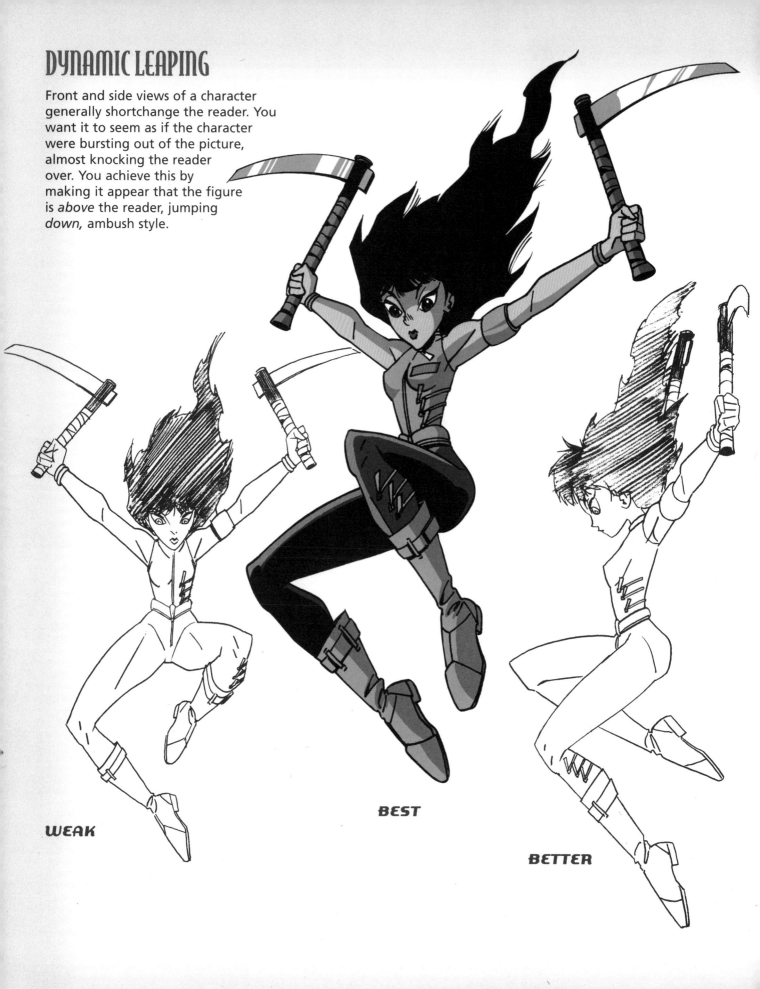

WEAK

BEST

BETTER

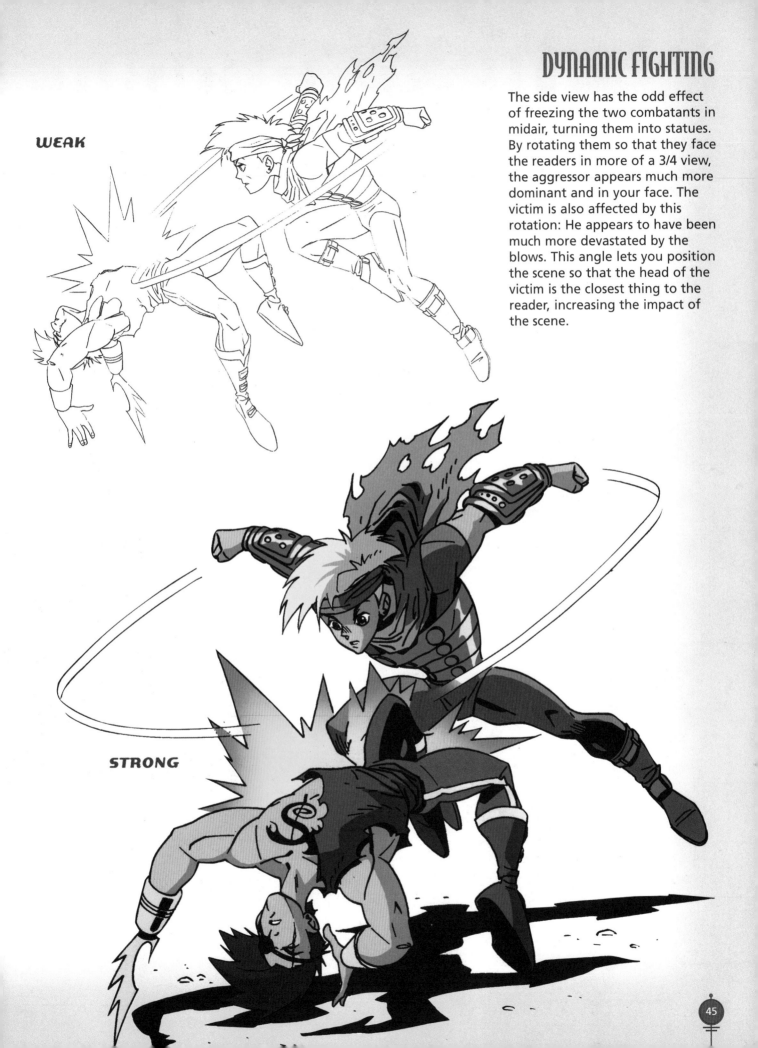

WEAK

DYNAMIC FIGHTING

The side view has the odd effect of freezing the two combatants in midair, turning them into statues. By rotating them so that they face the readers in more of a 3/4 view, the aggressor appears much more dominant and in your face. The victim is also affected by this rotation: He appears to have been much more devastated by the blows. This angle lets you position the scene so that the head of the victim is the closest thing to the reader, increasing the impact of the scene.

STRONG

THE BAD BOYS OF MANGA

A prominent figure in manga, what is it about the bad boy that makes him so attractive to teenage girls? Is it the danger, the angular features, the disdain for conformity, or the unavailability? It's all of the above but also something more. It's the self-confidence that's based on a self-centered world view. These guys are their own biggest fans. They see something they want, they take it. Someone tells them what to do, they ignore it. They know something is dangerous, they challenge it.

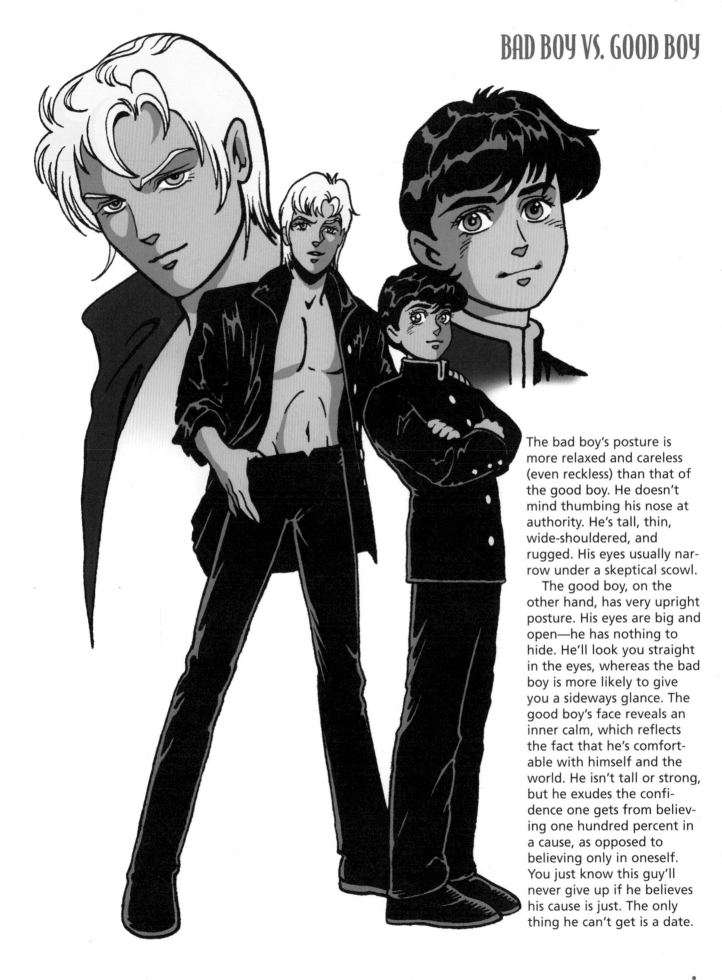

The bad boy's posture is more relaxed and careless (even reckless) than that of the good boy. He doesn't mind thumbing his nose at authority. He's tall, thin, wide-shouldered, and rugged. His eyes usually narrow under a skeptical scowl.

The good boy, on the other hand, has very upright posture. His eyes are big and open—he has nothing to hide. He'll look you straight in the eyes, whereas the bad boy is more likely to give you a sideways glance. The good boy's face reveals an inner calm, which reflects the fact that he's comfortable with himself and the world. He isn't tall or strong, but he exudes the confidence one gets from believing one hundred percent in a cause, as opposed to believing only in oneself. You just know this guy'll never give up if he believes his cause is just. The only thing he can't get is a date.

BAD BOY TYPES

Manga bad boys often blend the qualities of big eyes and flowing hair with strong eyebrows and a thick neck. This results in a character that appears more mature than the typical good-boy character.

From the types of clothing your characters wear, to the way in which they wear them, bad guys telegraph their antisocial world view. You don't have to draw big scars, tattoos, or grimy whiskered faces to convey character type; a scowl or sneer will do nicely, along with a stance that says, "To heck with you and your rules!"

HIGH SCHOOL BAD BOY

This bad boy's long hair, in particular, is a sign of rebellion. A good reference point would be to ask yourself, Would a mother like to see her daughter chatting with this guy in the school cafeteria? I doubt it. Chances are, they wouldn't be talking about homework.

ROCK STAR BAD BOY

Japan rocks. Believe it. So naturally, the bad boys of rock and roll are here to stay. The serious side of teenage angst is well conveyed in the posturing of a rock star. Rock stars brood, they suffer inner torment, they rail against the machine, they carefully check their royalty statements. Rock-star style can be grungy or glittery, but the flash of bejeweled costumes will make the character pop off the page.

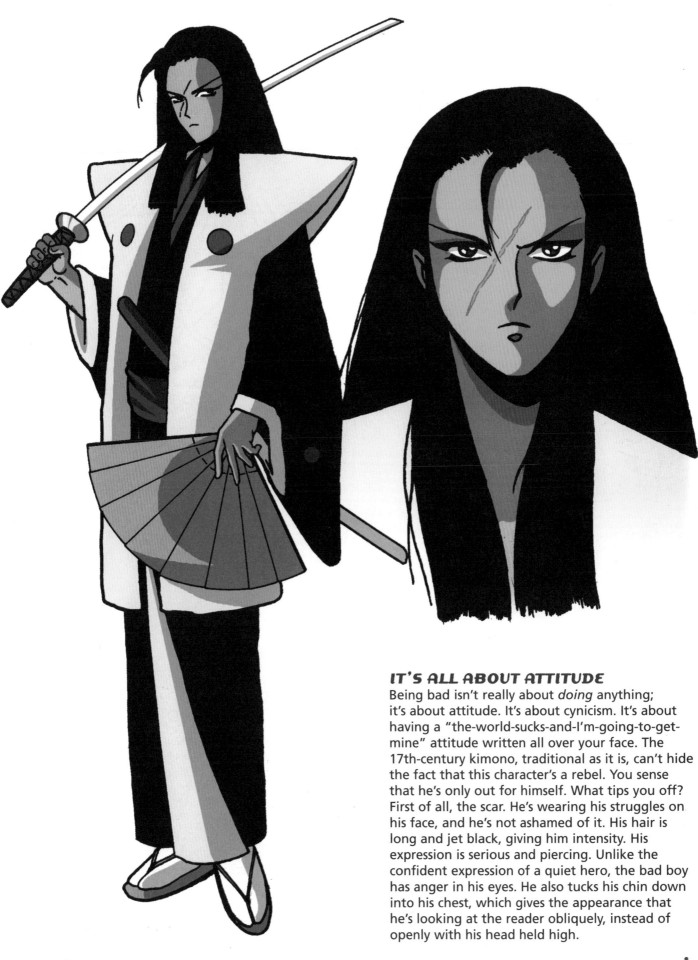

IT'S ALL ABOUT ATTITUDE

Being bad isn't really about *doing* anything; it's about attitude. It's about cynicism. It's about having a "the-world-sucks-and-I'm-going-to-get-mine" attitude written all over your face. The 17th-century kimono, traditional as it is, can't hide the fact that this character's a rebel. You sense that he's only out for himself. What tips you off? First of all, the scar. He's wearing his struggles on his face, and he's not ashamed of it. His hair is long and jet black, giving him intensity. His expression is serious and piercing. Unlike the confident expression of a quiet hero, the bad boy has anger in his eyes. He also tucks his chin down into his chest, which gives the appearance that he's looking at the reader obliquely, instead of openly with his head held high.

TRADITIONAL

He may be wearing a dignified kimono, but he's wearing it raggedly, with careless folds, as if to flaunt tradition. His head is cocked to the side, and his arm position conveys his "prove-it" attitude.

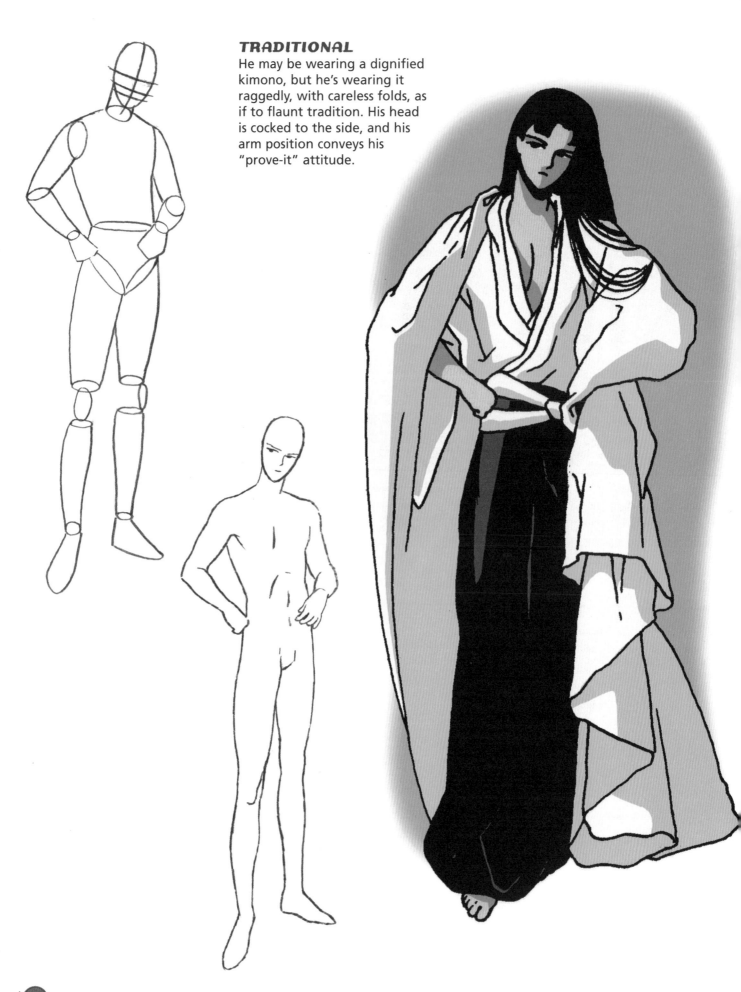

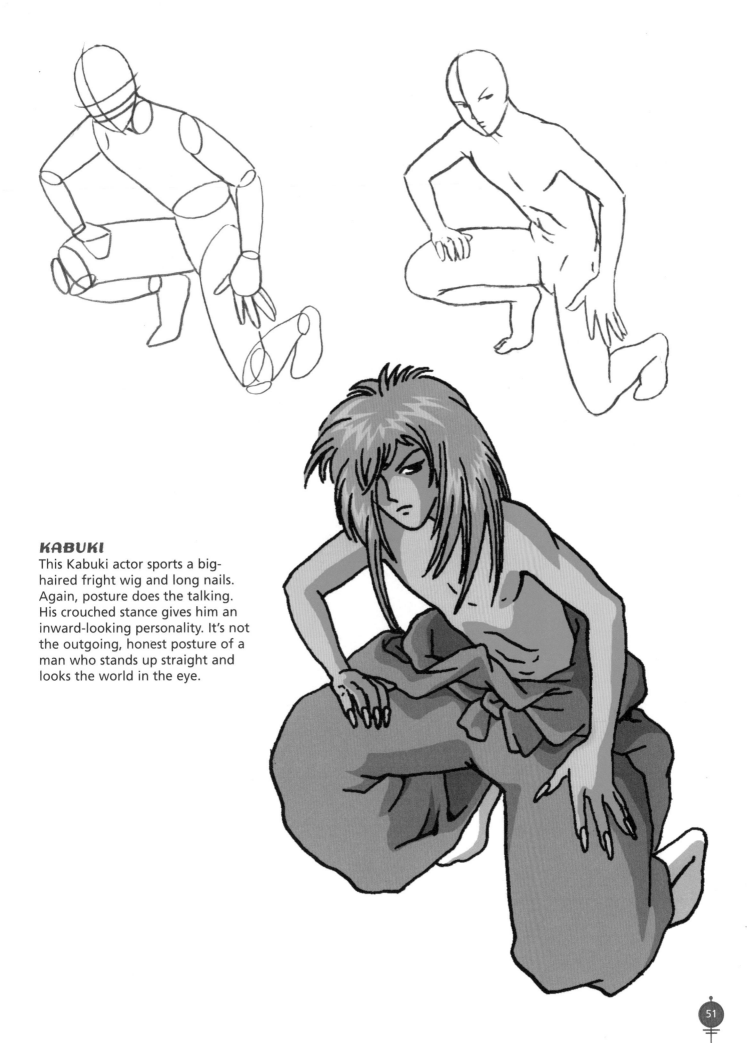

KABUKI

This Kabuki actor sports a big-haired fright wig and long nails. Again, posture does the talking. His crouched stance gives him an inward-looking personality. It's not the outgoing, honest posture of a man who stands up straight and looks the world in the eye.

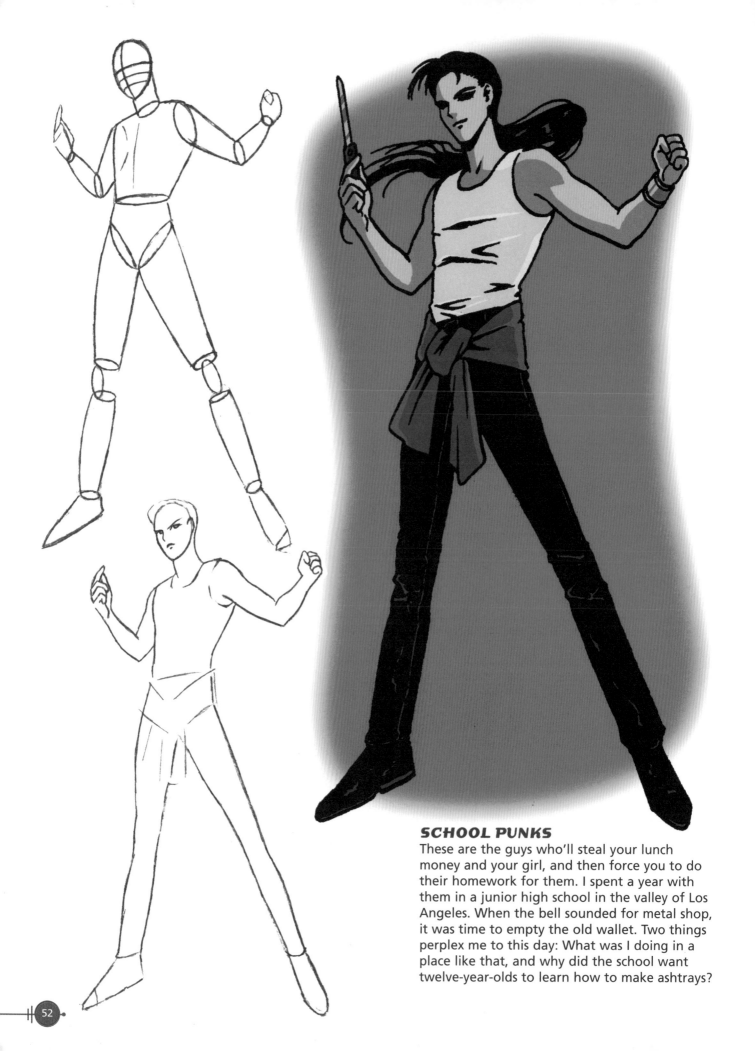

SCHOOL PUNKS

These are the guys who'll steal your lunch money and your girl, and then force you to do their homework for them. I spent a year with them in a junior high school in the valley of Los Angeles. When the bell sounded for metal shop, it was time to empty the old wallet. Two things perplex me to this day: What was I doing in a place like that, and why did the school want twelve-year-olds to learn how to make ashtrays?

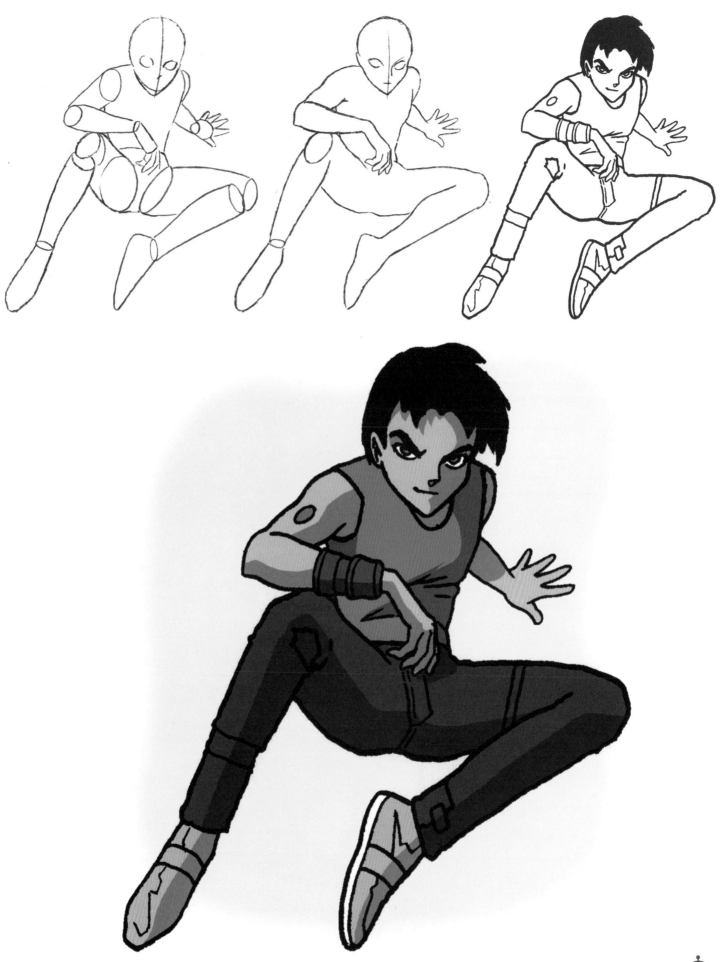

ANTIHEROES

Antiheroes are popular nowadays. Sometimes it's a good idea to cast one of these guys in a role in which he saves the day. In this case, the punk shouldn't be all bad. There's got to be a place deep down inside where something moral tugs at him, though he would never admit it and, certainly, never show it. If he joins a noble cause, he pretends he's fighting merely to settle a personal score. And when he succeeds in saving the day, at great risk to life and limb (what does he care about his safety?), don't expect him to hang around long enough to be thanked for it.

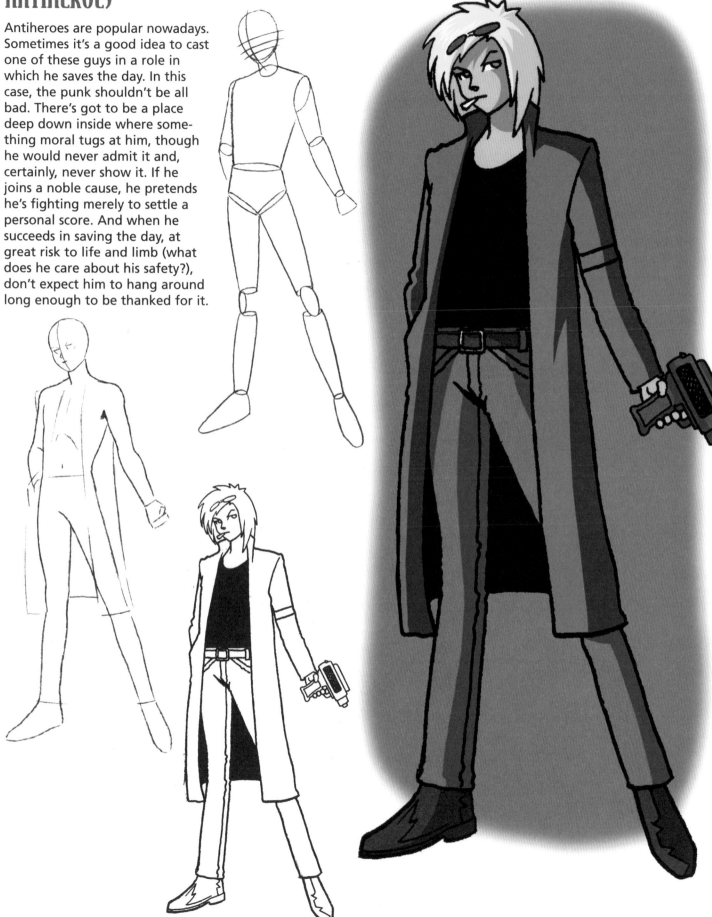

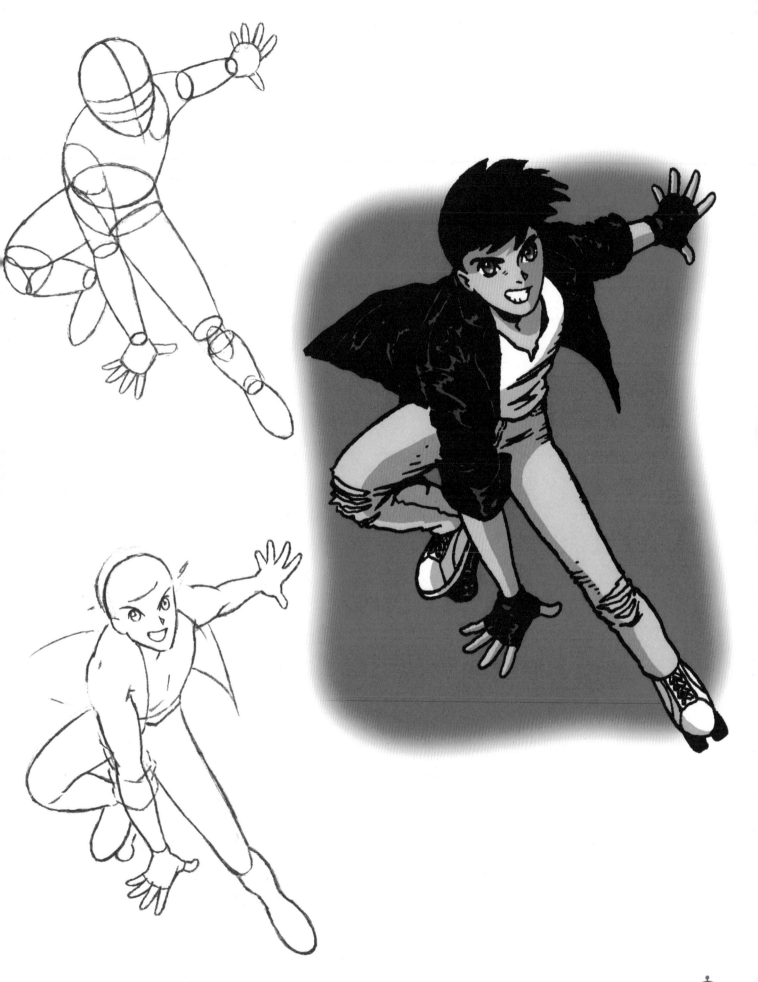

MANGA GENRES

There are many manga categories, or genres, each with its own styles, characters, humor, and ethos. You may be an ardent fan of one or two of these genres, but don't let that stop you from trying your hand at drawing all of them. You may discover a talent you didn't know you had. This chapter outlines the more popular manga genres and takes a more in-depth look at the granddaddy of them all: the venerable samurai.

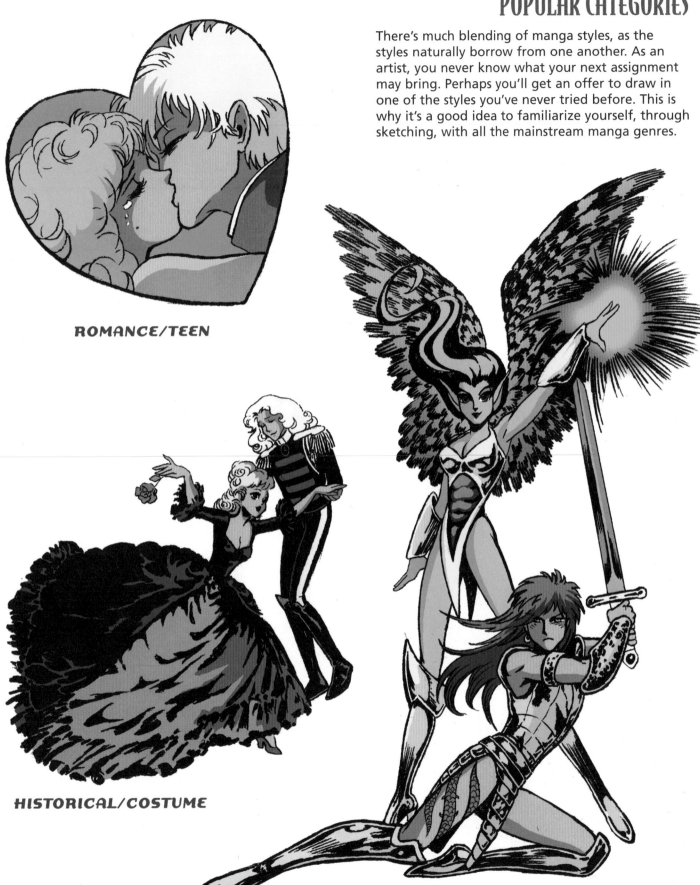

POPULAR CATEGORIES

There's much blending of manga styles, as the styles naturally borrow from one another. As an artist, you never know what your next assignment may bring. Perhaps you'll get an offer to draw in one of the styles you've never tried before. This is why it's a good idea to familiarize yourself, through sketching, with all the mainstream manga genres.

ROMANCE/TEEN

HISTORICAL/COSTUME

FANTASY/ADVENTURE

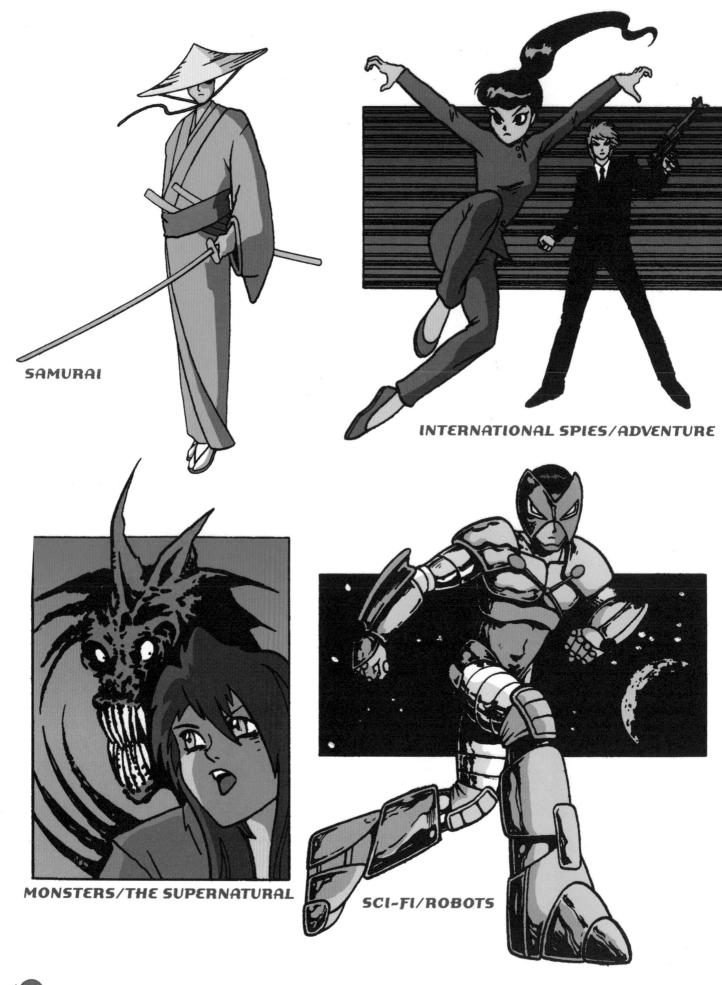

SAMURAI

INTERNATIONAL SPIES/ADVENTURE

MONSTERS/THE SUPERNATURAL

SCI-FI/ROBOTS

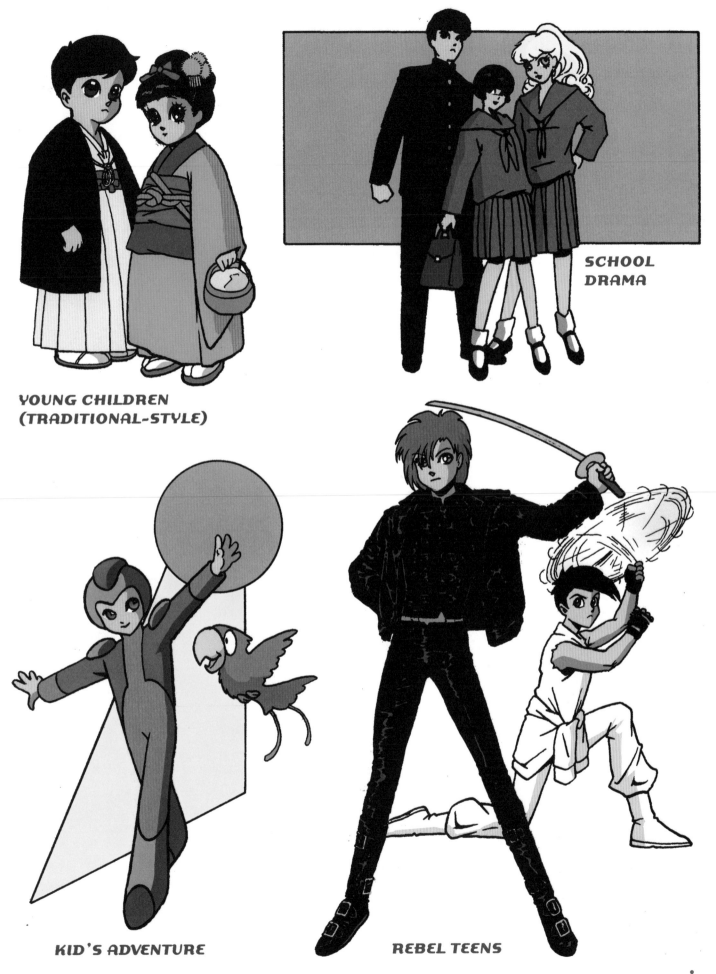

YOUNG CHILDREN
(TRADITIONAL-STYLE)

SCHOOL
DRAMA

KID'S ADVENTURE

REBEL TEENS

THE SAMURAI: ANCIENT FIGHTING WARRIORS

The figure of the samurai is not only popular but is, in a way, at the core of Japanese spirit and culture, embodying discipline, skill, ferocity, loyalty, and honor. This genre requires drawing a host of weapons, costumes, and martial arts techniques.

Samurai outfits were not only meant to protect, but to intimidate and to bring glory to the samurai patrons. Although the samurai used plenty of armor, their outfits also had a lot of padding, which had the advantage of being flexible and allowing for movement. It was also lighter than armor. Having to draw less armor also has a decided advantage for the artist: the ability to show the face of a character, instead of having to conceal it in an enclosed helmet of iron.

Unlike the knights of medieval Scotland, who would fight fiercely with a single, favorite weapon, the ancient samurai frequently carried an assortment of swords, knives, bows, and arrows and was trained to use more than one at a time.

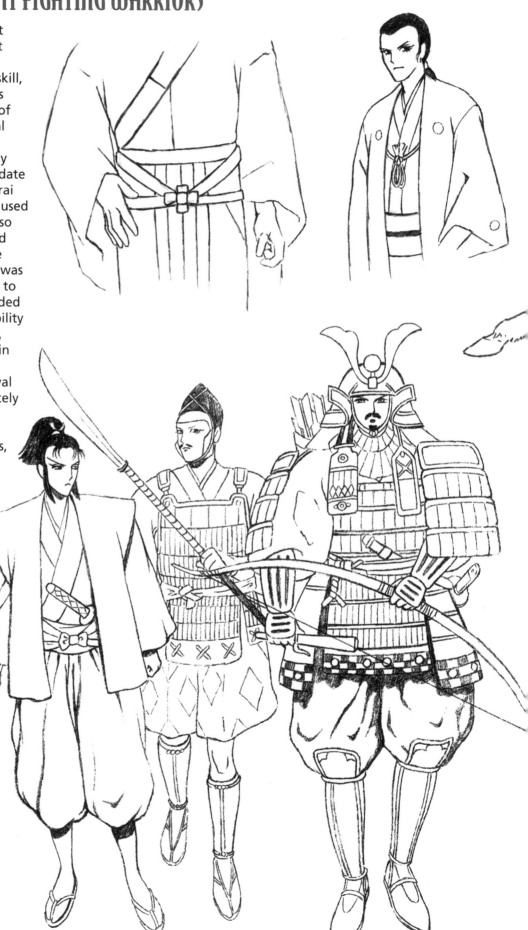

MARTIAL ARTS WARRIORS

When samurai weren't fighting, they were part of the gentleman class, and dressed as such. Ronin, on the other hand, were mercenary fighters and much scruffier in appearance.

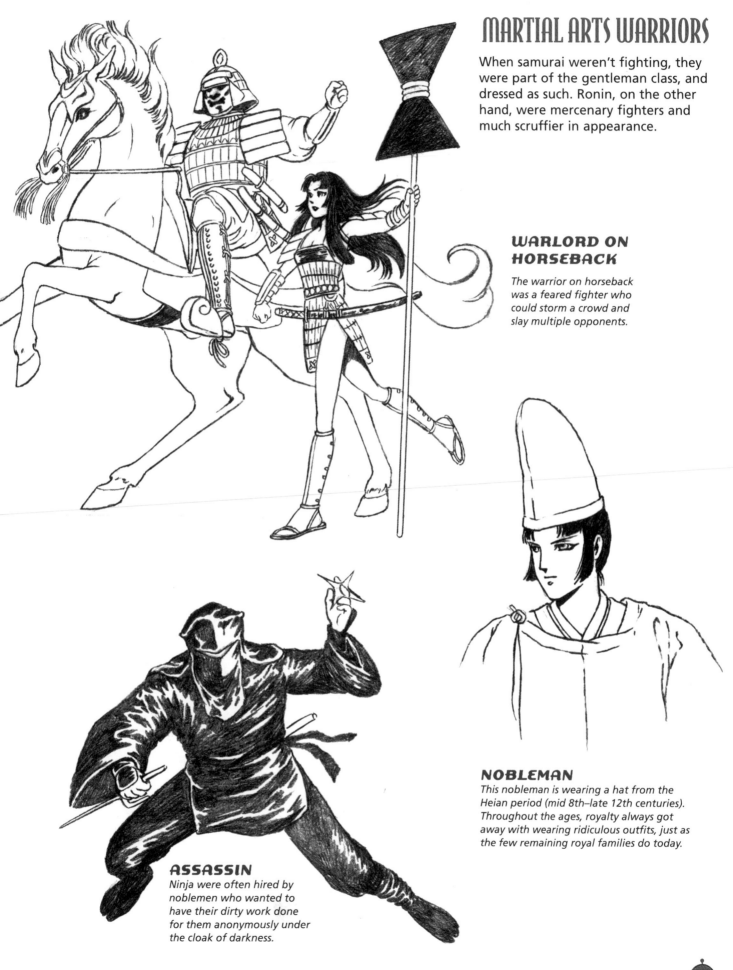

WARLORD ON HORSEBACK

The warrior on horseback was a feared fighter who could storm a crowd and slay multiple opponents.

NOBLEMAN

This nobleman is wearing a hat from the Heian period (mid 8th–late 12th centuries). Throughout the ages, royalty always got away with wearing ridiculous outfits, just as the few remaining royal families do today.

ASSASSIN

Ninja were often hired by noblemen who wanted to have their dirty work done for them anonymously under the cloak of darkness.

SAMURAI FIGHTING WEAPONS

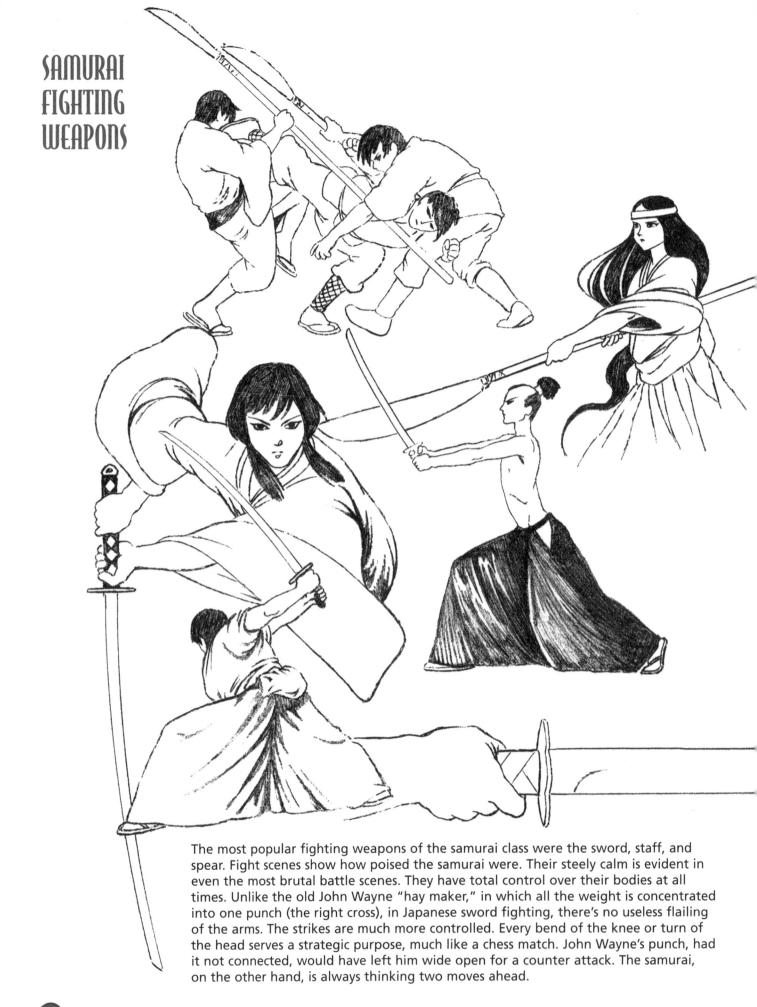

The most popular fighting weapons of the samurai class were the sword, staff, and spear. Fight scenes show how poised the samurai were. Their steely calm is evident in even the most brutal battle scenes. They have total control over their bodies at all times. Unlike the old John Wayne "hay maker," in which all the weight is concentrated into one punch (the right cross), in Japanese sword fighting, there's no useless flailing of the arms. The strikes are much more controlled. Every bend of the knee or turn of the head serves a strategic purpose, much like a chess match. John Wayne's punch, had it not connected, would have left him wide open for a counter attack. The samurai, on the other hand, is always thinking two moves ahead.

The most dramatic aspect of a samurai was his ability—through intense training, apprenticeship, and obedience to tradition—to successfully battle multiple opponents simultaneously. This frequently required a samurai to use two swords at once and to propel himself in circles, lashing out with the swords as if he were the hub of a wheel. Everywhere his enemies turned, they would find another slashing attack.

In addition to his fighting techniques, a samurai also used his cleverness before he even began an attack. For example, he would appear ready for battle on one side of a hill, and his opponent would not realize until it was too late that the samurai had chosen the side of the hill that would force his enemies to face directly into the blinding afternoon sun. As they say, it's all in the planning.

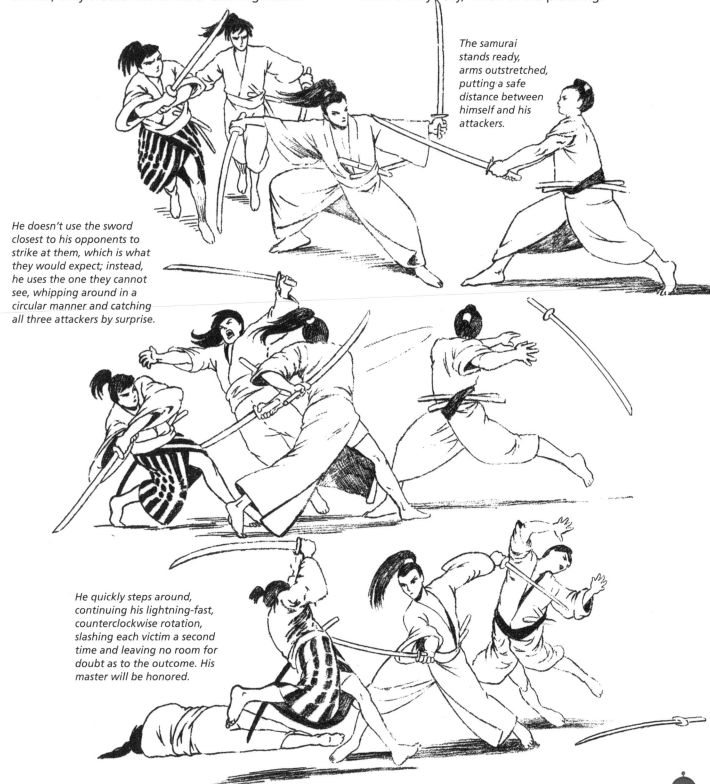

The samurai stands ready, arms outstretched, putting a safe distance between himself and his attackers.

He doesn't use the sword closest to his opponents to strike at them, which is what they would expect; instead, he uses the one they cannot see, whipping around in a circular manner and catching all three attackers by surprise.

He quickly steps around, continuing his lightning-fast, counterclockwise rotation, slashing each victim a second time and leaving no room for doubt as to the outcome. His master will be honored.

KARATE: THE EMPTY HAND

Karate is an extension of weapons-fighting, in that it uses the hands and feet as weapons. The martial arts (arts of combat and self-defense) fall into distinct categories. Karate emphasizes strikes. Judo (modernized and tailored into a sport from the deadlier jujitsu) emphasizes grappling, throwing, and sweeps. Kung fu is an older martial art that combines strikes and grappling, with an emphasis on circular motions and open-handed claws and gouges. *Karate* means "empty hand." When a karate expert has no weapon, he (or she) isn't necessarily unarmed. His hands are his knives, his fists his clubs, and his legs his staff.

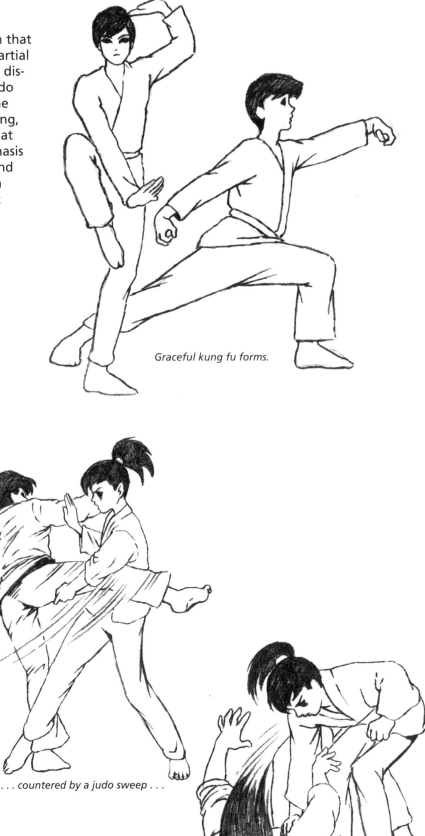

Graceful kung fu forms.

A karate kick . . .

. . . countered by a judo sweep . . .

The claw hand of kung fu.

. . . that overpowers the kicker.

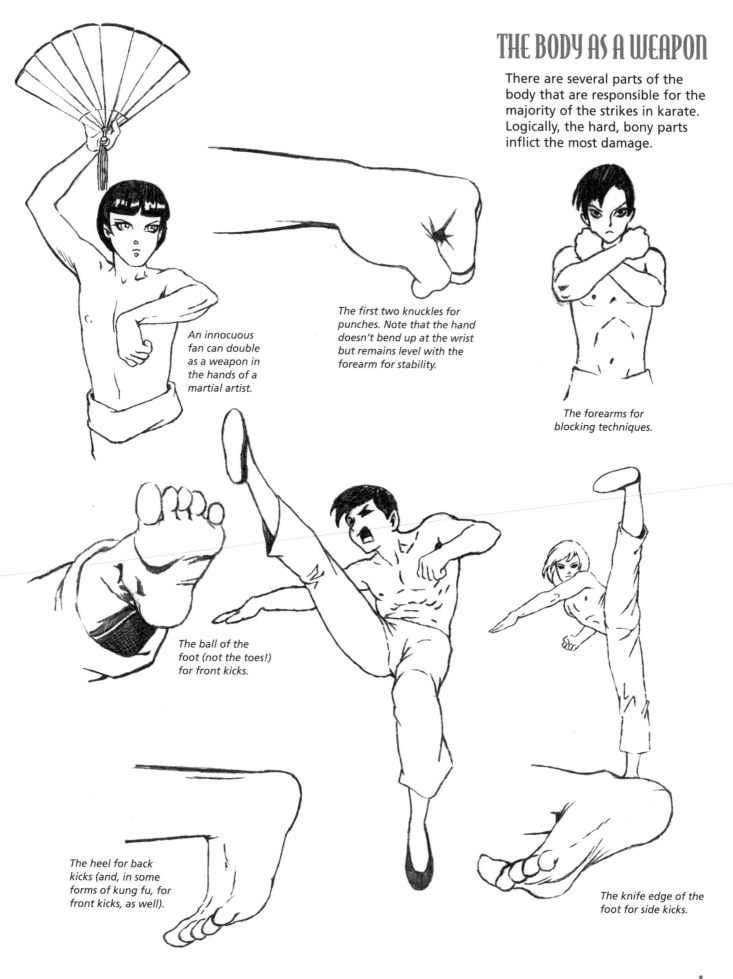

THE BODY AS A WEAPON

There are several parts of the body that are responsible for the majority of the strikes in karate. Logically, the hard, bony parts inflict the most damage.

An innocuous fan can double as a weapon in the hands of a martial artist.

The first two knuckles for punches. Note that the hand doesn't bend up at the wrist but remains level with the forearm for stability.

The forearms for blocking techniques.

The ball of the foot (not the toes!) for front kicks.

The heel for back kicks (and, in some forms of kung fu, for front kicks, as well).

The knife edge of the foot for side kicks.

MANGA'S FANTASY REALM

There are different types of fantasy worlds in manga. Elves, faeries, and other magical creatures and enchanted beings form one popular genre in this kind of manga. Fantasy heroes (and heroines) and sci-fi characters populate another manga fantasy world. We'll take a look at both here.

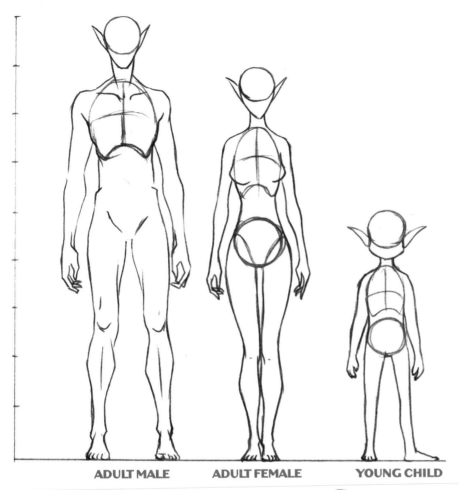

ADULT MALE **ADULT FEMALE** **YOUNG CHILD**

Elfin bodies can have curves and muscles, but the overall impression must be one of a smooth and gentle body, housing a peaceful soul. The most popular elves have long and slender bodies, and are always youthful.

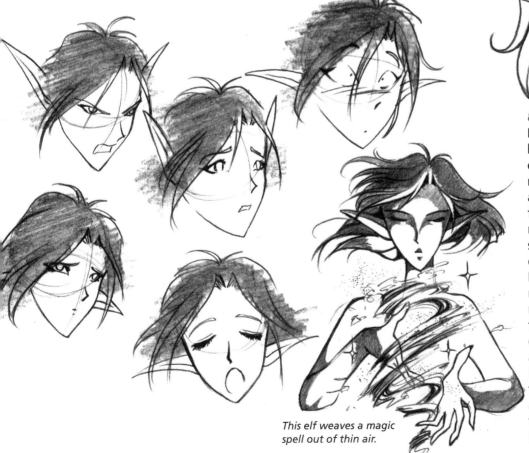

This elf weaves a magic spell out of thin air.

EXPRESSIONS
Elfin creatures are wondrous beings. They express great emotions—remorse, sorrow, melancholy, jubilation, astonishment, surprise, and fury. They are well suited to manga, because the manga style stresses a magical, lyrical quality, especially in the eyes. By making a few, small adjustments, you can transform regular manga characters into fanciful creatures. You should elongate the face, forming a gentle point at the chin. Make the ears long and thin, the noses small and pointed, and the eyes catlike. Also, the ink or pencil line must be thin and delicate.

THE ELF HEAD AND EYES

Note the curve that travels down the rounded forehead. It is reminiscent of a baby's head and gives the elf an innocent quality, while the slender jaw and pointy chin lend an air of mischief. Together, these attributes combine to create an impish character, one that's both good and devilish. Make note of the careless hair, which flaps gracefully in the wind; it's a sign of the free spirit that's inside each of these forest dwellers.

For the eyes, long lashes and sharp brows conspire to make the elf look other than human. A shine in the eye is very important; without it, elves have no magical spark to their spirit.

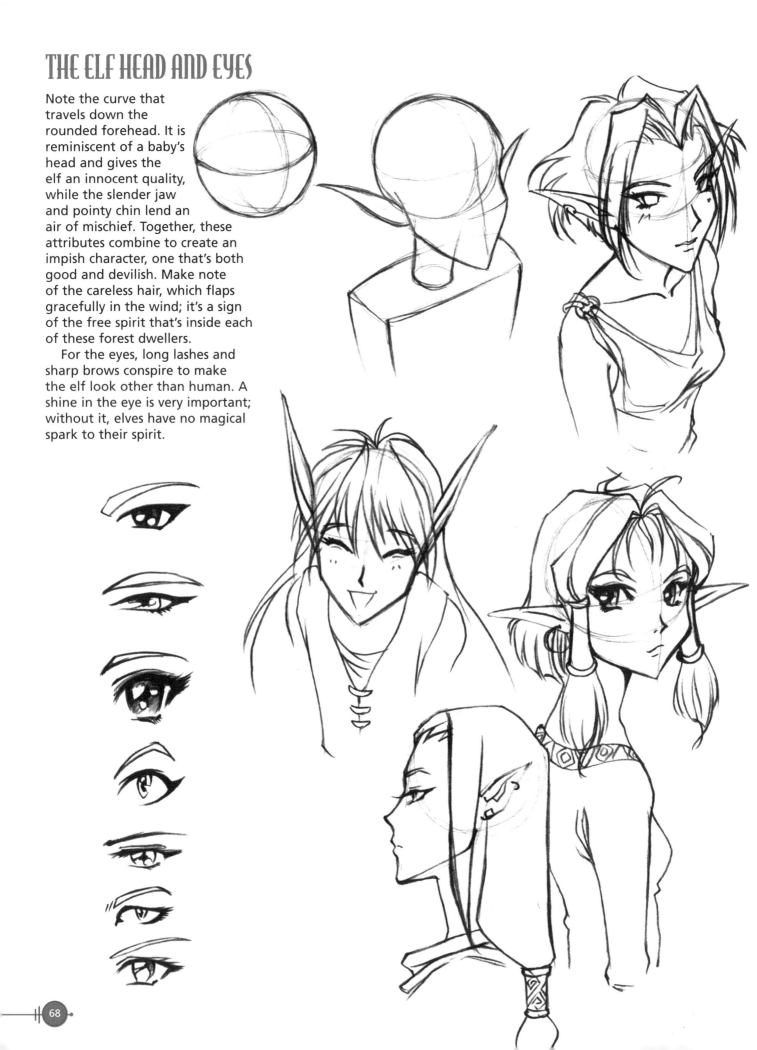

BODY LANGUAGE

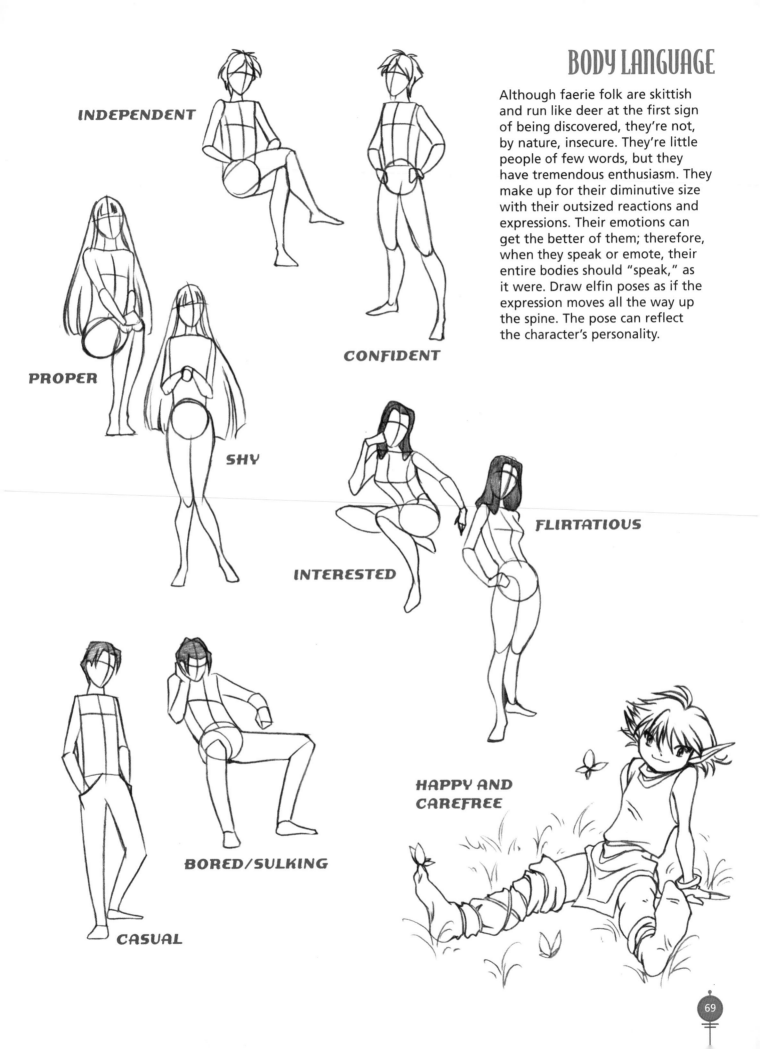

Although faerie folk are skittish and run like deer at the first sign of being discovered, they're not, by nature, insecure. They're little people of few words, but they have tremendous enthusiasm. They make up for their diminutive size with their outsized reactions and expressions. Their emotions can get the better of them; therefore, when they speak or emote, their entire bodies should "speak," as it were. Draw elfin poses as if the expression moves all the way up the spine. The pose can reflect the character's personality.

INDEPENDENT

PROPER

SHY

CONFIDENT

INTERESTED

FLIRTATIOUS

CASUAL

BORED/SULKING

HAPPY AND CAREFREE

FRIENDLY, FURRY ELFIN ANIMAL SIDEKICKS

In the same way that people have dogs and cats, elves also have furry pals to keep them company. Mischievous, hard to find, and even harder to capture, these adorable creatures play the humorous sidekicks to elves and faeries. They can also serve as rescuers who save the day when all seems lost. An entire tribe of elves might be trapped in a raging flood, with the waters rising rapidly all around, when the sidekick saves the day. Sidekicks always hold a big grudge against bad guys!

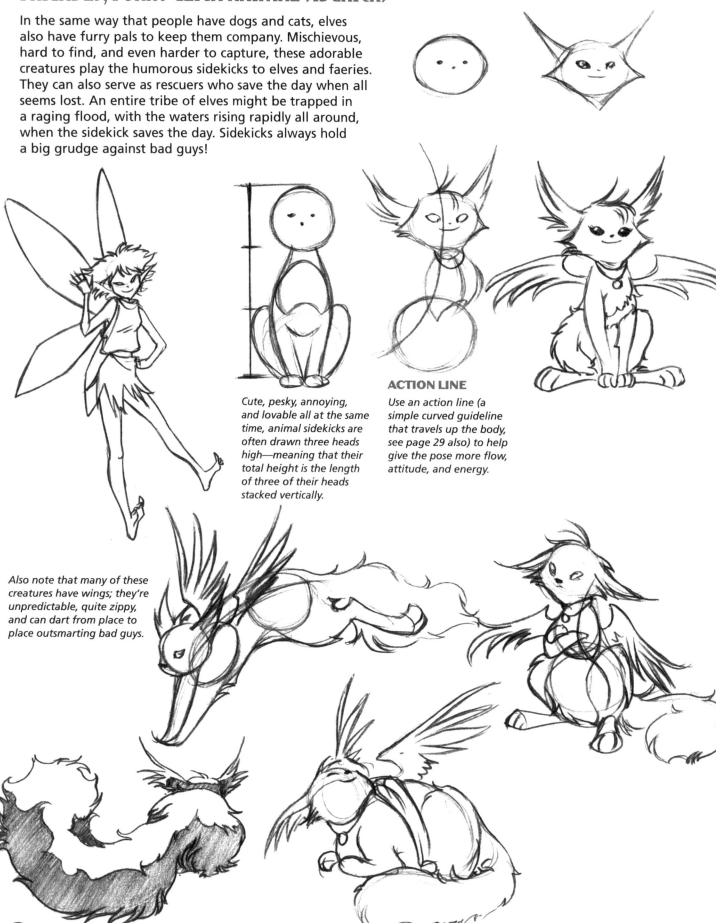

Cute, pesky, annoying, and lovable all at the same time, animal sidekicks are often drawn three heads high—meaning that their total height is the length of three of their heads stacked vertically.

ACTION LINE

Use an action line (a simple curved guideline that travels up the body, see page 29 also) to help give the pose more flow, attitude, and energy.

Also note that many of these creatures have wings; they're unpredictable, quite zippy, and can dart from place to place outsmarting bad guys.

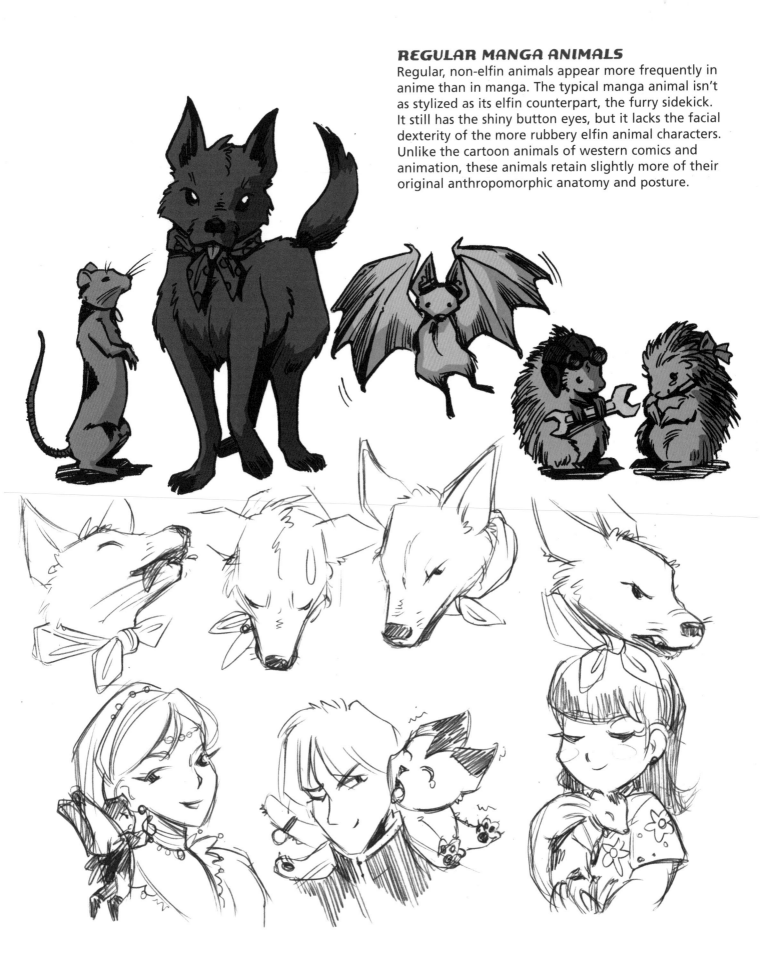

REGULAR MANGA ANIMALS

Regular, non-elfin animals appear more frequently in anime than in manga. The typical manga animal isn't as stylized as its elfin counterpart, the furry sidekick. It still has the shiny button eyes, but it lacks the facial dexterity of the more rubbery elfin animal characters. Unlike the cartoon animals of western comics and animation, these animals retain slightly more of their original anthropomorphic anatomy and posture.

LIGHT AND SHADOW

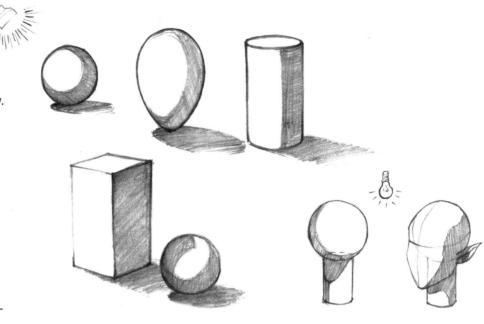

With their angular features and atmospheric presence, elves make the perfect characters on which to illustrate the use of light and shadow. Light and shadow not only create mood and atmosphere, but they also make shapes and forms appear more solid, more three-dimensional, and heavier. The simple shapes at right demonstrate the cast shadows that result from various light sources. The brighter the light, the darker the shadow.

If you're wondering what good it'll do to see the shadows cast from these simple shapes rather than from the more complex human figure, consider this: The human head casts the same shadow that an egg casts. And the neck casts the same shadow that a cylinder does. When you place an egg shape on top of a cylinder, you will have built, for all intents and purposes, a head on a neck.

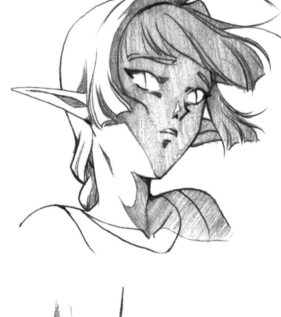

Note that shading occurs in the pockets of the eyes—near the tear duct, under the lower lid, under the eyebrow, and even across the top of the eyeball.

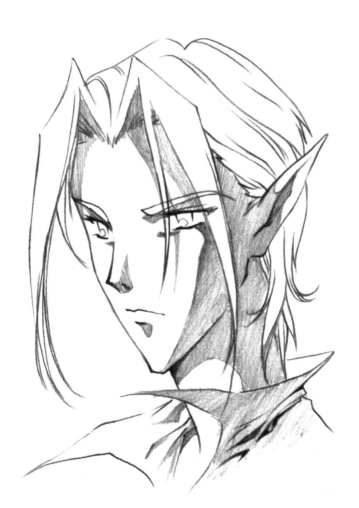

More shadows appear on the side of the nose, under the nose (an even darker shadow), and under the lower lip and chin.

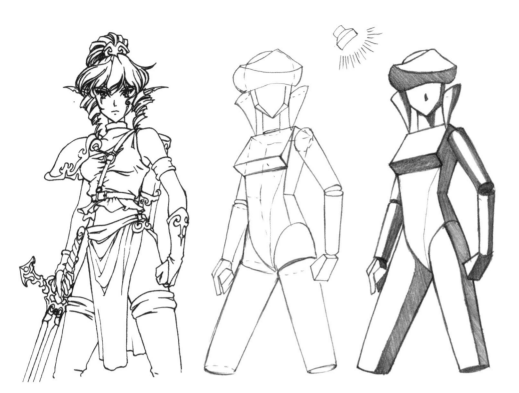

LIGHT AND SHADOW ON THE BODY

Think of the body, whether it's elfin or not, as a vertical slab of rock. Anything that projects out from the smooth surface will cause overhead light to cast a shadow below. Notice how intense the figure on the lower right looks in comparison to the same figure on the upper left. The difference is simply cast shadows!

IMPORTANT HINT

Do not draw every single shadow. Instead, try to combine shadows to create extended, simplified shapes.

HAIR AND SHADOWS

More important to the hair than the shadows is the *shine.* Like the shine in the pupils and irises, the shine on the hair gives brilliance to a character. It will make your character really pop.

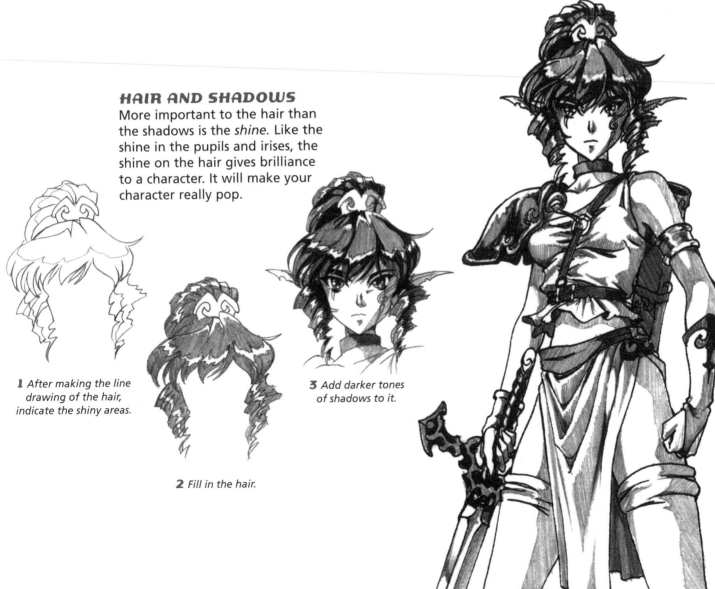

1 After making the line drawing of the hair, indicate the shiny areas.

2 Fill in the hair.

3 Add darker tones of shadows to it.

ELFIN FASHION

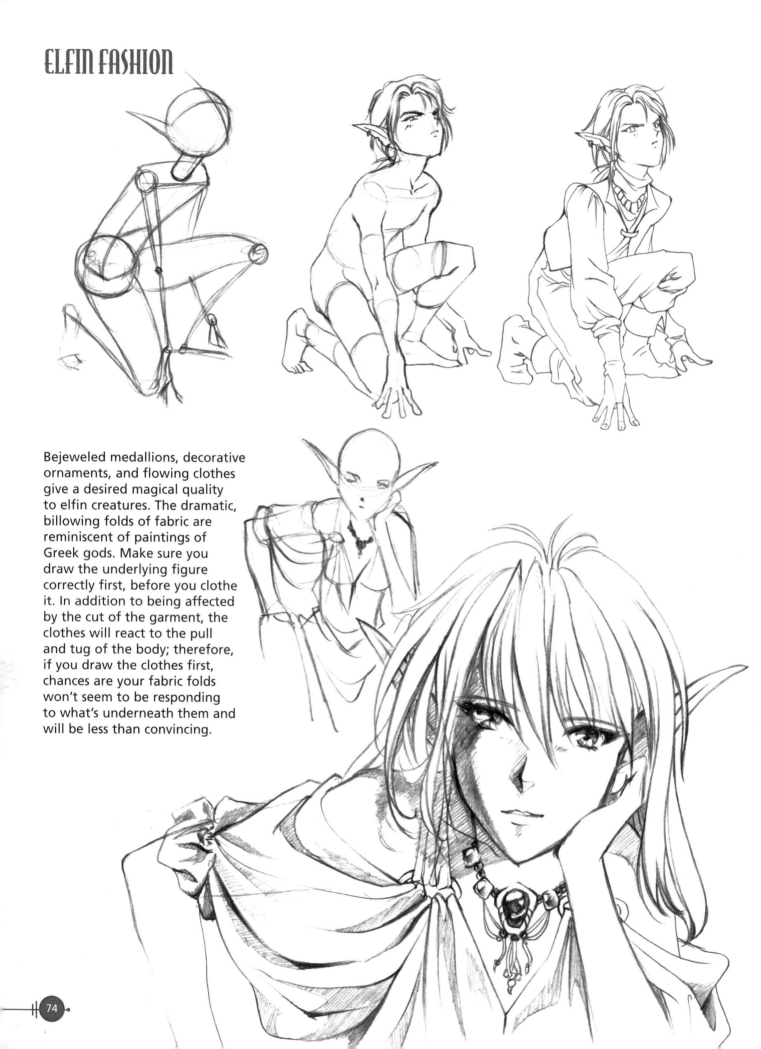

Bejeweled medallions, decorative ornaments, and flowing clothes give a desired magical quality to elfin creatures. The dramatic, billowing folds of fabric are reminiscent of paintings of Greek gods. Make sure you draw the underlying figure correctly first, before you clothe it. In addition to being affected by the cut of the garment, the clothes will react to the pull and tug of the body; therefore, if you draw the clothes first, chances are your fabric folds won't seem to be responding to what's underneath them and will be less than convincing.

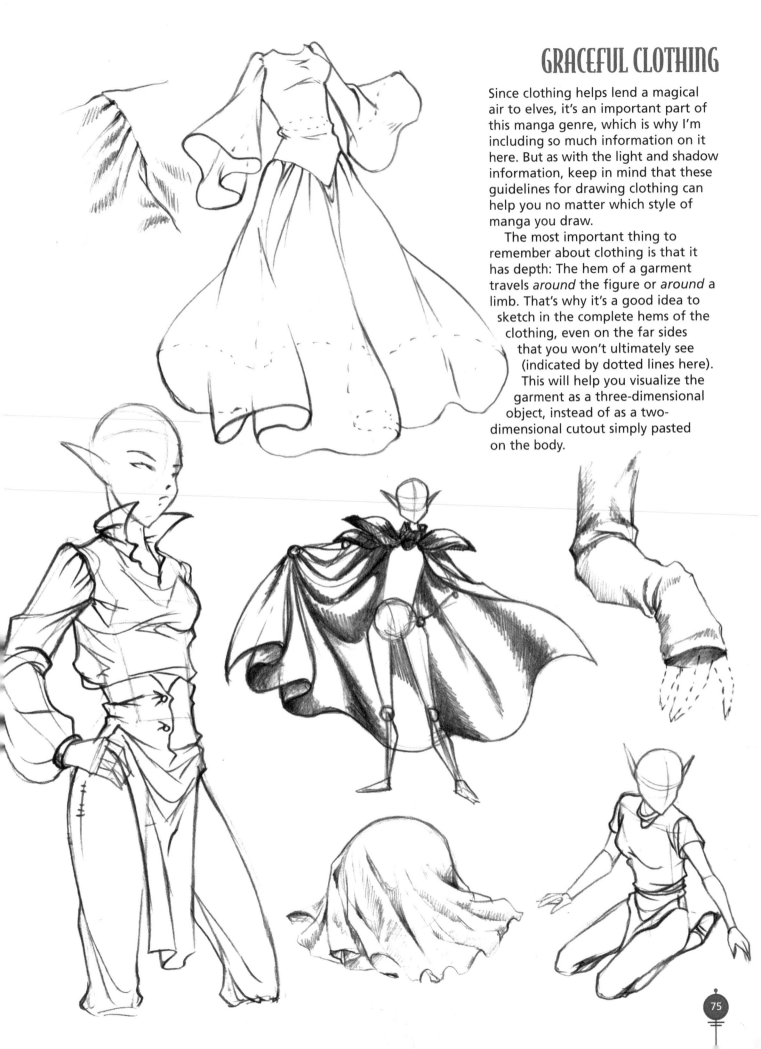

GRACEFUL CLOTHING

Since clothing helps lend a magical air to elves, it's an important part of this manga genre, which is why I'm including so much information on it here. But as with the light and shadow information, keep in mind that these guidelines for drawing clothing can help you no matter which style of manga you draw.

The most important thing to remember about clothing is that it has depth: The hem of a garment travels *around* the figure or *around* a limb. That's why it's a good idea to sketch in the complete hems of the clothing, even on the far sides that you won't ultimately see (indicated by dotted lines here). This will help you visualize the garment as a three-dimensional object, instead of as a two-dimensional cutout simply pasted on the body.

Dynamic Fabric Folds

The pull and tug of clothing create a variety of creases and wrinkles, and this variation results in visual interest. It's not an exact science, and as in all art, effect is as important as accuracy: Above all, you want it to *look good.* That said, if you understand, and can approximate, the basic forces working to create creases and folds, you'll have a better chance of making them look good—because you can make them look *convincing.*

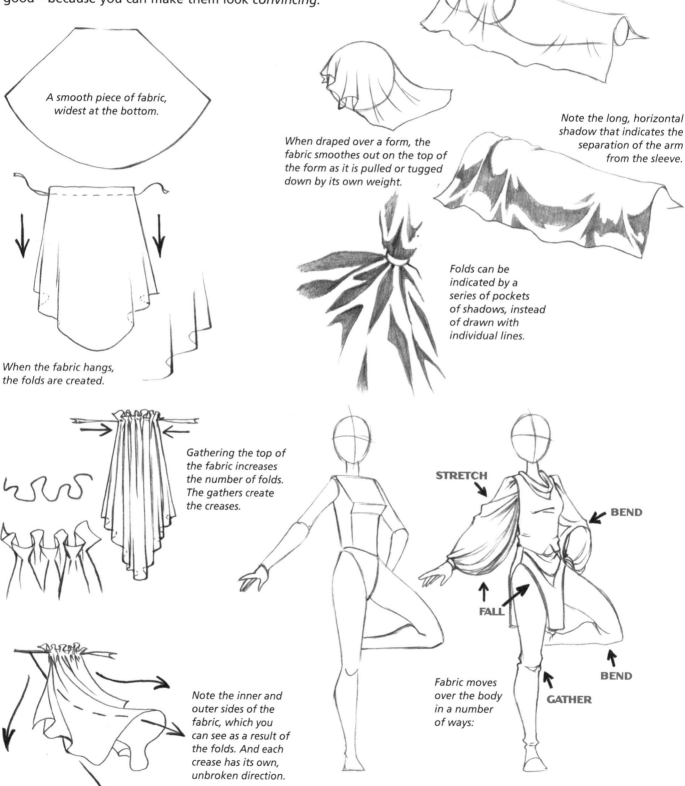

A smooth piece of fabric, widest at the bottom.

When the fabric hangs, the folds are created.

When draped over a form, the fabric smoothes out on the top of the form as it is pulled or tugged down by its own weight.

Note the long, horizontal shadow that indicates the separation of the arm from the sleeve.

Folds can be indicated by a series of pockets of shadows, instead of drawn with individual lines.

Gathering the top of the fabric increases the number of folds. The gathers create the creases.

Note the inner and outer sides of the fabric, which you can see as a result of the folds. And each crease has its own, unbroken direction.

STRETCH

BEND

FALL

BEND

GATHER

Fabric moves over the body in a number of ways:

ELVES IN MEDIEVAL COSTUME

You can combine genres to great effect. By casting elfin creatures in medieval times, you create a new amalgam of fantasy and courtly love. When we think of medieval times, most of us think of knights in armor. But much of the earlier medieval period was dominated by cloth costumes with mail (interwoven metal links), patches of armor, and armor vests and plates, rather than the huge tin cans the later knights wore. For the elfin creatures of manga, the cloth helps to retain the softness of the fantasy, while just touches of armor promote the idea of nobility and hark back to the chivalry of yore. (Also, elfin creatures would have to be uncharacteristically muscular to withstand the weight of full body armor.)

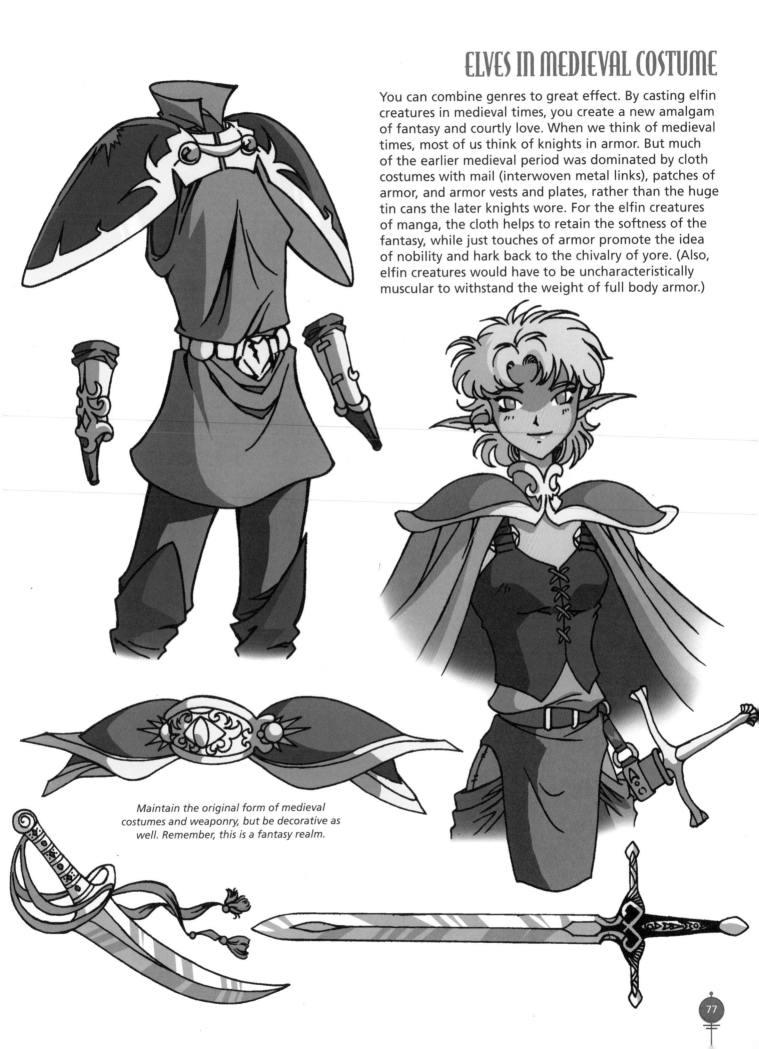

Maintain the original form of medieval costumes and weaponry, but be decorative as well. Remember, this is a fantasy realm.

THE ELFIN PRINCE

Here are a few good, different approaches to drawing an elfin prince's costume.

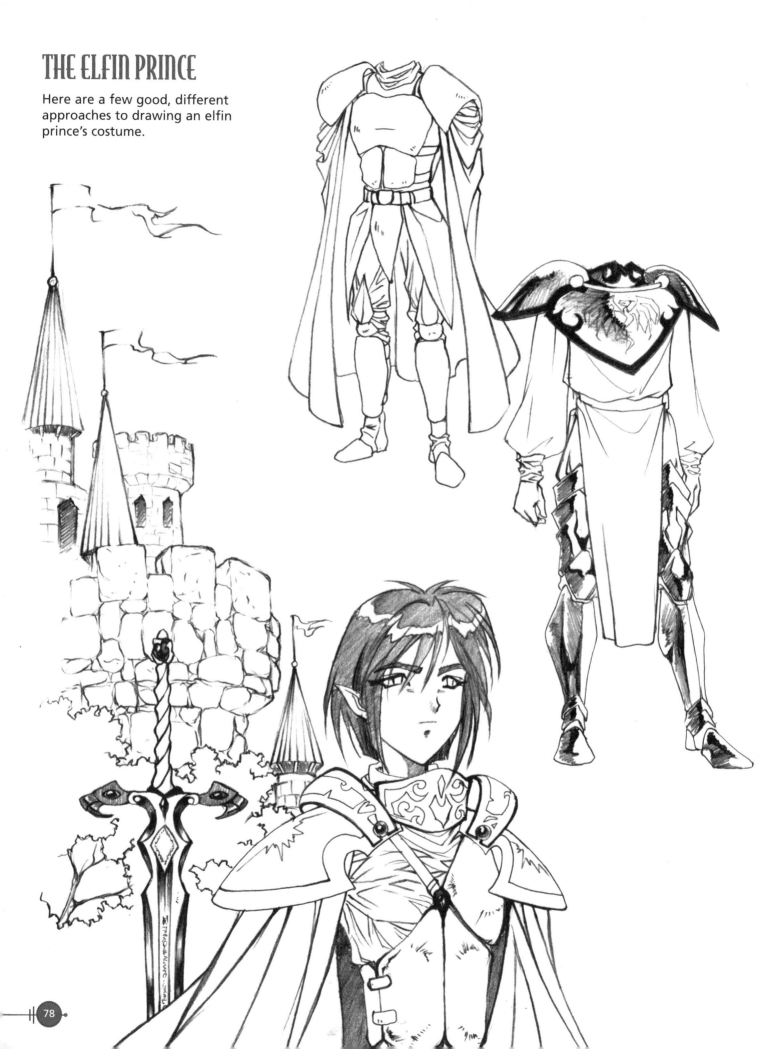

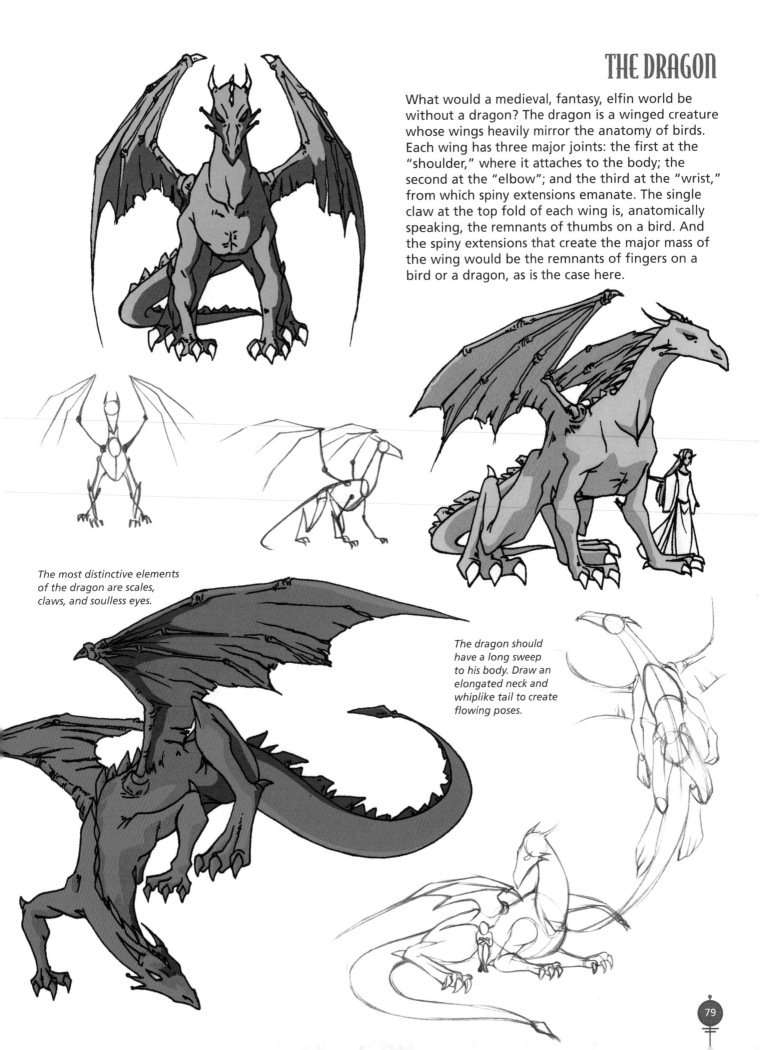

THE DRAGON

What would a medieval, fantasy, elfin world be without a dragon? The dragon is a winged creature whose wings heavily mirror the anatomy of birds. Each wing has three major joints: the first at the "shoulder," where it attaches to the body; the second at the "elbow"; and the third at the "wrist," from which spiny extensions emanate. The single claw at the top fold of each wing is, anatomically speaking, the remnants of thumbs on a bird. And the spiny extensions that create the major mass of the wing would be the remnants of fingers on a bird or a dragon, as is the case here.

The most distinctive elements of the dragon are scales, claws, and soulless eyes.

The dragon should have a long sweep to his body. Draw an elongated neck and whiplike tail to create flowing poses.

THE ELFIN ENVIRONMENT: FROM INITIAL SKETCH TO FINISHED DRAWING

Many beginning artists have so much confidence that they begin a finished drawing from the start, with no intention of redrawing it as they proceed toward a final version. Professional artists are not nearly as confident (or naive). From experience, they know there will be mistakes along the way, as well as happy accidents that should be incorporated as the drawing nears completion.

The route most artists take is to first sketch out a thumbnail drawing, which is a sketch that works out subject, foreground, and background placement. Often, many thumbnails are made, combined, or discarded before the right one appears. It's trial and error, with some inspiration and insight thrown in for good measure.

After a workable thumbnail is made, the artist will try to create interesting shapes for the elements; for example, the tree trunk, rocks, and window here. Then the details are attended to, with different approaches tried for rendering the flowers, leaves, and dress. The artist experiments with a variety of textures on the stones, the bench, and the leaves to make the final drawing a vibrant one.

When you see the final, inked drawing (opposite), you realize that it would be virtually impossible to draw this scene all the way through, from start to finish, without first experimenting with a number of approaches. In addition to creating a pleasing overall layout, each individual section of the scene must be attacked from a different angle in order to maintain reader interest.

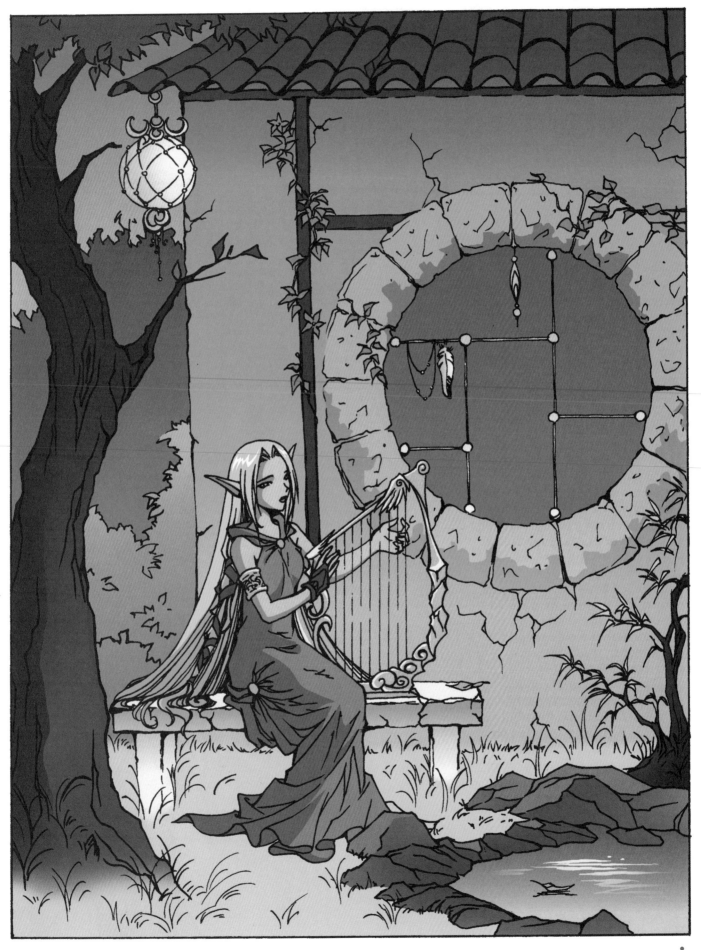

FANTASY HEROES AND SCI-FI CHARACTERS

The characters in these types of manga fantasy tales differ completely from the magical creatures that inhabit the fantasy elfin world. It's a different side of the fantasy realm. Fantasy heroes deal with fighting and armor and warlords. It's all swords and sorcery, whereas the elfin genre deals with peaceful creatures of the forest. *Lodoss War* is a good example of the manga fantasy style.

WESTERN STYLE VS. MANGA

Western comic book artists define every sinew of muscle on their characters. There's a rugged, harsh quality to western heroes, as if they've been hardened by a lifetime of fights and struggles. Manga heroes, while certainly of impressive physical stature, retain a boyish quality. The chin isn't as squared off and tapers to a rounded point. The nose is upturned in the classic manga style. The pupils, irises, and eyebrows are all slightly larger and thicker. The neck doesn't look like it came from a pit bull. Overall, manga characters have fewer lines of definition on the face and body, and the muscles appear smoother.

If you put both these characters in shirts, the western hero would still look freakishly large, while the manga hero would simply look athletic. In addition, the western hero is an antihero, a hero figure who conspicuously lacks heroic qualities. An antihero just happens to be on the right side of the law but looks as if he's only a hair's breath away from being a bad guy himself, due to his cynical, hardened demeanor and toughened body. This is not the case with most manga and anime heroes. They look like good guys who are all pumped up. They still have emotions and believe in something larger than themselves.

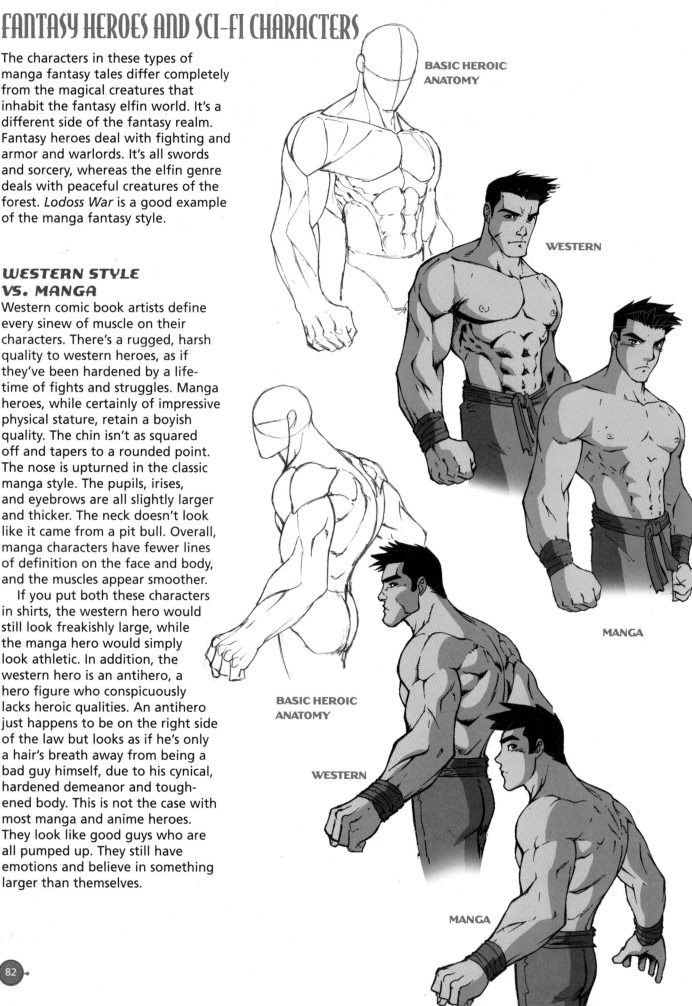

BASIC HEROIC ANATOMY

WESTERN

MANGA

BASIC HEROIC ANATOMY

WESTERN

MANGA

▲
GOOD GUY
▼

▲
BAD GUY
▼

If you can draw good guys, then drawing bad guys is a snap because the bad guys *are* the good guys—with a little tweaking. The differences are subtle but important, and they pertain to gals as well as guys. Good guys have larger and rounder eyes than bad guys. They also scowl and display skeptical, jaded expressions. In addition, their faces are "decorated" with telltale signs of badness: scars, stubble, multiple piercings, streaked hair, and the signs of general wear and tear that come from living on the wrong side.

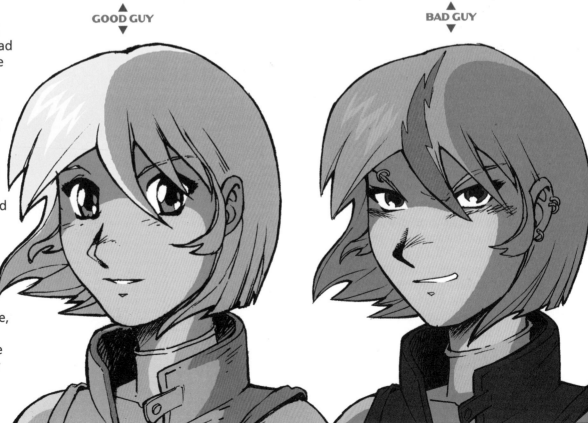

INKING TECHNIQUES IN THE FANTASY GENRE

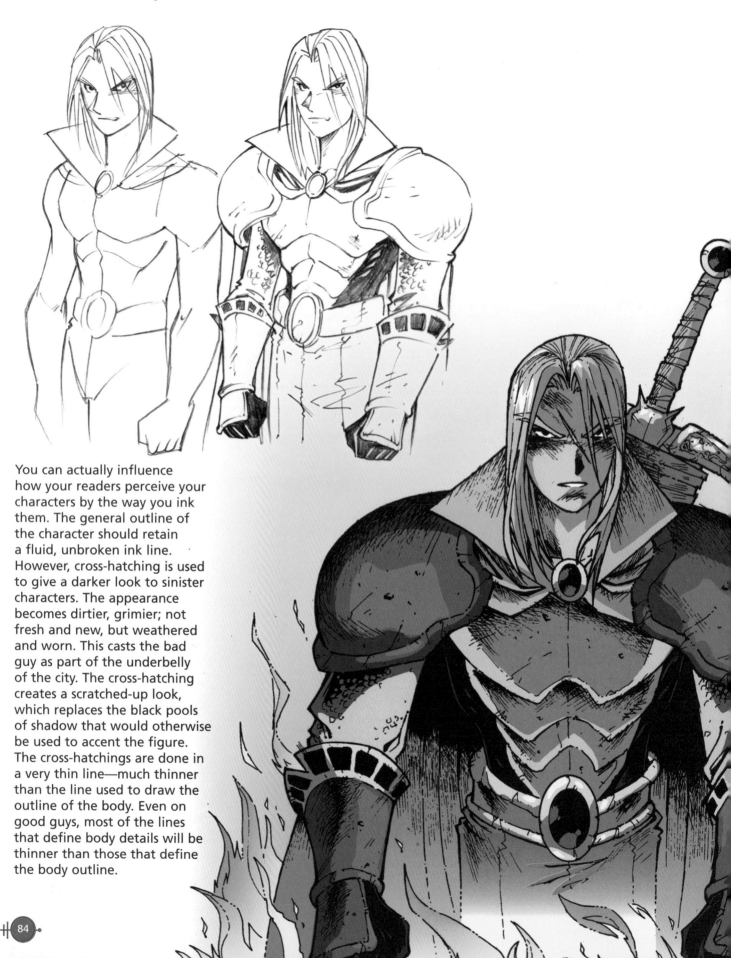

You can actually influence how your readers perceive your characters by the way you ink them. The general outline of the character should retain a fluid, unbroken ink line. However, cross-hatching is used to give a darker look to sinister characters. The appearance becomes dirtier, grimier; not fresh and new, but weathered and worn. This casts the bad guy as part of the underbelly of the city. The cross-hatching creates a scratched-up look, which replaces the black pools of shadow that would otherwise be used to accent the figure. The cross-hatchings are done in a very thin line—much thinner than the line used to draw the outline of the body. Even on good guys, most of the lines that define body details will be thinner than those that define the body outline.

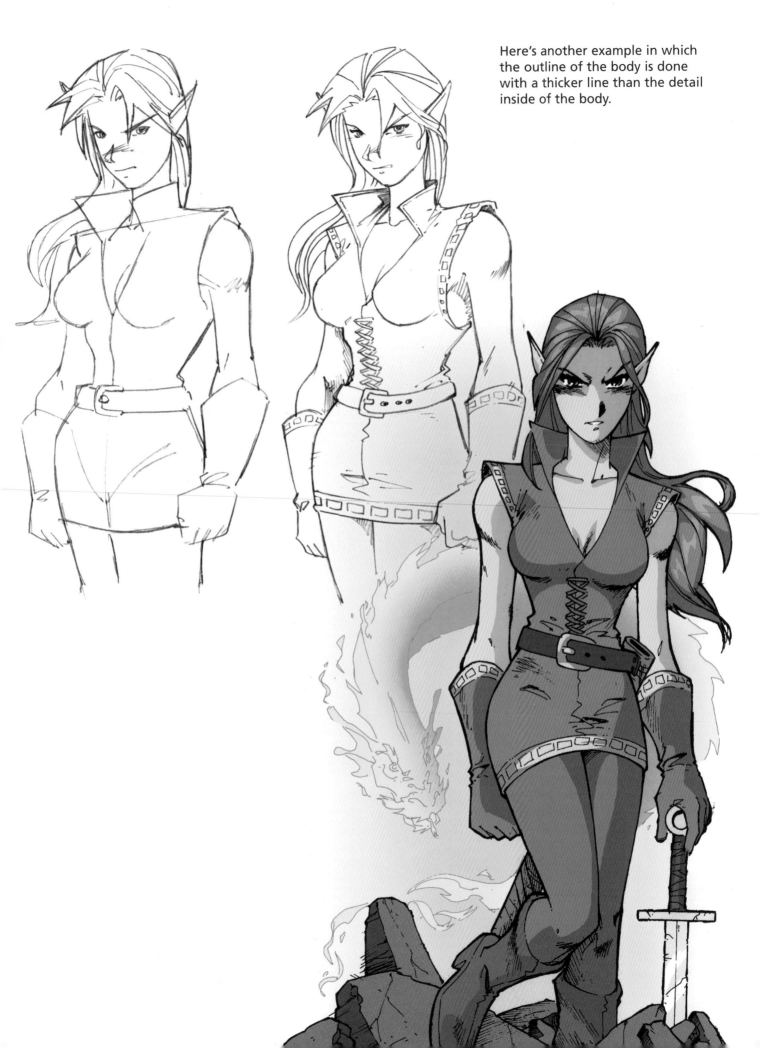

Here's another example in which the outline of the body is done with a thicker line than the detail inside of the body.

FANTASY HERO COSTUMES: GOOD GUY VS. BAD GUY

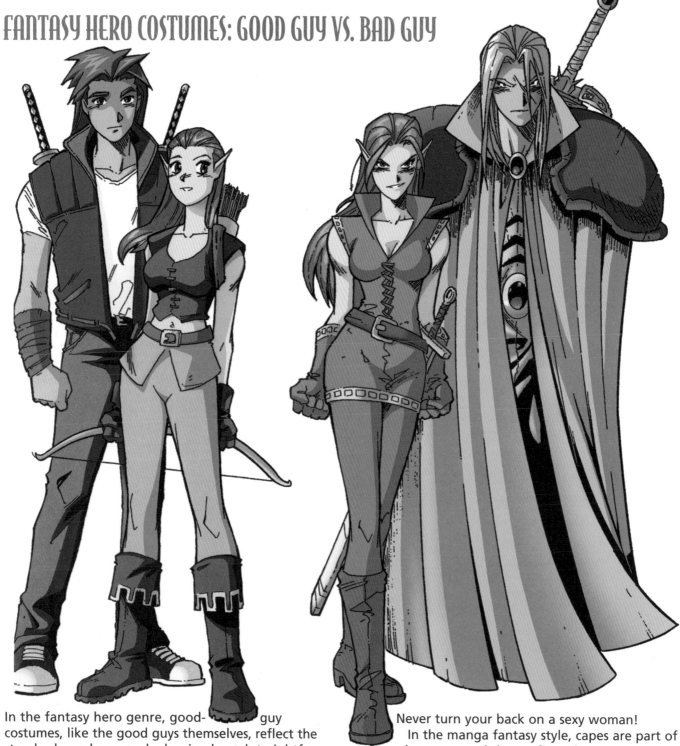

In the fantasy hero genre, good-guy costumes, like the good guys themselves, reflect the standard good-guy credo: be simple and straightforward. Good guys don't *have costumes* so much as they *wear clothes.* It's just the stuff they walk around in. They're not trying to announce their status everywhere they go. They're you and me—normal people thrust into challenging situations.

Not so for the bad guys. Bad-guy outfits are more extreme, oversized, and heavily dramatic. While good-guy clothes are functional, bad-guy clothes are not. The bad gal has a flared, pointed collar, and there are more patterns on her dress than on the good gal's outfit. She also wears a mini skirt, which is much sexier. And in comics, sexy equals dangerous.

Never turn your back on a sexy woman!

In the manga fantasy style, capes are part of the armor and the outfit and are aesthetic, unlike in western-style comics, in which a cape generally helps the wearer fly. The shoulders of this bad guy are as huge as can be, serving a dual role as body protector and intimidation device (in the same way that some animals puff themselves up to look bigger to their enemies). In comics, as in life, never trust anyone who wears a cape . . . or talks about "net" profits. This guy also sports a flared, pointed collar and amulets—one to fasten his cape and another on his shirt. Both the bad guy and gal let their hair cascade over their faces, creating a barrier between them and the reader.

BAD GUYS WITHOUT SUPER POWERS

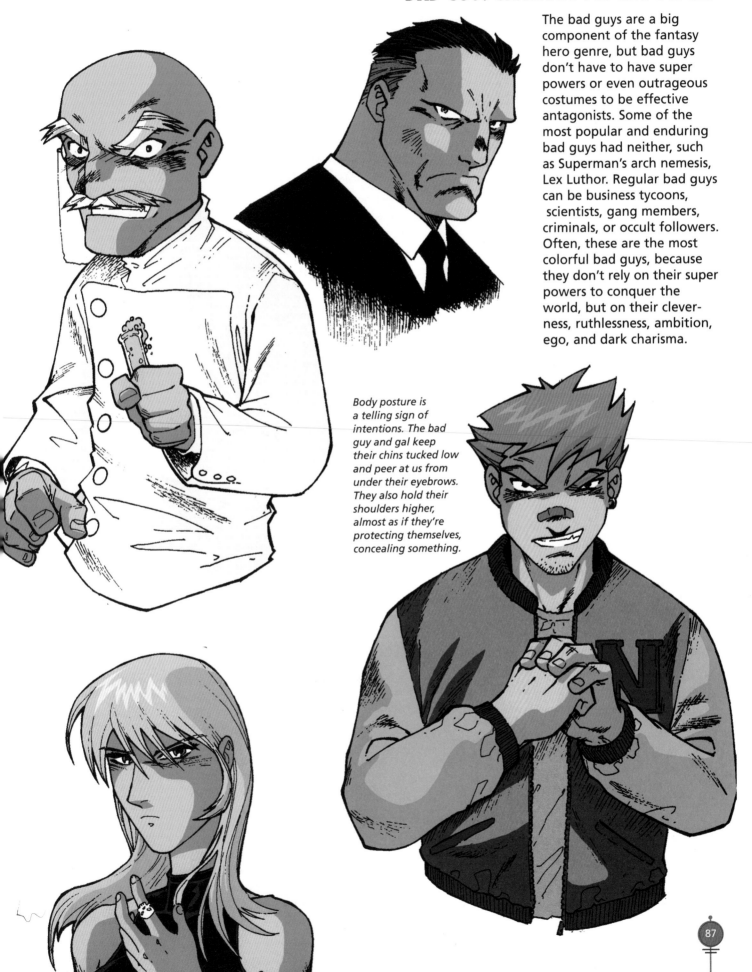

The bad guys are a big component of the fantasy hero genre, but bad guys don't have to have super powers or even outrageous costumes to be effective antagonists. Some of the most popular and enduring bad guys had neither, such as Superman's arch nemesis, Lex Luthor. Regular bad guys can be business tycoons, scientists, gang members, criminals, or occult followers. Often, these are the most colorful bad guys, because they don't rely on their super powers to conquer the world, but on their cleverness, ruthlessness, ambition, ego, and dark charisma.

Body posture is a telling sign of intentions. The bad guy and gal keep their chins tucked low and peer at us from under their eyebrows. They also hold their shoulders higher, almost as if they're protecting themselves, concealing something.

MUTANTS

Don't forget the mutants! Mutants belong in the sci-fi fantasy realm, too. Mutants are so popular you could write an entire book about them, which incidentally, I did: *How to Draw Aliens, Mutants & Mysterious Creatures*—pardon the commercial, and now, as they say, back to the show!

Mutants add a fascinating and eerie element to a story. They're wild cards, because they have abilities beyond those of humans and may react differently from humans in any given situation. Many have been created in the laboratories of evil scientists. For convenience and clarity, we can separate all mutants into the following two categories:

HUMAN-BASED MUTANTS

These characters are mutants who were once people and who, through either an experiment or a tragic accident, have mutated into something other than human. This accident usually affects the characters' minds, as well as their bodies, so that their souls are corrupted. They're not who they were.

One increasingly popular method for creating mutants in a storyline is to operate on a character who, for example, has been badly mangled in an industrial accident. Instead of just suturing up the areas where the limbs were destroyed, attach hi-tech weapons to create a being who is half human and half machine.

Many mutants have become who they are through exposure to radiation and have thereby gained incredible powers. I've always found it odd that, in comics, exposure to radiation frequently results in enhanced strength, whereas we know that, in reality, radiation exposure does exactly the opposite—think of cancer patients undergoing chemotherapy. My conclusion is that the comics' romance with the effects of radiation started in earnest in the early 1960s, when radiation was largely misunderstood and there were few other story devices available to comics writers. Now we have toxic waste, bioengineering, quantum physics, black holes, silicon, computer circuitry, cloning, and more.

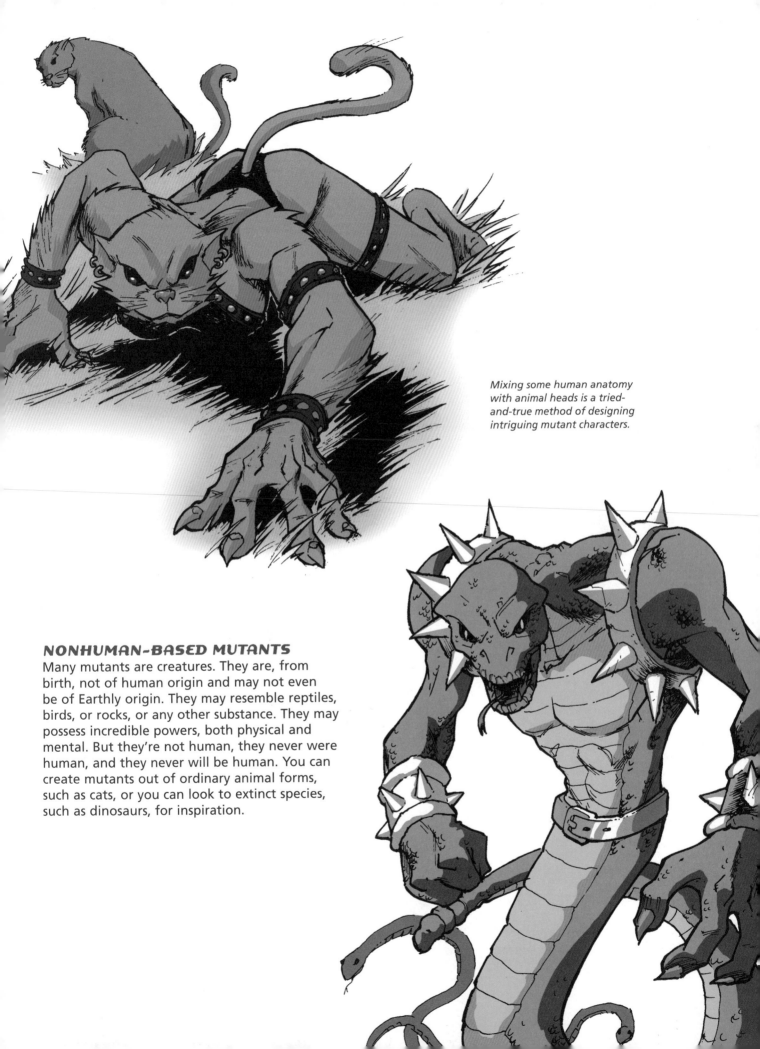

Mixing some human anatomy with animal heads is a tried-and-true method of designing intriguing mutant characters.

NONHUMAN-BASED MUTANTS

Many mutants are creatures. They are, from birth, not of human origin and may not even be of Earthly origin. They may resemble reptiles, birds, or rocks, or any other substance. They may possess incredible powers, both physical and mental. But they're not human, they never were human, and they never will be human. You can create mutants out of ordinary animal forms, such as cats, or you can look to extinct species, such as dinosaurs, for inspiration.

DROP-DEAD-GORGEOUS MANGA BABES

Every comic book genre has its femmes fatales, and manga is no slouch in that department. Manga beauties have eyes that shine like semiprecious stones. Their faces aren't as hard and angular as western-style comic book women, but rather, retain a youthful, twenty-something look. They don't look jaded, abused, or rugged—good gals can be sexy, too. Their bodies are curvy and athletic, but their muscles aren't heavily defined. As a result, they retain their femininity.

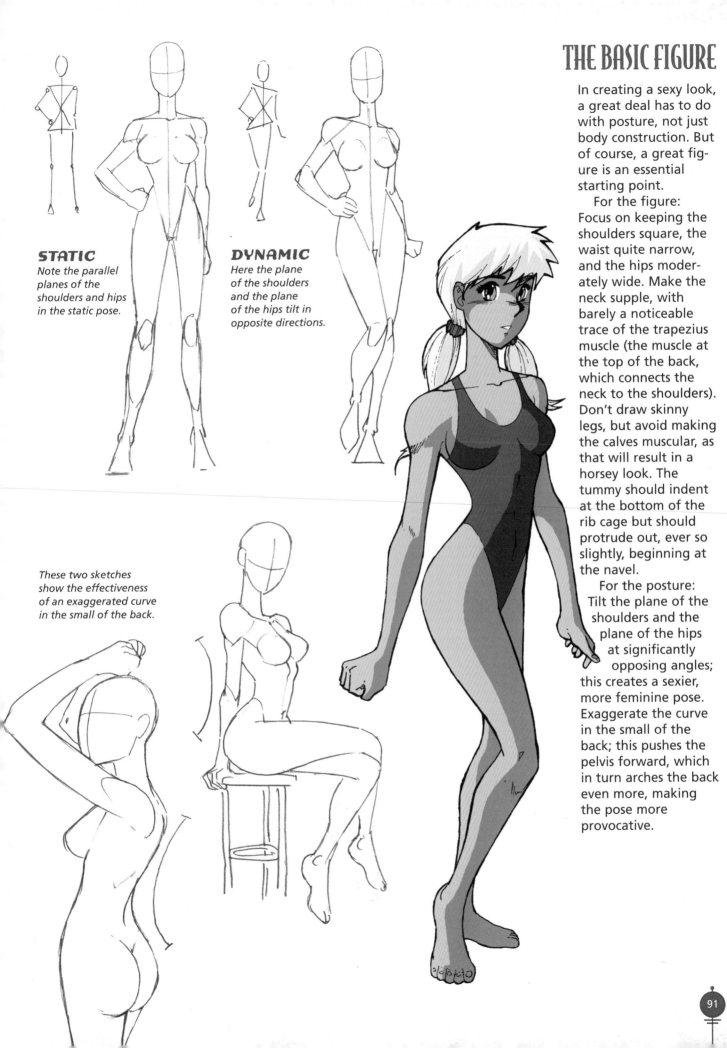

THE BASIC FIGURE

In creating a sexy look, a great deal has to do with posture, not just body construction. But of course, a great figure is an essential starting point.

For the figure: Focus on keeping the shoulders square, the waist quite narrow, and the hips moderately wide. Make the neck supple, with barely a noticeable trace of the trapezius muscle (the muscle at the top of the back, which connects the neck to the shoulders). Don't draw skinny legs, but avoid making the calves muscular, as that will result in a horsey look. The tummy should indent at the bottom of the rib cage but should protrude out, ever so slightly, beginning at the navel.

For the posture: Tilt the plane of the shoulders and the plane of the hips at significantly opposing angles; this creates a sexier, more feminine pose. Exaggerate the curve in the small of the back; this pushes the pelvis forward, which in turn arches the back even more, making the pose more provocative.

STATIC
Note the parallel planes of the shoulders and hips in the static pose.

DYNAMIC
Here the plane of the shoulders and the plane of the hips tilt in opposite directions.

These two sketches show the effectiveness of an exaggerated curve in the small of the back.

THE SPY

This gal's on a mission. She's armed and dangerous, which makes her even more desirable than she already is. Note the exaggerated curve in the small of the back (see page 93 also). It creates a suggestive pose that's popular not only in comics but in advertising, as well. And, it's more natural. A woman's pelvis naturally tilts forward more, as opposed to that of a man, which shows less tilt.

The line of the back is serpentine, curving out near the shoulder blades, in at the lower back, and then out again. The line of the front of the figure is straight. This asymmetrical overall design prevents the form from becoming repetitious.

Her bathing suit is a great costume because it's skin tight and wet. And, anytime you can indicate the wind blowing long hair randomly around a beautiful girl's face, do it; it's always more appealing to show individual strands of windswept hair rather than big clumps bunched together.

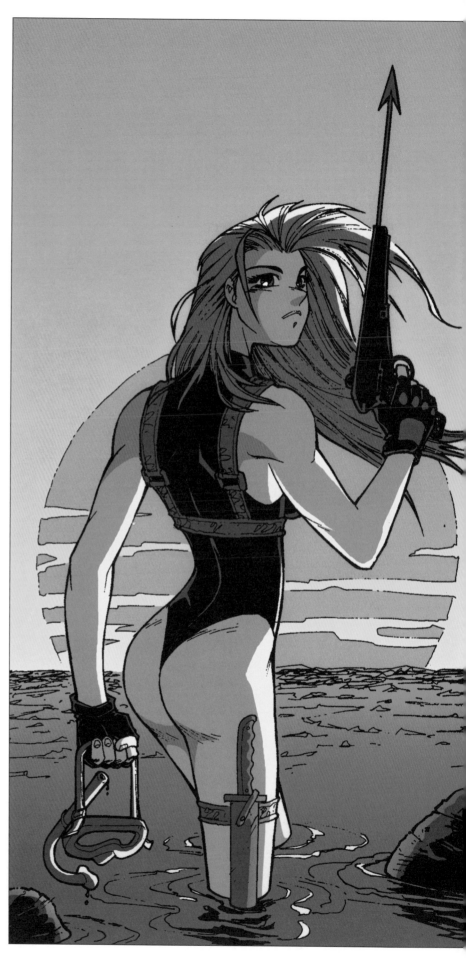

FUTURISTIC BABE

Sci-fi girls are intense. They have to be. They're survivors in a postapocalyptic mess of a world. As they make their way through the rubble, they've got to look great. Hey, you can't let a planetary invasion ruin your perm. The costumes of futuristic babes should be peppered with protective gear, such as goggles, gloves, shoulder pads, and boots. They should also have small pouches on their clothing in which to store any supplies they might need—remember, they're in survival mode.

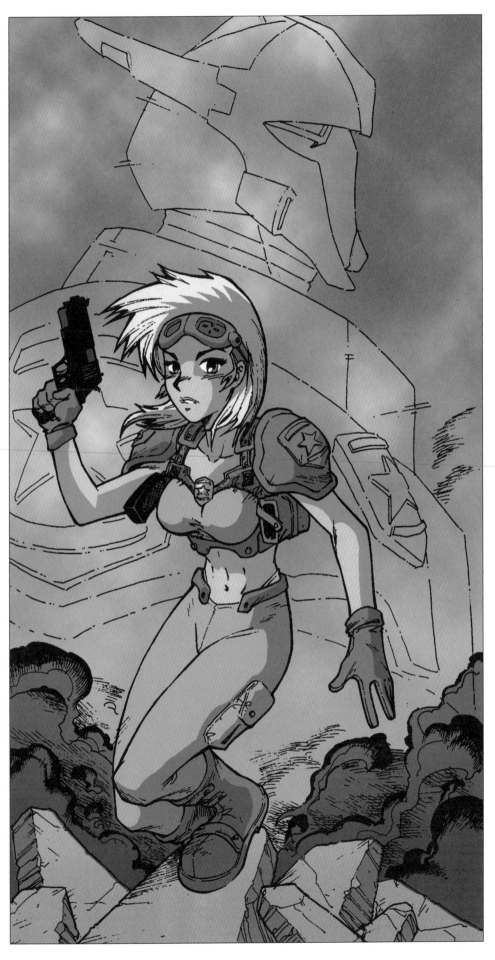

A GIRL AND HER TYRANNOSAURUS

Cave gals are great-looking comic book heroines. They wear scanty animal skins and sport a great shape. Hey, it takes a lot of hard physical work to stay one step ahead of those giant lizards. Remember, cave people aren't at the top of the food chain, like you and me, but somewhere in the dangerous middle. Back in the Jurassic era, we would have been groceries, pal.

The characters are nature-lovers and should appear squeaky clean, as if they've been bathing in a lake all day. The jewelry should be made of precious stones, animal teeth, bones, feathers, and perhaps, tusks. The clothing should have varied textures. For example, here the top is the texture of tanned leather but the boots show the ruffles of animal fur, with leather straps wrapped around to secure them.

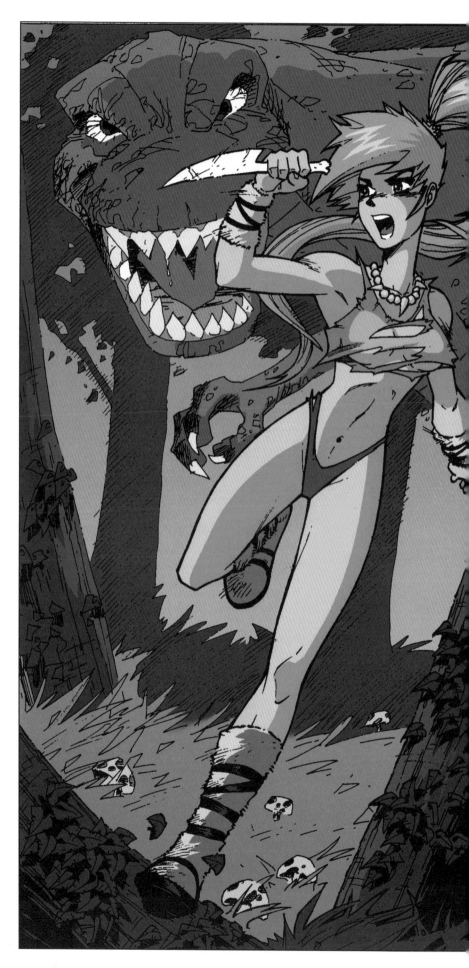

A VALLEY GIRL IN JAPAN

Like, manga to the max! The valley girl's hair is cropped and trendy. (Long hair works better on younger high-school girls.) Her body's a killer. She wears very revealing clothing without being self-conscious about it. As opposed to a character who's always *trying* to be seductive, the valley girl just *is* sexy. Sexy works for her.

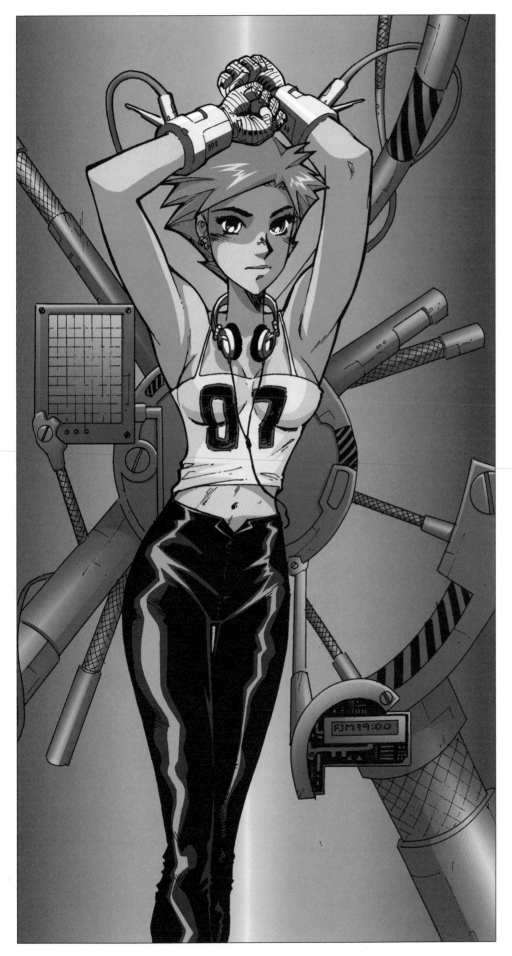

AWESOME ROBOTS AND OTHER COOL STUFF

Giant robots have been raging across the pages of manga comics since before you and I stopped spilling strained carrots on our bibs. I'm talking about skyscraper-tall robots who can crush cars underfoot. Unlike their western counterparts—which often look like naked people covered in liquid chrome—manga robots firmly retain their decidedly mechanical look, making them appear more extreme. After all, they haven't been humanized—they are machines of destruction and devastation.

"BUILDING" A ROBOT: BASIC POINTERS

Take your time and go slowly when drawing the characters in this section. It takes some draftsmanship and is a departure from drawing manga people. The skill is in some ways similar to being an architect—you're constructing things from straight lines, angles, and shapes. A ruler is a necessity! Some artists specialize in drawing robots, while others concentrate more on people but like to draw robots to broaden their repertoire of characters.

You don't *draw* manga robots so much as you *build* them out of shapes and blocks. As the steps here and on the next two pages show, it's imperative that you think in terms of three-dimensional forms. You must convey the thickness and blockiness of the structure. It's a process of refinement, chipping away at the form, making small changes but retaining the angularity and depth of the shapes. Try to *see through* the forms. This means trying to visualize the entire form—the inside as well as the outside. It's an exercise that will greatly improve your ability to handle a series of complex forms, because it will help you understand where all of the angles join—you won't be guessing.

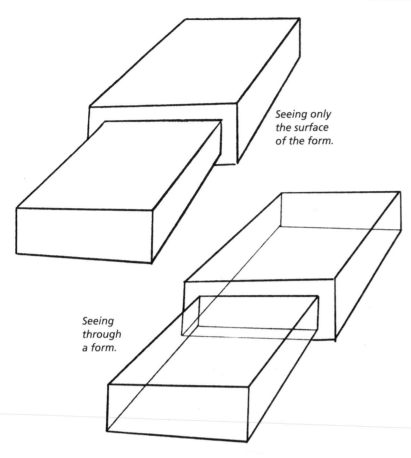

Seeing only the surface of the form.

Seeing through a form.

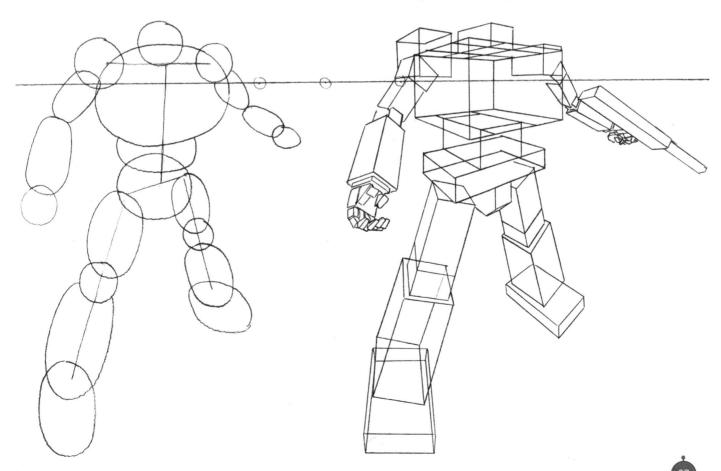

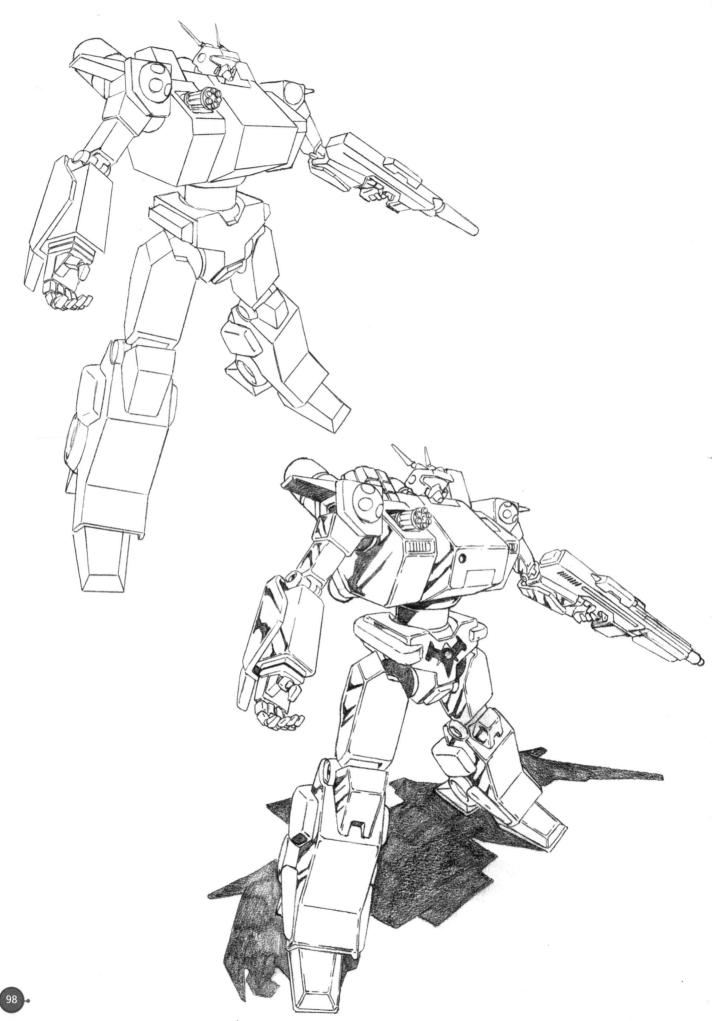

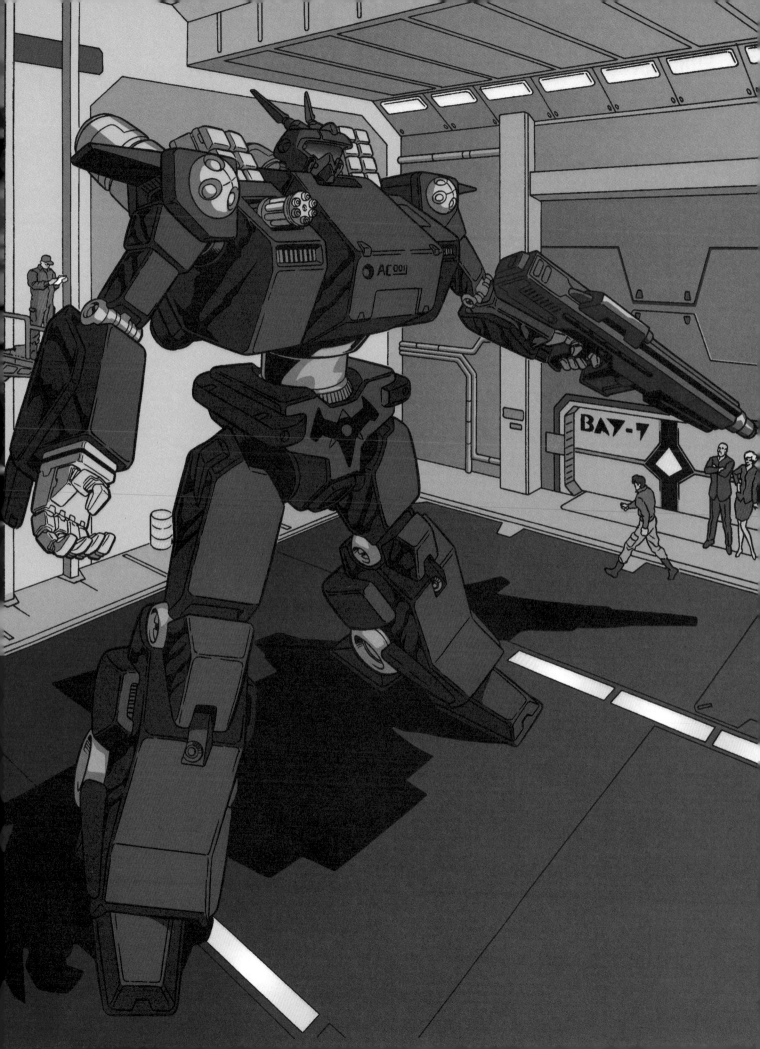

ROBOT DEFENDER

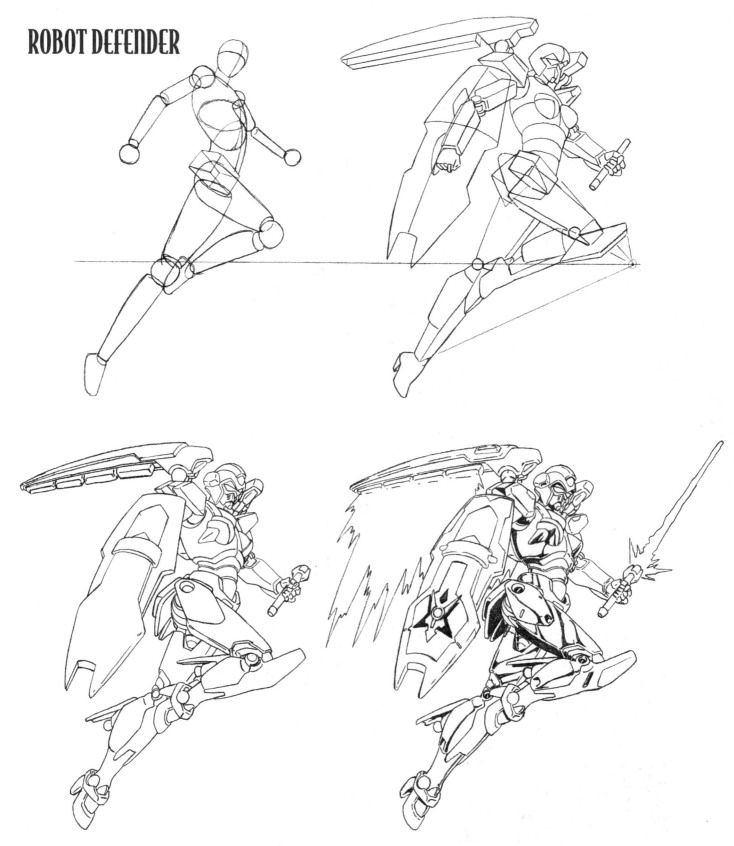

This robot reflects a combination of design approaches. It's a humanized form, like western comic book robots tend to be, but the parts are highly mechanical looking, which is an eastern approach. By displaying the knobs and joints where the various mechanical body sections join, you reinforce the idea that this is definitely a mechanical creature.

Robot figures can be either "male" or "female" and, regardless of gender, are the modern-day equivalents of knights in armor. Their costumes can be subtly reminiscent of this fact, or can overtly reflect it. Technically, that may be an energy beam in the robot's hand, but you and I both know that it's really Excalibur, King Arthur's sword.

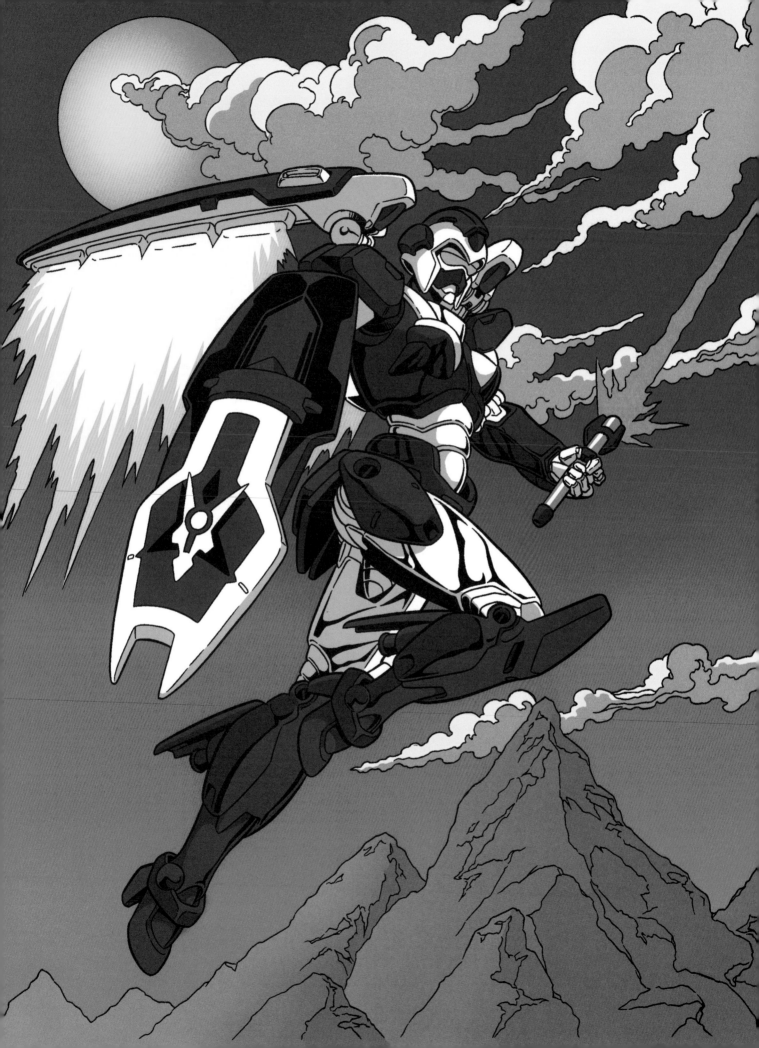

GIANT ROBOT INSECTS

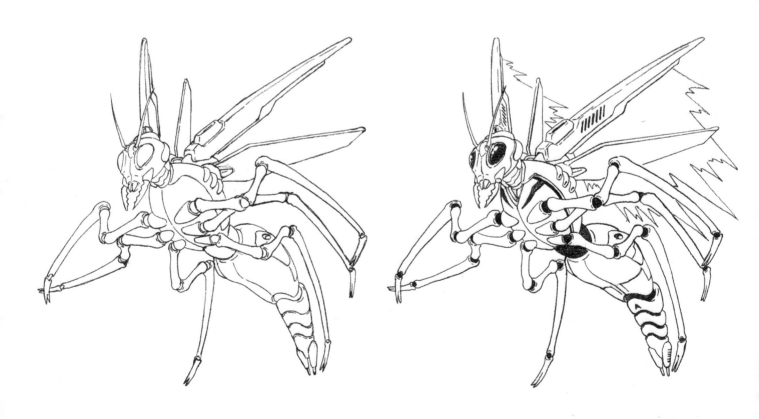

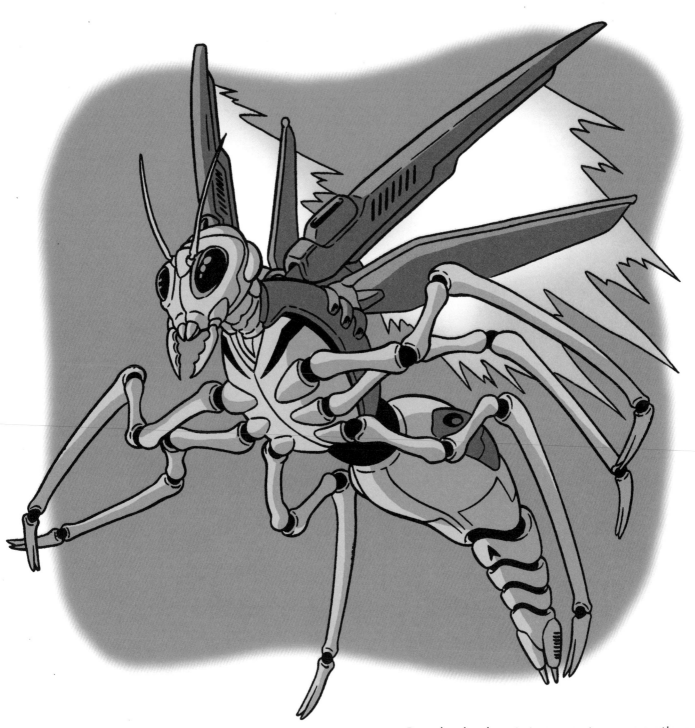

By enlarging insects to gargantuan proportions, you create ruthless, repulsive predators. You can use giant robot insects to create interesting allegories: The humans become the small pests and the insects become the exterminators. Insects have a highly mechanical look to begin with. Their bodies are clearly defined in sections and have hard outer coatings; therefore, it's unnecessary to outfit a robot insect with as much gadgetry as you would when designing a human-based robot.

ROBOT DRAGONS

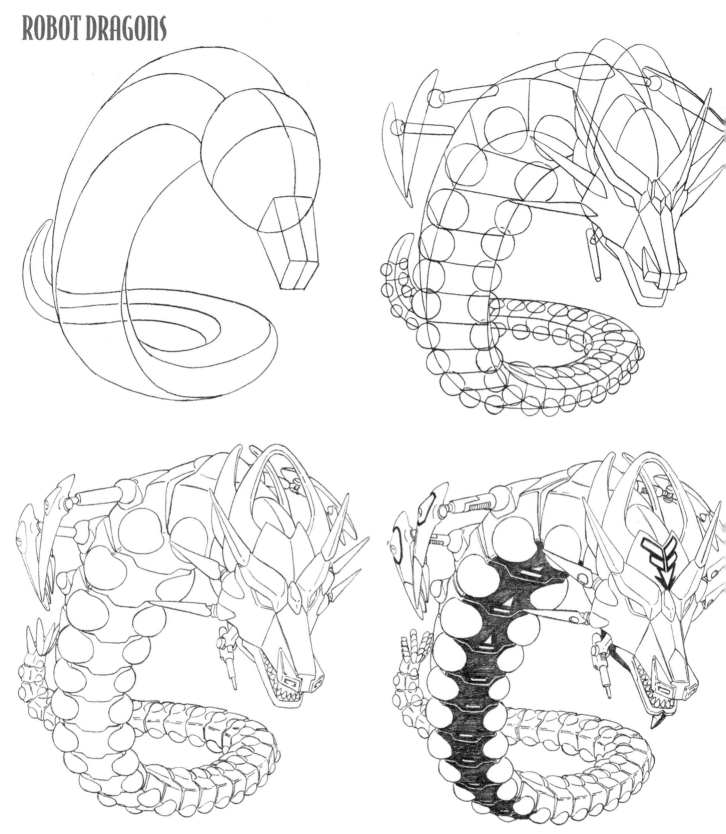

You can combine reptiles of all kinds—turtles, lizards, snakes, and even mythic dragons—to create ferocious robots. In drawing the robot dragon, keep the head large and imposing. Spikes emerging from the crown, like armor plates, give it a bit of a dinosaur look. Clearly delineate the underbelly, defining it as separate from the top half of the body. Make sure that the sections of the body diminish in size as they recede into the background.

It's rarely necessary, or even a good idea, to draw the eyeballs in robots; eyes are the "windows to the soul," and these soulless creatures should have nothing behind their eyes except circuitry.

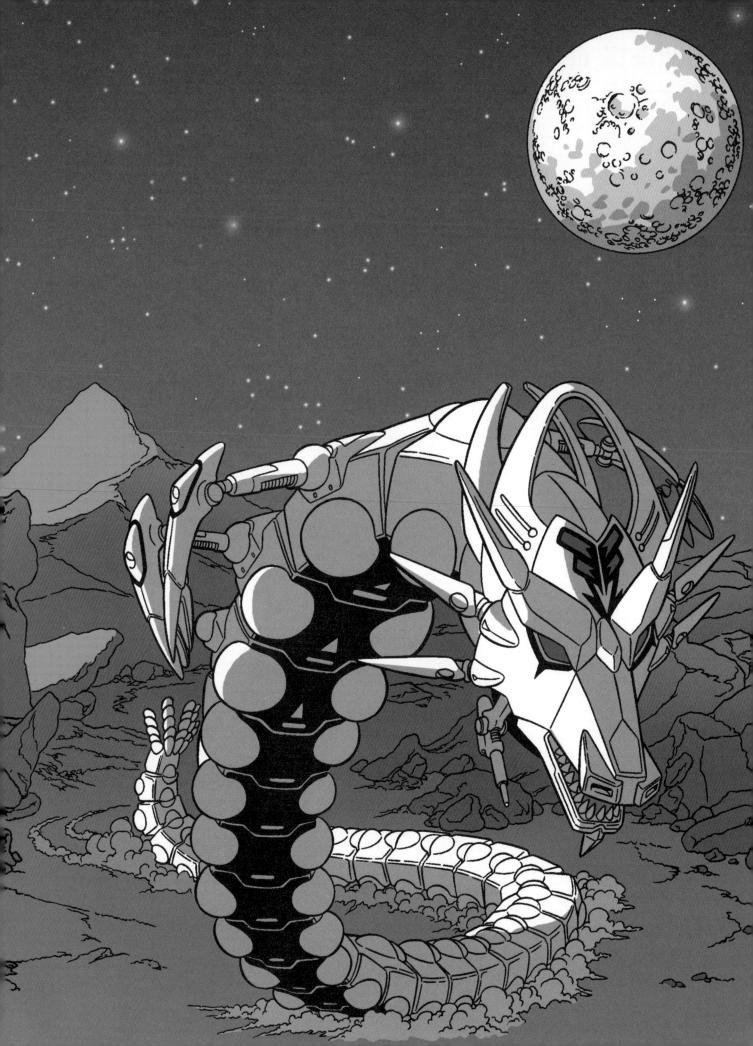

CLASH OF THE GIANT ROBOTS

When laying out a scene that makes heavy use of geometric shapes, first establish where you want the horizon line to be. You can put it anywhere you like, but once you begin to sketch out the scene, the horizon line must remain in that chosen spot because you'll be referring to it continuously to get the perspective of the buildings correct. (See pages 43 and 123.)

Note that the lines of the buildings in this scene recede to both the left and right. All lines that aren't parallel or perpendicular to the horizon line will, if extended, eventually converge in the distance at one of two *vanishing points,* either vanishing point left or vanishing point right, on the horizon line. Oftentimes, vanishing points don't appear in a drawing (they are

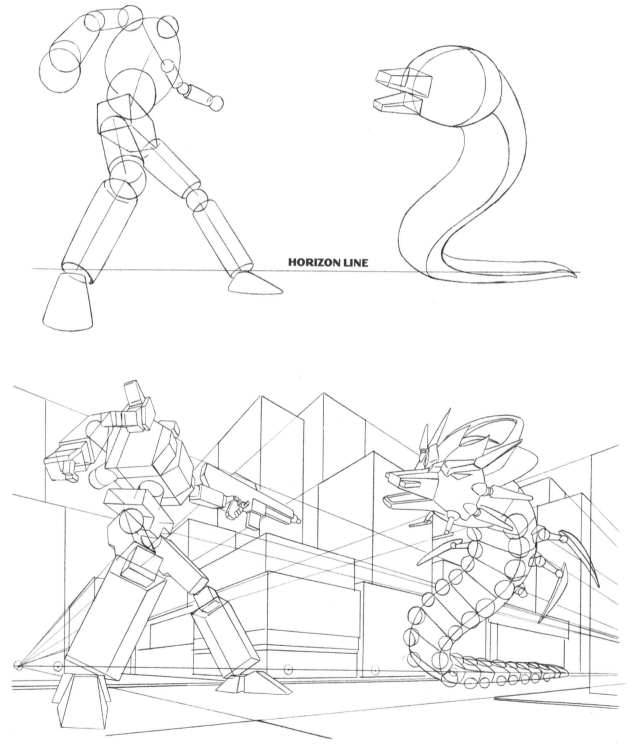

HORIZON LINE

too far in the distance), but if you draw all your lines receding toward these points, your scenes will have perspective and look three-dimensional and correct.

Positioning of the characters is important, as well. Since the robots here are giants, it's important that they completely dominate the composition. By placing them farther apart from each other, rather than close together, you get them to command several city blocks. In addition, the robot with the gun needs room to fire his weapon; and that robot dragon can probably shoot a stream of flame one hundred yards long—so he could also use the space. Note that if the armed robot were simply throwing punches at the robot dragon, a potentially awesome scene would be much more banal. When you create something out of the ordinary, treat it as something out of the ordinary by avoiding a mundane execution. (See next page for final drawing.)

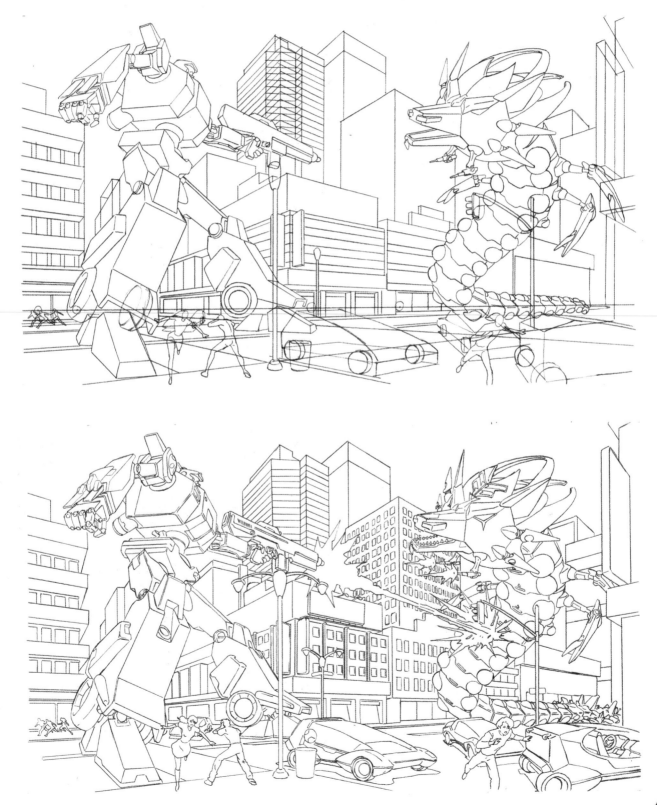

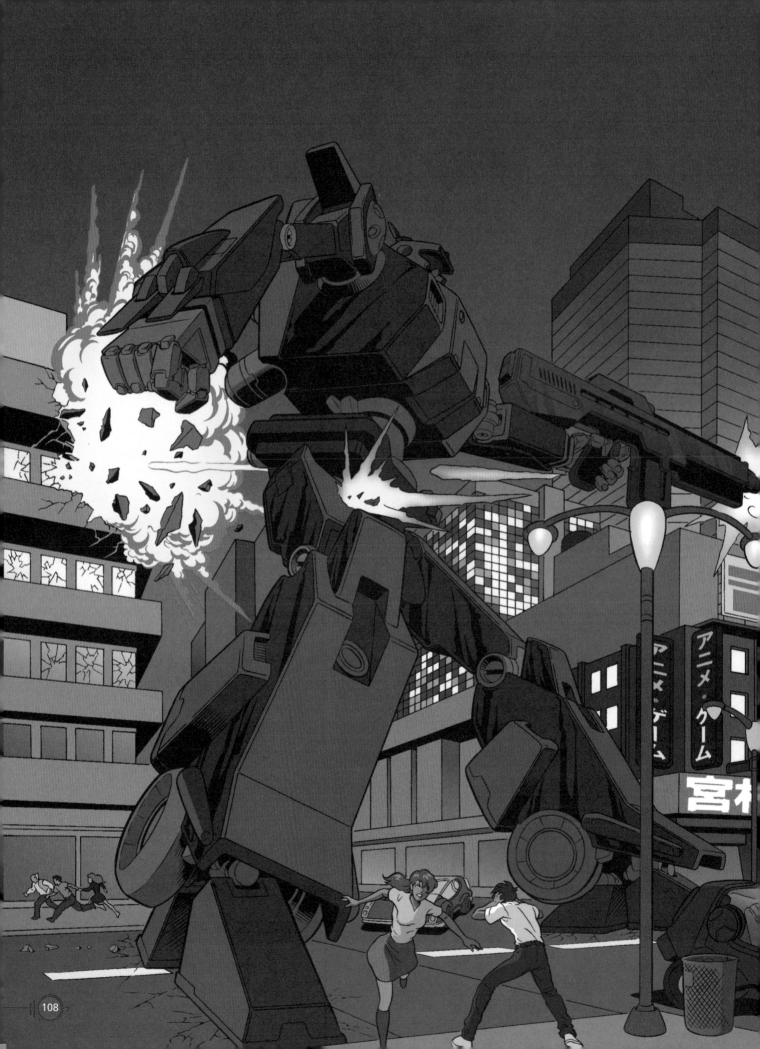

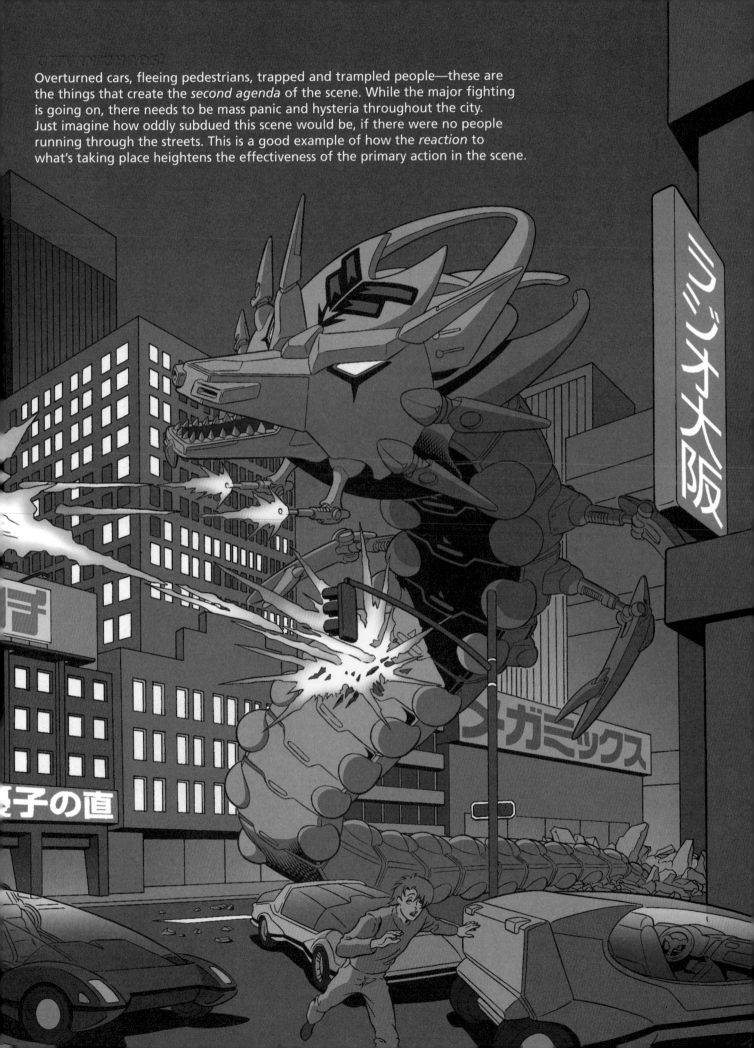

Overturned cars, fleeing pedestrians, trapped and trampled people—these are the things that create the *second agenda* of the scene. While the major fighting is going on, there needs to be mass panic and hysteria throughout the city. Just imagine how oddly subdued this scene would be, if there were no people running through the streets. This is a good example of how the *reaction* to what's taking place heightens the effectiveness of the primary action in the scene.

ULTRACOOL CARS AND BOATS OF THE FUTURE

Your manga heroes have to get around in something, and that something had better be as cool as they are.

HIGH-SPEED CRUISER

Notice that the wheels are hidden from view. While this car could be driven by the hero, it's also well suited for the villain because of its sly styling and the way it masks its occupants. Note: The faster the car, the lower to the ground it will be, and you can't get much lower to the ground than this. The extra length of the car also accentuates the look of speed. The darkened windshield signifies a villainous vehicle.

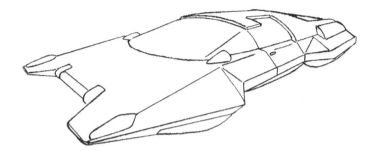

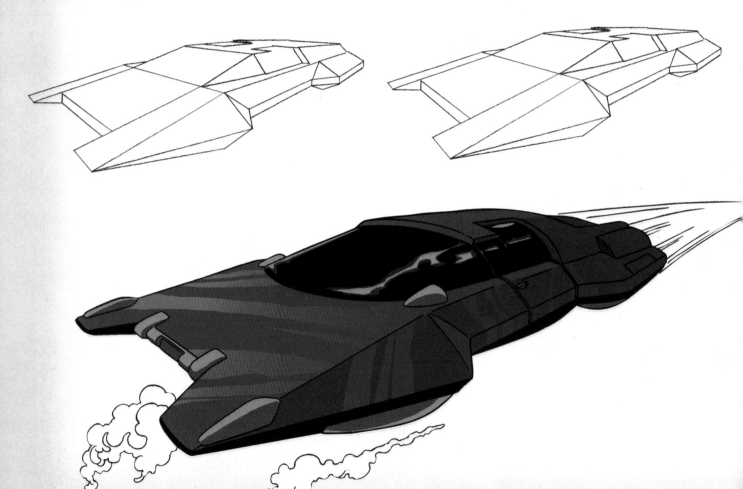

This sporty car has a long windshield that not only looks cool but also serves a function—it allows the comic book artist to fully show the main characters seated inside of the car. Convertibles also work well in this regard. Most cars have so much metal on them that it hinders the artist's ability to depict the scene well, which is why you see so many long shots of cars or close interior shots of people in cars.

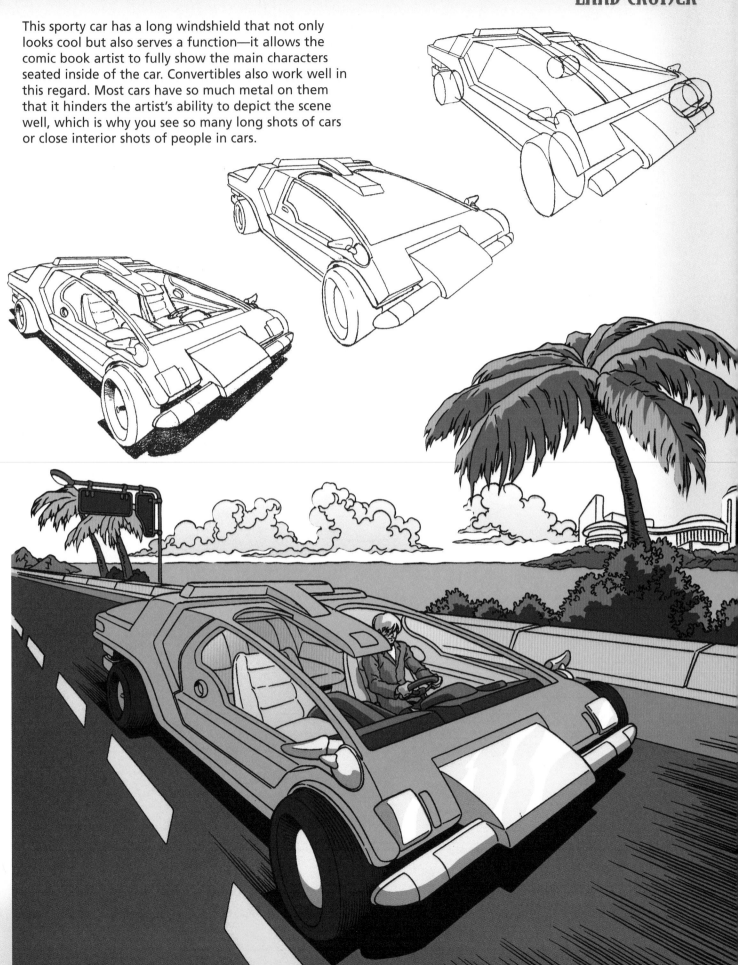

SPEED BOAT

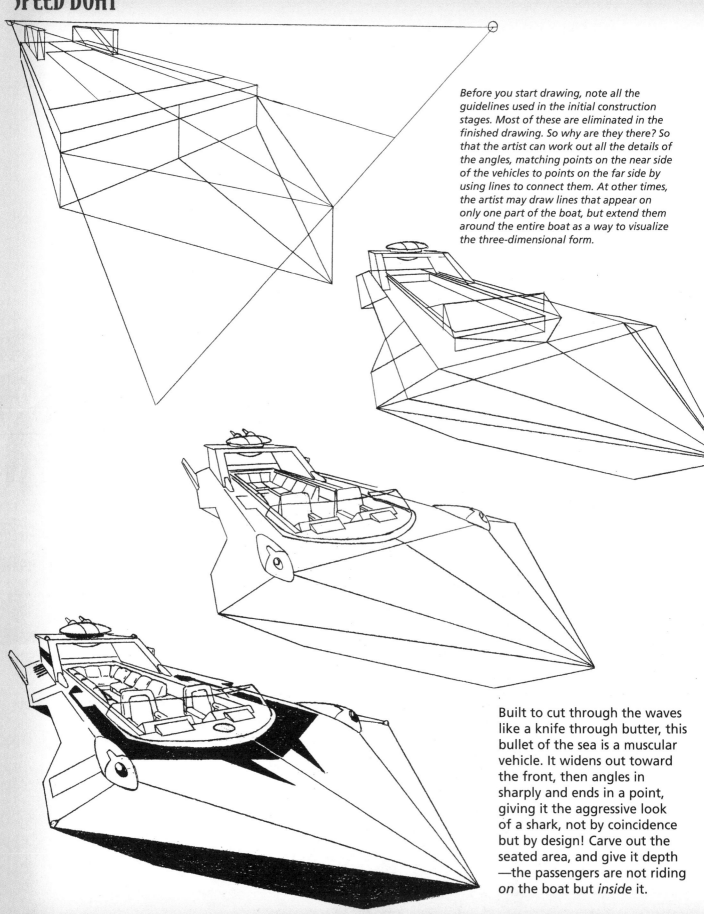

Before you start drawing, note all the guidelines used in the initial construction stages. Most of these are eliminated in the finished drawing. So why are they there? So that the artist can work out all the details of the angles, matching points on the near side of the vehicles to points on the far side by using lines to connect them. At other times, the artist may draw lines that appear on only one part of the boat, but extend them around the entire boat as a way to visualize the three-dimensional form.

Built to cut through the waves like a knife through butter, this bullet of the sea is a muscular vehicle. It widens out toward the front, then angles in sharply and ends in a point, giving it the aggressive look of a shark, not by coincidence but by design! Carve out the seated area, and give it depth —the passengers are not riding *on* the boat but *inside* it.

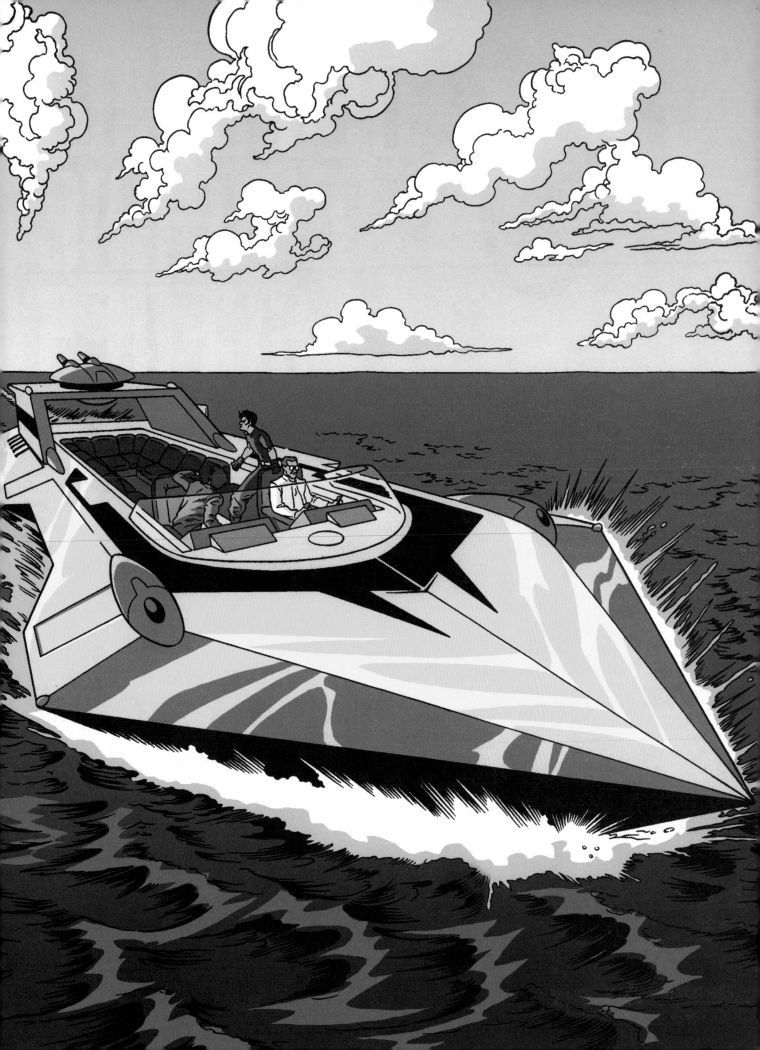

DESIGNING DYNAMIC SCENES

Now that you've gotten the specifics of drawing many different types of manga characters, it's time to cover a few basics of drawing panel-to-panel, which is the essence of comic book storytelling.

Comic book scenes are broken down into panels for several reasons:

1. To prevent the dialogue balloons from becoming overwhelmingly large.

2. To create interesting visual designs.

3. To provide a sense of pacing and rhythm.

4. To draw attention to specific aspects of a sequence of events.

5. To tell a story cinematically, from a variety of "camera" angles.

6. To avoid having to tell a story in "real time"; in other words, to be able to eliminate uninteresting parts of the story (such as crossing the street) while focusing on the essential parts.

7. To guide the reader's eye in the direction of the action. In western comics, this is from left to right, top to bottom; in manga, it's from right to left. (The front cover of a manga comic book is the back cover of a western comic book.)

Each panel *presents* a new idea to the reader, and you must decide on that presentation. Should it be straightforward, dramatic, or shrouded in mystery?

Should it be visually explosive, heavily shaded, or contain detailed backgrounds? Of course, some scenes are written in such a way that they demand a specific treatment. If an entire story is carefully crafted to lead up to the moment when a band of terrorists detonates a huge bomb in the United Nations building in New York City, then that explosion must be huge, jarring, and extreme—and it must fill the page. There's not much room for interpretation in that particular panel.

However, there are just as many aspects of story-telling that require artists to infuse the scene with their own vision and sensitivity. Think of the story as a piece of music. As the artist, you decide when to turn up the volume, punch up the bass, or tread softly. We've all seen comics by artists who haven't bothered to change the panels much, and the result is a big yawn. When you begin to draw a panel, ask yourself, What mood am I trying to convey? What's the best way to convey it? How close should I let the reader get to the character at this moment? Should they see him from the front, from behind, or from an angle? You might introduce a straight-shooter type character in a frontal shot, because he's got nothing to hide; whereas you might introduce a villain in the shadows, his back to the reader. Whatever you're trying to communicate, underscore it with the design of the panel.

A

B

C

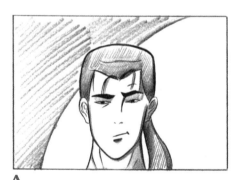

D

E

F

THERE'S MORE THAN ONE "HEAD SHOT"

Panel A represents what most of us think of as a head shot. But, is that the only head shot, or even the best one? If you take a look at panels B through F, you'll start to appreciate that it's not just what you draw that counts but how you present what you draw.

DON'T SAY IT—SHOW IT!

Japanese comics are meant to be read quickly, the panels guiding the eye, uninterrupted, from moment to moment. Allow the pictures to tell the story whenever possible. Cut down on unnecessary text, and let the expressions and actions explain the state of mind of the characters.

WESTERN STYLE	MANGA STYLE

INTENSITY

GRIEF

FURY

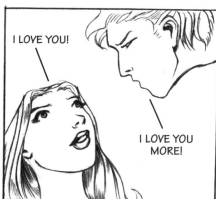

ROMANCE

SPECIAL EFFECTS AND PANEL DESIGN

Manga special effects, and especially the special effects in shōjo manga, go far beyond the speed lines of western-style comics. The inner thoughts and emotions of characters burst forth, festooning the panels with flowers, petals, stars, swirls, and more. Use these effects as you would any spice: sparingly. If every other panel teems with hearts and flowers, the effect will lose its impact.

SUNBURST
Denotes an intense moment of thought—perhaps, a wicked thought.

FLOATING ROSES
Indicates a romantic moment.

CONFUSION BUBBLES
Represents a "double take"—a moment when a character is baffled.

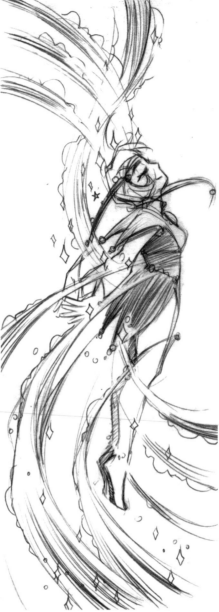

SWIRLING LINES
Denotes the enchanted nature of a character or a moment. Swirling lines and shapes trail the character like the tail of a comet.

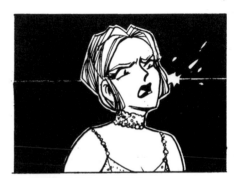

SURPRISE LINE
Used to show shock.

BURSTS OF LIGHTNING
Indicates scheming.

FLOWER PETALS
Indicates a thoughtful moment.

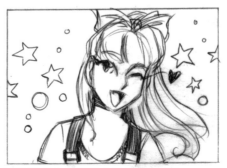

STARS AND PLANETS
Represents joy and happiness.

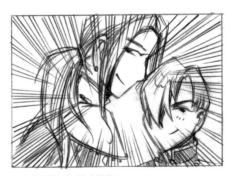

SPEED LINES
Speed lines traveling toward the center of a panel, add emphasis to the panel.

BASIC COMIC BOOK SHOTS

In order to transform ordinary events into comic book *moments*, you need to choose shots (panel views that make up the scenes) that are best suited to conveying the drama of the plot. Here are the basic shots used by all the comic book pros.

HORIZONTAL ESTABLISHING SHOT

This is a long shot. It shows the surroundings and is not good for conveying action. It's often used at the outset of a scene and establishes the setting. You can also use it in the middle of a scene to reestablish the spatial relationships between the characters, after a lot of cutting back and forth between close-ups has occurred.

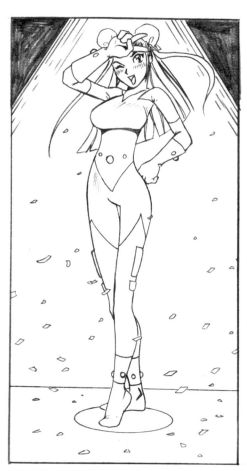

GROUP SHOT

This is especially important for "team hero" comics, as it reinforces the members of the group to the reader. Make sure to vary the closeness of the characters to the reader and stagger them unevenly in the space to avoid monotony.

FULL SHOT

Use this shot to bring the focus onto one character, giving him or her added importance. For example, perhaps the character has something important to say that will move the story ahead dramatically at this moment. You can also use the full shot to isolate a character. For example, suppose a group of characters is discussing who among them betrayed them, and suddenly, you cut to a full shot of one character. Not another word is needed to tell the story.

MEDIUM SHOT

If you use only full or establishing shots, your reader will never bond with the characters. You could zoom all the way in close, but often, you still need to leave room in the panel to show an action. This is the perfect time for a medium shot, which brings readers intimately close to the characters but also allows room for the story to progress.

BASIC CLOSE-UP

You don't have to fit the entire head neatly within the panel; often, it's more effective to bring the head in a bit closer to the reader and cut off part of the forehead.

EXTREME CLOSE-UP

This is an excellent shot to use to convey intensity and wake up the reader. Although the ECU (extreme close-up) usually features a character's eyes, it could just as easily focus on the mouth, a single eye, or half the face cut down the middle vertically.

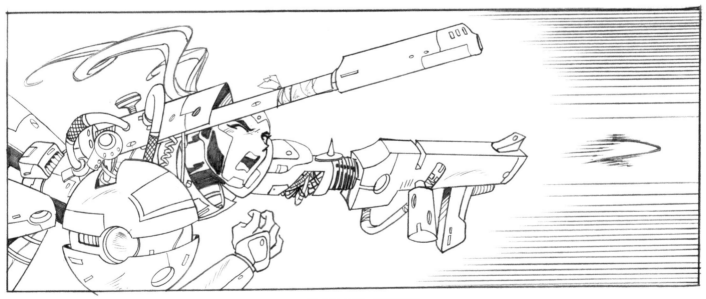

DETAIL SHOT

A detail shot eliminates the unimportant stuff and focuses the reader's attention on a specific thing in a story—in this case, a gun. For example, a detail shot could show a phone ringing if someone's awaiting a life or death decision, or a computer keyboard if an important code is about to be broken.

USING PANELS EFFECTIVELY

Don't let yourself be tyrannized by the comic book panel. It's not a jail within which your characters must remain. It's a device to focus attention on each individual sequence, that's all. If you never break a panel border, your pages will become too blocky and predictable. Your characters must dominate the panels, not the other way around.

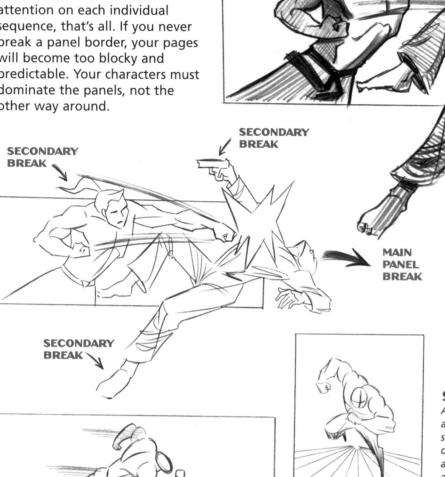

SECONDARY BREAK

SECONDARY BREAK

SECONDARY BREAK

MAIN PANEL BREAK

BREAKING THE PANEL BORDERS

Although it's common for artists to break panel borders to enliven a scene, it's especially useful if breaking the borders also furthers the action of the scene. In this example, a man is literally knocked out of the panel by a punch. The force of the punch feels that much greater because it sends the victim reeling "out of bounds." There are also secondary breaks in the panel sides, which are more artistic choices than they are strategic design devices.

SIDE VIEW VS. FRONT VIEW

At first glance, it seems to make sense to draw a character running from left to right in the side view. But this view doesn't make use of depth. Facing forward, the character now appears to be running straight at the reader, and as a result, the urgency of the scene is considerably greater. Additionally, lines on the ground can now recede into the distance, again making the panel more dynamic.

MATCHING THE PANEL SHAPE TO THE ACTION

When you have a character make a committed action, in any direction, it's important to consider how to frame the figure within the comic book panel. The first impulse often is to create a very spacious panel so as not to interfere with the action, but that approach may instead rob the action of its impact. Consider the following: Which looks faster—a race car moving at top speeds through a narrow band of track, or a race car driving fast over open terrain? The car barreling through the narrow track, of course. When confined, the action becomes more powerful and dramatic. The same principle applies for comic book action scenes.

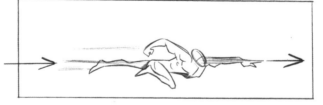

In the approach above, the panel shape mirrors exactly the direction of the movement, and it narrows the path of action. This reinforces the idea and feeling of speed, and you could fill in the background with colorful blur and speed lines to great effect.

In the approach at right, the character still travels horizontally, but the shape of the panel is more vertical. The feeling of this scene is not so much one of speed as it is of flying, high off the ground, through space. Skyscrapers would work well in the background, but the speed of the scene is not emphasized.

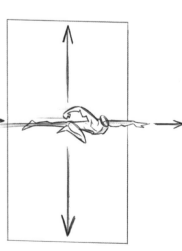

DYNAMIC HORIZON LINE PLACEMENT

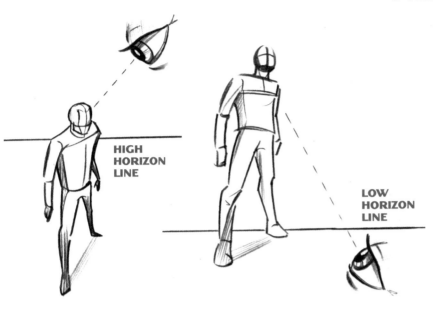

HIGH HORIZON LINE

LOW HORIZON LINE

The horizon line is the place where the ground meets the sky. On interior shots, it's the place where the ground would meet the sky if we could see it through the building. In shots in which there's no visible ground, it falls wherever the readers' eyes would be if they were viewing the scene; the reader would, therefore, be looking up at anything that's above the horizon line and looking down at anything that's below it. (The scene is drawn from the reader's point of view.)

As the artist, you can put the horizon line anywhere you like. If you place it high in the panel, the reader will be looking *down* on almost everything. If you place it low in the panel, the reader will be looking *up* at almost everything.

ASYMMETRY

It's usually best to avoid symmetry, which is calming, predictable, and uninteresting. A horizon line that cuts exactly through the halfway point of a panel creates two symmetrically shaped sections within that panel. Instead of doing this, establish a horizon line that divides the panel into uneven, asymmetrical sections.

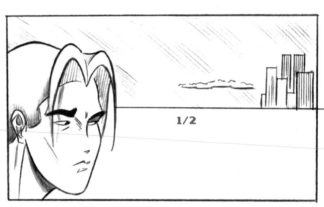

1/2

DRAMA

Your panels will be more dramatic if your characters stand against a big sky.

low horizon line creates a big sky

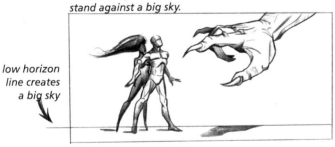

higher horizon line creates a smaller sky

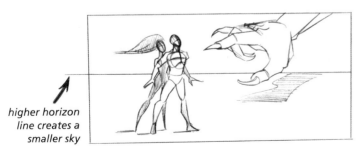

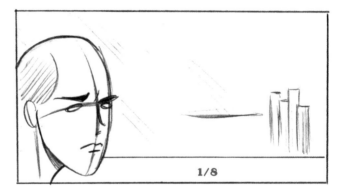

1/8

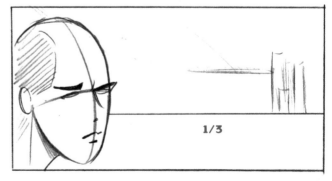

1/3

FOCUSING ATTENTION WITHIN A PANEL

Not everything in a panel is of equal importance to the story, nor should it be. As the artist, you must create *moments* in the story—things that register in the reader's mind. This can, of course, be accomplished with good story writing. But, just as a superior director can turn a good screenplay into a great movie, an illustrator can turn a good comic book scene into an outstanding sequence with a few effective visual choices. Here are some hints:

Don't place the object of focus too close to the body or it may become lost in (or near) the silhouette of the body.

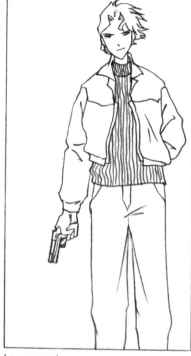

Leave empty space around the focal point of the panel, in this case, the gun.

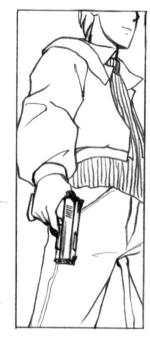

You can overlap the gun with the body if the hard, metallic shape of the gun will contrast with the soft shapes and textures of the clothing.

Divide the panel into thirds horizontally and vertically, and place the focal point on one of the points where the lines intersect for maximum impact.

Cut off unnecessary elements within the panel.

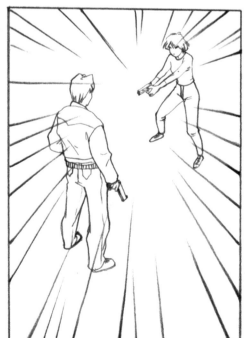

Use speed lines to direct the reader's attention to the center of the panel.

Enhance the foreground with a close-up detail of the gun.

Enhance the background with a tone.

Use strong silhouettes, contrasting tones, and values to add interest.

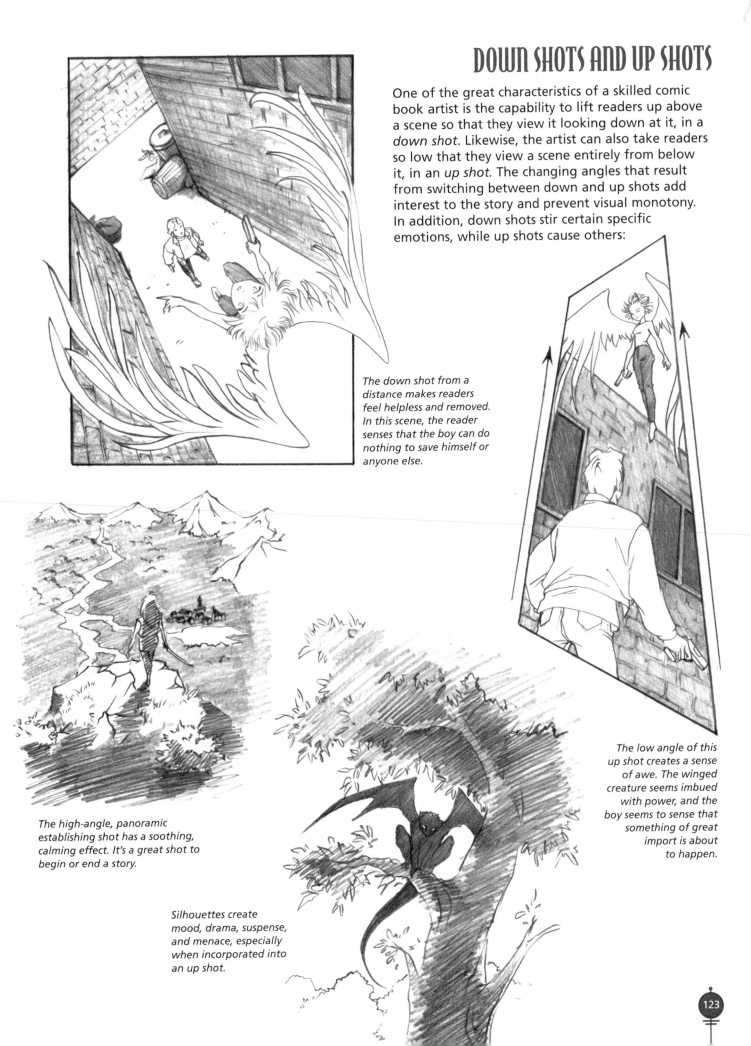

DOWN SHOTS AND UP SHOTS

One of the great characteristics of a skilled comic book artist is the capability to lift readers up above a scene so that they view it looking down at it, in a *down shot*. Likewise, the artist can also take readers so low that they view a scene entirely from below it, in an *up shot*. The changing angles that result from switching between down and up shots add interest to the story and prevent visual monotony. In addition, down shots stir certain specific emotions, while up shots cause others:

The down shot from a distance makes readers feel helpless and removed. In this scene, the reader senses that the boy can do nothing to save himself or anyone else.

The low angle of this up shot creates a sense of awe. The winged creature seems imbued with power, and the boy seems to sense that something of great import is about to happen.

The high-angle, panoramic establishing shot has a soothing, calming effect. It's a great shot to begin or end a story.

Silhouettes create mood, drama, suspense, and menace, especially when incorporated into an up shot.

STRINGING PANELS TOGETHER

By now, you're not only thinking in terms of creating interesting characters, but also how to present them within a panel. Now you need to start thinking about how to tell a story from panel to panel—how to string a series of panels together. Here are two techniques that will help:

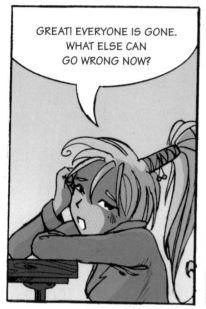

CUTTING IN WITHOUT CHANGING THE ANGLE

This is generally done when there isn't much action in a scene. It focuses attention on a character's state of mind, bringing readers closer as the thoughts grow more profound. You can also use the technique to reveal something that can't be seen from a distance. As you cut in closer, be sure to add more detail to the character.

CHANGING ANGLES AS YOU CHANGE PANELS

Sometimes you change angles to create excitement and to stir things up. Changing angles between panels adds energy to a scene. It reveals different things about the character. It also keeps the audience alert and involved.

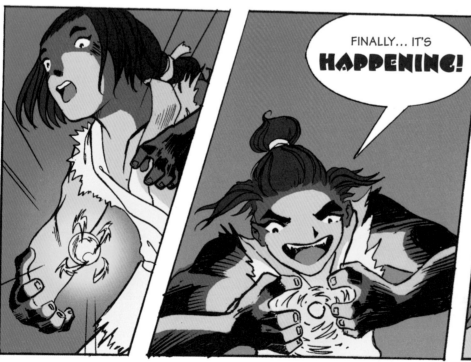

Imagine that you have a fight scene between a heroine and a monster. Further imagine that the following scene shows a reporter being chewed out by her boss. You could draw the first scene to completion and follow it by the second scene. Or, you could intertwine the scenes so that they are occurring simultaneously. By cutting back and forth between the scenes, you link them together and introduce the *ticking clock* element, meaning that time becomes of the essence.

COMMON JAPANESE TERMS

女男家歩上の朝中夜向真

Here are a few pages of essential Japanese words and phrases that you'll need as both a tourist and a manga artist.

COMMON JAPANESE TERMS FOR MANGA FANS

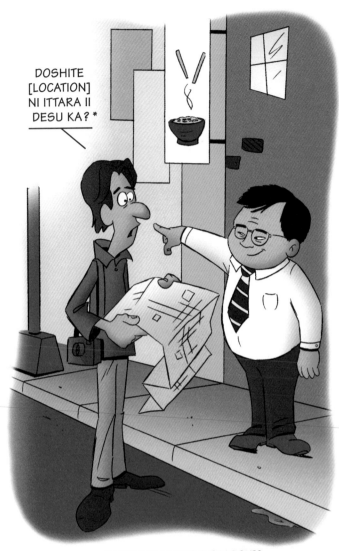

DOSHITE [LOCATION] NI ITTARA II DESU KA? *

*HOW DO I GET TO [LOCATION]?

More and more, comic book artists are going abroad to attend important comic book conventions. These cross-cultural exchanges promote a deeper understanding of each nation's artistic tastes, styles, and trends. In addition, they allow artists to broaden their circles of professional contacts, which may result in new opportunities and career paths. As a manga artist, you'd be well advised to consider, at some point in your career, visiting Japan. But whether you do so for business or pleasure, a visit to the Mecca of the manga world would give you firsthand exposure to the culture represented in the comics you love to draw.

Of course, if you are to explore Japan, you'll need to be able to communicate. It's not like visiting many European cities, where just about everyone speaks English. It's hard to find an address if you can't ask where it is. You also have specific needs as an artist. You may not find a Japanese/English dictionary that has the key words of interest to comic book illustrators. In addition, when you meet guest manga artists from Japan, who are speaking at conventions in the USA, it will no doubt impress them that you have taken the time, and are interested enough, to be able to communicate some ideas in Japanese.

SOME WORDS YOU SHOULD KNOW
SHŌJO = GIRLS (refers to manga comics read primarily by girls)
SHŌNEN = BOYS (refers to manga comics read primarily by boys)
SEINEN = YOUNG MAN (refers to manga comics read primarily by young men)
OTAKU = has come to mean an enthusiastic MANGA FAN or AFICIONADO, overcoming most of the negative connotations it once had in Japan
SHUPPAN-SHA = PUBLISHER
ORI KA BAN = PORTFOLIO
MANGA-KA = MANGA ARTIST
E NO DO GU = ART SUPPLIES
HENSHU-SHA = EDITOR
TOKO = SUBMISSION
SHIGOTO = WORK

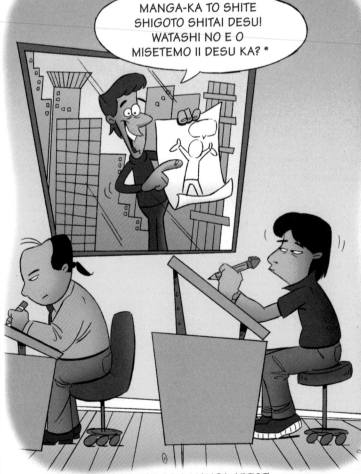

MANGA-KA TO SHITE SHIGOTO SHITAI DESU! WATASHI NO E O MISETEMO II DESU KA? *

*I WANT TO GET A JOB AS A MANGA ARTIST! MAY I SHOW YOU MY DRAWINGS?

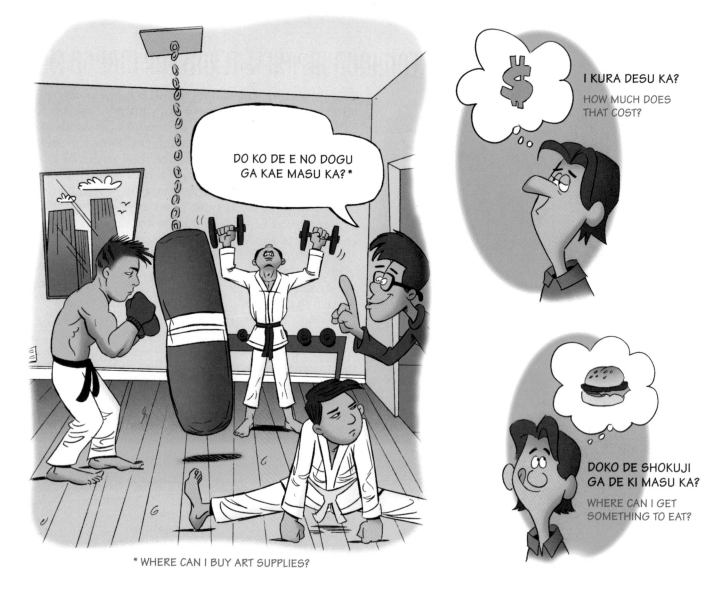

DO KO DE E NO DOGU GA KAE MASU KA? *

* WHERE CAN I BUY ART SUPPLIES?

I KURA DESU KA?

HOW MUCH DOES THAT COST?

DOKO DE SHOKUJI GA DE KI MASU KA?

WHERE CAN I GET SOMETHING TO EAT?

MORE WORDS YOU SHOULD KNOW
SAYONARA = GOOD-BYE
DOMO ARIGATOU = MANY THANKS
DENWA BANGO = PHONE NUMBER
CHO SHO KU = BREAKFAST
CHU SHO KU = LUNCH
YU SHO KU = DINNER
SHOKUJI = MEAL

DEN WA BANGO O KO KAN SHIMA SHO! *

* LET'S EXCHANGE PHONE NUMBERS!

CHIPPU O IKURA HARAABA II DESU KA? *

WATASHI-TACHI NO SHASHIN O TOTTE ITADAKE MASU KA? *

*HOW MUCH SHOULD I TIP?

*WOULD YOU TAKE OUR PICTURE?

OTE A RAI WA DO KO DESU KA?

WHERE IS THE BATHROOM?

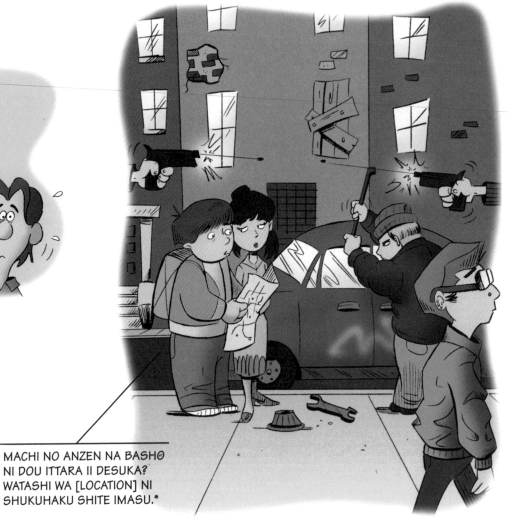

MORE WORDS YOU SHOULD KNOW

HAI = YES	
IIE = NO	
ITSU = WHEN	
ITAI! = YEEOOWCH!	
SUGOI = COOL	
KISHA = TRAIN	
GEKIJO = THEATER	
RYOKAN = INN	

MACHI NO ANZEN NA BASHO NI DOU ITTARA II DESUKA? WATASHI WA [LOCATION] NI SHUKUHAKU SHITE IMASU.*

*HOW DO I GET BACK TO THE GOOD PART OF TOWN? I'M STAYING AT [LOCATION].

SO YOU WANT TO BE A CARTOONIST?

As you grow as an artist, you'll recognize the considerable talent required of cartoonists in all fields. It can only improve your stature to be able to cross over and draw in a number of different styles and venues. This will also expand your network of professional contacts and bring in more income and job security. Cartoons and comics are the most popular visual art form today. They're used in innumerable ways. It's my hope that this chapter will give you a glimpse of some career opportunities that you may not have considered, simply because you didn't know they existed.

MAJOR POSITIONS: THE MOST COVETED JOBS IN COMICS

COMIC BOOK PENCILER

INKER

WRITER

EDITOR

COVER ARTIST
(usually only big names get to specialize exclusively in covers)

PUBLISHER
(corporate or self-published)

Within the field of comic books, there are many different occupations. Sometimes these complement each other or even overlap, as when a comic book illustrator launches his or her own comic book and becomes the writer as well as the artist. Other positions, rarely cross over; a comics editor rarely becomes a penciler, for example. Still others, such as computer colorist, often cross over to completely different fields, like advertising, web design, and multimedia.

SUPPORT POSITIONS

These flesh out the work of the major positions. Although they are important careers in and of themselves, they can also serve as springboards to the major positions.

- COLOR COMP ARTIST (does the initial color schemes in marker or watercolors, then sends them to the computer colorist to match)

- COMPUTER COLORIST

- COVER COORDINATOR (does artistic retouching where needed, adds titles and logos)

- LETTERER (nowadays, lettering is almost all done on computer; letterers create their own font, which is considered a piece of art and which they then own)

- ASSOCIATE EDITOR

- PROOFREADER

- TRANSLATOR/EDITOR (for manga imports)

OTHER FIELDS

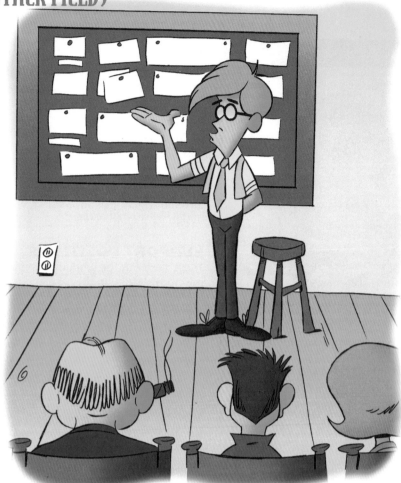

Who hasn't, at some point, wanted to be a *comic strip artist*? I was watching a recent interview with actor Tom Hanks who, when asked what he would have done if he could have done something other than acting, said he would have wanted to be a cartoonist. My guess is that he was thinking about comic strips. Comic strips bring cheer to readers. They're highly regarded and seen by vast audiences. And while the competition to get syndicated is considerable, the financial rewards can be immense. Character licensing can earn a comic strip artist more than the comic strip itself.

Little or no art training is required to be a comic strip artist. That is not meant to say that art training will be a negative. And many comic strip artists are well schooled. But a kooky, primitive style can find a readership in the comics pages more easily than in any other cartoon art form, aside from humorous illustration.

Not everyone creates his or her own comic strip; sometimes people partner, forming a writer-artist team. Artists sometimes join established comic strips, and most major strips buy material from freelance gag writers. But the dream of the comic strip artist—to launch an original strip—remains unshakable. Although the odds are daunting, it's always *possible* to become syndicated. In fact, many of the most popular comic strips were created by people who were little known before their seemingly overnight success—people such as Scott Adams of *Dilbert* fame, Cathy Guiswite of *Cathy*, Gary Larson of *The Far Side,* and Bill Watterson of *Calvin and Hobbes,* although Watterson did a stint as a newspaper editorial cartoonist prior to his syndication with *Calvin and Hobbes.*

ANIMATION

Many comic book artists cross over to animation because many animated television shows are based on comic book characters—and this is especially true of manga. TV animation is experiencing a period of soaring popularity and shows no sign of slowing down.

As *animators*, comic book artists have an edge when drawing the human figure; animators who aren't highly trained sometimes have difficulty drawing realistic, non-cartoony figures. Animators are usually more comfortable with flowing, sweeping linework. Comic book artists, who typically draw the figure from new angles in each comic book panel, may find animation tedious. They may also have trouble drawing action sequences from beginning to end; while comic book artists can draw a good punch, animators must be able to draw every sliver of the entire motion, from wind up to punch to follow-through to settle-down. Most comic book artists aren't as versed in the nuances of action as animators.

There are, however, many other important jobs in the field of animation, other than that of animator. The illustration above shows a typical pitch meeting with a *storyboard artist* showing the producers and director his vision for an animated sequence. Storyboards are like comic book pages in that they take the written dialogue of the script and break it down into rough drawings showing the progress of the action from shot to shot. Every animation studio needs several good storyboard artists. It's an appealing position because it combines art and storytelling but doesn't get bogged down in the mechanics of animation per se. Many comic book artists have made the smooth transition to storyboarding with great success.

Other positions in animation are: character designer, layout artist (the layout is a tight version of the storyboard, with precise camera moves included—good draftsmanship is essential), production designer (the art director for an animated film), background painter, computer animator, writer, director, producer, and animator's agent.

EDITORIAL CARTOONS

Not only do major, medium-size, and even smaller newspapers use editorial cartoons to attract readership, but many newspapers, magazines, and e-zines also run collections of their best editorial cartoons of the week. As an *editorial cartoonist,* you must have a sophisticated style; a sharp, critical sense of humor; and enjoy politics and controversy. It's also very important that you can be funny under intense deadlines and draw caricatures.

Editorial cartoonists associate themselves with a particular newspaper, which brings camaraderie and professional stature (depending on the newspaper). They're eligible for the heady Pulitzer Prize, and many have won it. Being on staff at a newspaper also brings security in the form of benefits like health plans and 401(k)s. Many newspapers allow their cartoonists creative freedom, wherein the cartoonist may take a view in opposition to the Op-Ed piece with which it is coupled. In addition, the exposure that their work receives plus the experience working under the pressure of newspaper deadlines, make editorial cartoonists excellent candidates for becoming syndicated comic strip artists, and many have done this, like Jim Borgman, co-creator of the *Baby Blues* strip and author of the *Zits* strip.

There's an obvious potential for vertical mobility as an editorial cartoonist, since you can always leapfrog to a paper with greater circulation. It's important to get onto any paper of any size and keep working your way up.

CHARACTER LICENSING

There's a tremendous amount of demand for artists who can draw established characters. *Animators* and *comic book artists* are particularly good at this because they draw other people's characters as part of their job. This is an important division for film and publishing companies. In fact, I've heard reports that some big-name comic book publishers are producing comic books solely to keep their more lucrative licensing divisions active. There's also a variety of positions within this field. For example, people who excel may be promoted to *manager of licensed art,* screening and hiring new artists, and guiding them to "stay on model" (accurately portray a character as it is meant to be drawn).

Michael Horowitz, a character art manager for one of the largest animation studios in Hollywood, notes that people who like to do sculpture are also needed in character licensing. Sculptures are provided as models for the illustrators, to give them the three-dimensional feel for the character that they cannot get from a model sheet. *Sculptors* must also be aware of breakage points—weak links in a toy's design that are liable to break when handled. Child safety is always an important consideration. Horowitz notes that many aspiring artists aren't even aware these departments exist until they begin to explore opportunities in animation and are subsequently recruited to these positions by the studios.

HUMOROUS ILLUSTRATION

Humorous illustration is a general term that includes magazine spot gags and greeting card art. Apart from the major magazines that feature cartoon spot gags, there are many specialty magazines, newsletters, and e-zines that all need cartoons. *Humor illustrators* usually only sell "first time rights" to their work and, therefore, can resell the same cartoon many times to separate publications. Some cartoonists earn their living doing this exclusively, but it takes a very organized person who can continue to submit and resubmit spot gags on an ongoing basis. More often, cartoonists use this market as a supplement to other work.

One of the most popular forms of humorous illustration is greeting cards. Greeting cards can establish an artist and his or her particular style, since greeting cards tend to be more cutting edge than the average cartoon. Whereas in comic books and animation it's important to be able to draw someone else's character, in greeting cards it's important that you establish your own unique style and sensibility. A good design sense and a gift for visualizing gags are very important. Many greeting card companies buy from freelancers, in addition to having full-time on-staff artists. Greeting cards generally pay advances and royalties, so popular cards can continue to spin off revenue for months after they've been created.

COMPUTER GAMES

It's a fun job, but somebody's got to do it. Perhaps you've got the Peter Pan Syndrome: You never want to grow up. If you want to "play" all day, consider working in computer games. The electronics industry is a youth-oriented, hip business, and their graphics are edgier than other fields.

ADVERTISING

Most *advertising art directors* I've known can't draw. I don't mean that as a criticism of their drawing style, I mean that they *can't draw*. They're like directors who tell actors what to do. As they say, it's good to be the king. Advertising is an intensely competitive, high-pressure business. If you thrive on adrenaline, it may be a good fit.

Advertising agencies generally have no use for people who draw by hand, instead requiring their creative staff to be well versed in many different computer programs, which are constantly being upgraded. If you like to draw, it may be a better idea to use an *art rep* to sell your work to advertising agencies, which generally outsource hand illustration, meaning that they subcontract work out project by project. Art directors at top agencies make buckets of money.

TOY DESIGN

Toy companies are always searching for talented *concept artists* who can flesh out ideas from initial sketch to tight rendering. These days, toy companies are focusing more and more on character licensing. In fact, in many of the new toy launches, the toys are merely thought of as delivery systems for licensed character art. Toy industry professionals believe they get more bang for their buck offering recognizable characters than they do taking a chance on introducing new, untested, original toy characters. Nonetheless, there are still companies that put out lots of original product.

BOARD GAMES, PAPER GOODS, GIFT ITEMS

There are many novelty, board game, and gift item companies that need a lot of cartoons and illustration work. Many of these companies do almost all their business in the fourth quarter of the year, starting with Halloween and ending with Christmas, for which each product must be illustration-heavy. Visit the TMA (Toy Manufacturers of America) website (www.toy-tma.com); also check out toy and gift show conventions in a city near you.

CHILDREN'S BOOK ILLUSTRATION

Despite what you may assume and what would seem like a natural match, publishers generally *do not* use cartoon-style art to illustrate children's storybooks. They fear that it looks too much like licensed art. In addition, they're usually looking for something less conventional.

Artists most often get illustration jobs in children's publishing (*illustration* here includes paintings) through artist's reps specializing in *juvenile publishing*. You can also contact publishers directly by sending them samples of your work and following up every three to six months with a phone call or some additional samples by mail.

CORPORATE ILLUSTRATION AND STOCK ART

Wanna make lots of money as an illustrator? Corporations are well funded and pay handsomely for graphics to enhance the look of their annual reports, printed matter, corporate identity, and advertising. Getting assignments from corporations is best handled by an artist's representative. Look up key words "artist's rep" on the internet to find pertinent sites.

Corporations also buy stock art from stock art houses, which sell and resell (rent is probably a more accurate term) works of various artists. This work generally has a painted look or a very stylized ink line. But more and more, cartoon work is finding its way into stock art libraries. Look up key words "stock art" on the internet to browse the type of styles most used. Stock art also pays very well.

NETWORKING

An important element in any career development is networking. I cannot stress enough how important it is to maintain existing personal contacts and develop new ones. Take advantage of every opportunity to socialize (you wouldn't want to turn down a party, anyway), and make a point of knowing most of the people in the room and their function in their industry. And, of course, encourage them to know the same about you.

A great place to develop skills and relationships is at trade organization meetings. For example, the primary group in the theme park industry is TEA, Themed Entertainment Association at www.teaonline.org. Joining and participating in a group like this will allow you to hobnob with all sorts of heavyweights in an industry. Often, meetings are held at member's facilities, so you'll be able to get additional inside views.

The emphasis here is learning how a business operates, and who's operating it. Keeping your name (and often your face) in front of many different people can lead to unexpected opportunities. Being in the right place at the right time is important, and the more right places you can find, the better your chances of a breakthrough.

THEME PARK DESIGN

The top-notch theme parks of the world are a marvel to behold. They're almost like miracles, the equivalent to walking into a storybook. When you look at a well-crafted theme park (as opposed to an amusement park, which offers thrills and rides but not the total experience of a self-contained land of wonder and fun), it's hard to comprehend it all. Every detail supports the enchanting overall experience. The operative word is *detail.* Everything, from the way the trash cans are designed to the directional signs to the way the music speakers are camouflaged, is given great thought and effort. Everything is used to create a magical mood for the visitor.

While there are many brilliant theme parks, it's impossible to discuss the subject without mentioning the master of them all: Disney. If you want to really see the artistry involved in designing theme parks, look at the surroundings at the Magic Kingdom rather than at the rides. A stroll down Disney Land's Main Street USA reveals buildings designed and built at a smaller-than-normal scale, creating a more intimate feel as well as storybook charm. It's an important artistic decision that only reaches the visiting public on a subconscious level. I remember, on my first visit to Switzerland, looking around at the impressive architecture and commenting to my wife that it looked just like Fantasy Land at Disney's Magic Kingdom. She reminded me that it was Fantasy Land that looks like Switzerland, to which I replied, "Yeah, but Disney does it better."

Joe Lansizero, who designs rides and theme parks for Walt Disney Imagineering (the theme park division of The Walt Disney Company), began his career as an animation artist but decided to branch out when the opportunity arose. He's now in charge of running the company's Tokyo theme park. As this proves, designing theme parks is not the sole province of engineers. Cartoonists are very much in need, for it's only by their talents (and those of other artists) that amusement parks are transformed into total theme experiences.

Bob Konikow, who has worked extensively in developing major theme parks and has a background in producing animation and multi-media, offers valuable advice to the newcomer: In any field, the best game plan is to get to know that industry as well as possible, preferably from the inside. Find your friendly local theme park design company and make yourself available for any (yes, I mean *any*) job that comes along. Most companies prefer to promote from the inside, and even if your starting job has no artistic value at all, at least you have your foot firmly planted in the door. If you're as good as you say you are, your artistic talents will become obvious soon enough.

The theme park industry is exciting and fickle. There are many character-design and graphic opportunities around, but they can be very elusive, and tracking them down can be an art in itself. But the rewards can be worth it, and seeing one of your characters on the front of a roller coaster is a thrill you won't soon forget.

To get a behind-the-scenes look at the latest trends in the Japanese publishing world, you've got to go to a publisher of Japanese comics. And that's just what I've done here.

Cover art for an America Extra Graphic Novel, Fushigi Yûgi, The Mysterious Play, Vol. 1: Priestess, story and art by Yû Watase

Viz Communications is a major publisher of manga comics and magazines. The people at Viz have their fingers on the pulse of the comics fans in Japan; they're keen to note the latest trends in Japan and bring them over to the United States months, if not years, ahead of the pack. Go to your local comic book store and ask for manga, and chances are, you'll find rows of Viz comics. Therefore, it's with great pleasure that I bring to you the insights of Bill Flanagan, editor-in-chief of *Animerica Extra* magazine at Viz, who has been gracious enough to grant an exclusive interview for this book.

Chris Hart: Bill, why don't you tell us something about Viz and a few of the titles that you've worked on.
Bill Flanagan: Viz is the fifth largest comics distributor in the United States, which is interesting because we only distribute licensed comics from Japan. We find interesting comics that have been published in Japan, and as you probably know, Japan has a huge thriving comics industry. We find popular titles there that would also become popular titles here. Then we acquire the license for those titles; we translate them.

Generally we have to do a thing which is called "flopping," which is taking the artwork—because in Japan the artwork reads from right to left—[and flopping] it so that it reads left to right. Sometimes there are problems with that—for example, with baseball comics that would have the runners running to third base on a base hit! So we don't do a lot of that, but in most cases, it's the best way for an American to read it because it's the most natural.

And there are certain comics that we do unflopped. *Dragon Ball* is a series we do unflopped. Our *Evangelion* series is also done two ways, one flopped and one unflopped version. Since that one is a big fan favorite, we do it both ways because there are fans who feel it's more pure if they read it the same way that they would have read it in Japan.

CH: How did you come to work at Viz Comics?

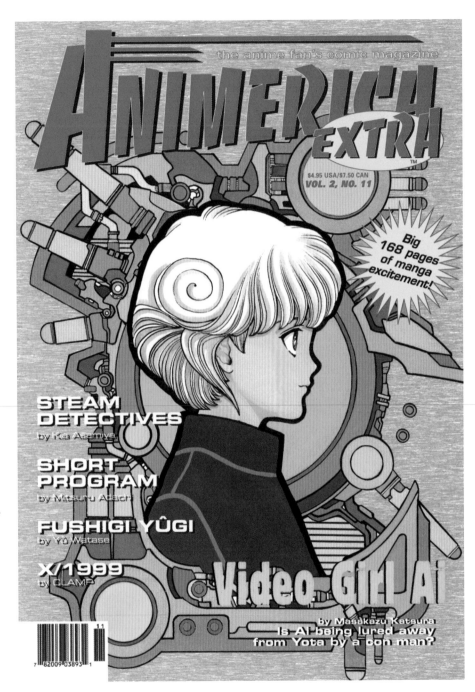

BF: I've been doing freelance translations for about a decade. Over the course of it, I've worked freelance doing manga and anime translations—I've probably translated about 200 different video titles that are on the shelf in places like Blockbuster. I also did about seven or eight manga series. And about two years ago, one of my contacts at Viz, because I had been doing freelance translations for Viz, my contact here said there was an opening for an editor.

CH: What does translating comics from one culture to another entail?
BF: For one thing, there are comics that probably won't translate well. There's one comic in particular that is wildly popular in Japan, but it's based on local areas and customs that everyone in Japan would know but nobody

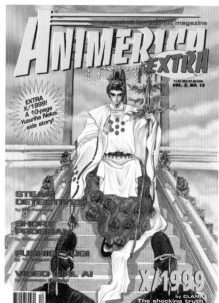

outside of Japan would. It's a police comedy. That probably wouldn't come over here because most of the jokes are based on dialects and things that wouldn't translate very well. There's just an enormous variety of genres and comics that are available in Japan. We can choose some with more universal themes. And by that I don't mean that we shy away from Japanese culture. There's a comic called *Urusei Yatsura* that's really heavily based on Japanese culture, but the characters are universal. The main boy character is something of a lecher. The main girl character is something of a sweet but air-headed girl. Everybody can relate to the characters, even if the situation seems slightly strange.

There's another one that's very popular that I'm working on at the moment that's called *Fushigi Yûgi.* That one is about a Japanese girl who gets transported into the culture of ancient China. And there, there's absolutely nothing that, supposedly, an American reader would sympathize with. But it's the characters that really make the story universal.

We do have a few advantages. Japan is an industrialized nation, much like the United States. And there are a lot of surface similarities in the cultures. So there are a lot of things that we'll just come across. Getting stuck in a traffic jam, for example.

CH: There are many styles of manga, such as shōjo, etc. Which styles do you

mainly focus on?

BF: One of my main areas is a magazine called *Animerica Extra.* It focuses on girl-friendly titles, because more than half of our audience is women, which is actually very strange for American comics. In most American comics, at least eighty-five percent of the audience is boys. But for anime and a lot of the manga titles, there's a very large women's contingent. And so most of the ones you'll find in *Animerica Extra* are shōjo, which are girls' comics, or shōnen, which are mainly based around romance. There's a title called *Video Girl Ai,* and that one originally came from a boy's comic, but it's heavily based in romance and a lot of our girl readers have written in to say that they knew it was a boy's title, so they would never have picked it up originally, but when they actually got around to reading it, they fell in love with it.

CH: From your position, what do you see as the major difference between manga and the classic western-style comic book?

BF: I think the biggest difference is that the main characters of manga tend to be normal people. Normal people caught in unusual situations who have to rise above those situations to triumph over whatever the problem is. Whereas most western-style comic books, especially the ones that concentrate on superheroes, are basically power-trip stuff. *X-Men* is a prime example. You go through puberty, and suddenly, you have amazing powers. Its popularity comes from what every kid wants—to be in control of his situation.

But the strength of manga [is in showing] that you don't have to be able to shoot beams from your eyes to overcome a situation and still have self-confidence. As kids are reaching high school age and growing out of the superhero genre, manga fills that area between high school and college with more complicated stories. It has more sympathetic characters—characters that you can relate to. And they're also going through experiences that those high-school-age and college-age people are also going through. Romance used to be a very large part of American comics in the 1950s, but it has died since; whereas romance has gone strong and is only getting stronger in the Japanese comics.

CH: Manga is certainly influencing western-style comics. Are western-style comics influencing manga?

BF: Yes they are. The classic example is by the father of manga, Ozama Tezuka, who did the original *Astro Boy* series from America in the 1960s. He pretty much started all of comics in Japan, and this was in the early '50s and late '40s when Japan was pulling itself out from the damages of the war. And he started drawing very interesting and fun comics that picked up people's spirits at a very rough time, and it was very cheap entertainment. He got most of his influences from early Disney. Which is why, when people make comments that the characters

NAUSICAÄ
OF THE VALLEY OF WIND™
PERFECT COLLECTION 1

STORY AND ART BY
HAYAO MIYAZAKI

MOBILE POLICE
PATLABOR
VOL. 1

STORY AND ART BY Masami Yuki

United States for the huge tomes, the 500- or 1,000-page books, that are very popular in Japan?

BF: We're just in the birth stages of that here. We started with a thing called *Manga Vision,* which is an anthology comic that sells for about five bucks and has a little over 100 pages per book. We followed it up with a comic that's aimed at adults, with more sophisticated stories, which is going to be 200 pages. Those are getting to be very popular. One nice thing about the anthology is it allows you to have, for example, an anchor series, something that's very popular to begin with. You can put in some experimental stuff that people probably wouldn't buy if they just happened to see it alone on the shelf. There's a series called *Short Program* authored by Mitsuru Adachi that we put into *Animerica Extra* and that is a series of about eight different short stories; each one is self-contained and the art style is very laid back. And then, at the end, he usually gives you a plot twist that really catches you. But because it's not big, flashy, beautiful art, most people probably would have ignored it if it hadn't gone into an anthology comic. But since we put it into an anthology comic where they're picking it up for some of the other more popular series anyway, it was able to find an audience.

CH: How many comic books does a successful manga artist usually produce in a year?

look western and that their eyes are very round, it's mainly from taking the animal/anthropomorphic stuff of Disney cartoons. The eyes were very large. Over the years, the eyes have gotten smaller and smaller, but they're still much larger than normal, and most of that came from Disney.

On a more recent note, it's funny because when we invite a lot of the Japanese manga artists to places like the San Diego Comic Con, or some of the conventions, their first move is to rush over and meet all of their favorite American comic book artists! They seem to admire the way Americans do *mood.* Sometimes they say they wish they could do mood the way some of the American artists do. So that's more of a modern influence.

CH: Has there been any market in the

BF: That varies greatly. For example, there are some manga artists who produce two or three series weekly, and that's sixteen pages for each series, every single week. They usually have a small army of assistants helping them. But they're still the ones doing all of the pencils and most of the inks.

CH: It's amazing, because the average American artist will do twenty-two pages in a month.

BF: The main thing is that the system is different. You don't have to worry about colors. I've noticed that a lot of American artists are very detailed in single panels, whereas manga artists tend to go for a more cinematic approach in which the backgrounds need only be a bunch of motion lines, for example. It depends on how each manga artist works, the kind of assistants that they have helping them, or the editorial policy of the magazines.

CH: A lot of the manga comics produced in America for Americans are in color, but most of the authentic Japanese ones are in black and white. Is there any hint of the Japanese ones moving toward color?

BF: Little smatterings now and again. Black and white seems to be the area of choice for manga, and when it goes to animation, then it takes on the color.

CH: What are the current trends in the manga world, either in storylines or art?

visual style is remarkable. It alternates urban and rural settings and imbues nature with a surreal, space-age edge.
T.V. Guide

STORY AND ART BY **Toshihiro Ono**

BASED ON THE ANIMATED SERIES BY **Tsunekazu Ishihara & Satoshi Tajiri**

BF: In the US, there's a big push toward girls' comics, even among the boys who are reading manga. That's kind of cool because [this] is one of the more inventive areas. Boys' comics have more "at stake"—heroic heroes. Since they're the comics with the highest circulation, they also have the most pressure on them to perform well. Girls' comics don't have quite the same pressure. They don't have quite the same

circulation. So the artists in girls' comics are allowed to explore a little bit outside of the boundaries.

CH: There seems to be a fierce loyalty among manga readers. Do you find this so, and to what might you attribute this?

BF: Absolutely! *Fushigi Yûgi*, which I mentioned before, is one of the bigger ones that has enormous loyalty among

SHORT PROGRAM

STORY AND ART BY
Mitsuru Adachi

Video-Girl Ai
VOL. 1: Pre-Production

STORY AND ART BY

fans, and I have to tread on eggshells to make sure that our basic fan base is satisfied with the translation. But also, it reaches a general enough audience that people who have never heard of this series before can still pick it up and enjoy it. Little things, like the pronunciation of some of the names, can spark enormous controversy among these fans. And if you do a [web] search for *Fushigi Yûgi,* you'll find page after page after page, probably hundreds of *Fushigi Yûgi* fans.

CH: I remember watching Japanese television when I was a kid. My favorite was *Tobor the Eighth Man,* and of course, *Astro Boy*—I even got the record album from *Astro Boy* and would trace him from the cover. There were also *Speed Racer, Gigantor,* and I remember that my sister loved *Kimba.* When did this more recent manga invasion start, when the average American kid discovered that there's this neat other type of comic book style out there?

BF: It comes in waves. The first wave was what you remember. Basically, early '60s was *Astro Boy,* late '60s was *Tobor.* In the later '70s and early '80s were shows called *Star Blazers* and *Battle of the Planets.* A big one came around 1985 when a series called *Robotech* came out. That was a very large one, and what that one did was prove that anime wasn't just for kids, that a lot of adults could enjoy this, too.

More recently, in the '90s, things have been coming along. *Power*

Rangers, as most people know, is originally Japanese. And the company that puts it out, Toei, is also heavily into animation. Then came the late '90s with this enormous new wave that was pretty much fronted by *Pokémon.* Actually, *Sailor Moon* came a little bit before that. *Sailor Moon* and *Dragon Ball Z* garnered a few people. *Sailor Moon* was wonderful because it started catching the girls' interest.

CH: And my girls in particular.
BF: Oh, really?

CH: Absolutely. I remember one Christmas at a toy store, I raced to beat another parent to the last Sailor Moon doll! I had never done that before, but I beat some woman out of a doll! I grabbed it before she could get it for her kid.
BF: [laughs] It's a great series. That was probably around '97. And then *Pokémon* came along and convinced American cable networks and the major networks, especially networks like Fox, that Japanese anime, as is —without a whole lot of changing— can still attract a large enough audience for them to be satisfied with their numbers. Right after that came things like *Digimon* and now the Cartoon Network is showing *Gundam Wing.*

CH: Bill, thanks for sharing your insights with my readers.

CLOSING NOTE

I hope you've been inspired by the art in this book. And I further hope that you've had some of the complexities of drawing demystified for you. I've concentrated on manga as a separate art form from western comics because the styles are distinct, each with their own set of rules. But artists across all genres are influenced by each other. A technique that may seem like a new invention when introduced into a western-style comic book may be a tried-and-true approach in manga; and the reverse may also be true. Therefore, it can only aid the comic book artist to explore as many styles as there are. And although it may seem that the professional cartoonist is quite different from the beginner, that's not necessarily true. Both had to begin somewhere. Both continue to make mistakes, as well as a good number of happy accidents, which are seized with delight and transformed into appealing drawings. And each approaches his or her work in the very same way: with a pencil, a blank piece of paper, and an imagination raring to go. Good luck to you!

INDEX